Masterpieces from the Pompidou Center

Musée National d'Art Moderne

SELECTED AND INTRODUCED BY **EDWARD LUCIE-SMITH**

FOREWORD BY **GERMAIN VIATTE**
CURATOR OF THE MUSÉE NATIONAL
D'ART MODERNE

FRENCH TEXTS TRANSLATED BY
SIMON WATSON TAYLOR

with 120 illustrations
103 in color

THAMES AND HUDSON

English translation © 1983 Thames and Hudson Ltd, London
© 1982 Centre Georges Pompidou, Paris and
Thames and Hudson Ltd, London

First published in the USA in 1983 by Thames and Hudson Inc.,
500 Fifth Avenue, New York, New York 10110

Library of Congress Catalog Card Number 82–50741

Filmset in Great Britain by Tradespools Ltd, Frome
Monochrome origination in Great Britain by DSCI, London
Colour origination in Switzerland by Cliché Lux, Neuchâtel
Printed and bound in the Netherlands by Smeets B.V., Weert

Contents

Foreword

GERMAIN VIATTE
Curator of the Musée National d'Art Moderne

How can one convey the essence of an entire museum in a mere 120 images? Even more, how does one explain the strange paradox of a 'museum' of 'modern art'? The function of any museum – to record, preserve, reflect and make choices – seems quite out of step with the whole thrust of modern art, and has, from the early days of the century, provoked endless controversy and debate. Nevertheless, such an institution became an obvious necessity, and the new concept of a place of contemplation emerged in which each work exists in its own right as well as in its interactions with the surrounding space – with the architecture, and here at the Beaubourg with Paris itself. Each confrontation, in its chronological context or within a personal universe, adds support to what Georges Salles called 'vision's ever-shifting focus'.

It was as Director of the Museums of France that Georges Salles, whose keen intelligence made him an ideal collector, authorized and encouraged the creation of the Musée National d'Art Moderne in 1947. He perceived the imaginative possibilities of a dialogue between objects. No one has better described the emotional potential of a museum: the freedom it offers, the happy encounters, harmonies and clashes, the richness of diversity and choice, which kindle enthusiasm or provoke discontent. The uniqueness and charm of a museum lies in its capacity to stimulate, challenge, go beyond life, to welcome a vast throng of people, to surprise and enchant them and to open the eyes of experts no less than those of outsiders who find themselves unexpectedly overwhelmed.

The layout that evolved during the first five years at the Pompidou Centre provided an interim response to certain architectural problems – problems soon to be tackled anew. It aimed to create spaces in time, harmonious or abrupt, reflecting life itself. It aimed to invite each work to speak with its own voice, unstifled by the constrictions of museography and pedagogy. Georges Salles' aims were correct: 'Instead of numbing the visitor's imagination with systematically uniform classification, let us try to provoke, to excite with our choices, to startle with surprises. This way we will effortlessly create a setting which shows things at their best. The atmosphere will sizzle with energy, there will be no dead corners or black holes. We shall have created what some call a "climate", although I prefer the term "presence", because of the strength of the works exhibited.'

The Pompidou Centre confronts Paris as if it were a mirror, fleetingly reflecting the images of this century's ideas and theories. The museum's role in this visual feast is to mark each innovation and to question all that is new. It suggests to visitors the flux and movement of creativity, while respecting the character of a particular body of work. And the collection itself has its own complex history. Ranged invisibly behind the several hundred works on display, there are thousands of others which help to sum up a century of hesitations, errors, lost

opportunities, obstructions, hobby-horses, campaigns and initiatives: a thick sediment of hope strained through the filter of the state to produce an image of contemporary reality.

Jeanne Laurent, in her book *Arts et pouvoirs* ('The Arts and the Authorities'), has traced this difficult and paradoxical collaboration from the end of the eighteenth century to the present day. Throughout the evolution of our collection a clear image emerges of public authorities, almost invariably lagging behind, submissive since the heyday of academism to intolerable pressures from the 'Institute'. In 1894 the Musée du Luxembourg was reluctant to accept a magnificent bequest of impressionist paintings from Gustave Caillebotte, and Apollinaire could still complain in 1914 of the same museum's neglect of new art from abroad. All this reflected an often xenophobic policy, and a suspicion of the cosmopolitan intelligensia that defiantly chose to live, with marvellous contradiction, in Paris. These artists dreaded official contacts and repudiated museums with the bitterness of scorned lovers. Some, either within or without the system, eventually determined to break with it. As early as 1925 the review *L'Art Vivant*, in the course of a lengthy inquiry into the possibility of creating a long-overdue French Museum of Modern Art, laid emphasis on the dilemma posed by any collaboration – or divorce – between artists and the state.

Unhappily, private patronage in France long remained ineffectual. This was, of course, by no means the case in several other countries. In the United States, for example, the 1913 Armory Show provided the initial impetus that led to the opening on 30 April 1920 of the New York premises of the 'Société Anonyme'. The artist-impresarios responsible – Katherine Dreier, Marcel Duchamp and Man Ray – lost no time in proposing an ambitious museum of modern art, one that corresponds precisely to our present-day concept. In Russia too, artists had organized similar movements, particularly the one spearheaded by Malevich in 1922–23 for the establishment of a Museum of Artistic Culture in Petrograd. Similarly in Poland, Wladyslaw Strzeminski and the Revolutionary Artists' Group succeeded in having an International Collection of Modern Art housed at the Lodz Museum in 1931.

In France it was left to a minor painter and poster artist, Andry-Farcy, who, as director of the Grenoble Museum, took the first step in 1923 by beginning to purchase contemporary art for inclusion in its permanent collection. In Paris, Louis Hautecoeur, who took over from the disastrous directorship of Léonce Bénédite at the Luxembourg in 1931, expressed a number of good intentions that unfortunately remained unfulfilled. In New York, on the other hand, the Museum of Modern Art had already come into being two years before, thanks entirely to private enterprise. Christian Zervos had written an important article in *Cahiers d'Art* in 1930, demanding the 'creation of a museum of living artists', and the following year he published Le Corbusier's proposal for a museum 'in continual growth'. Le Corbusier warned that this should 'steer clear of the academicians and all official support' and consider 'private initiative as the sole viable basis'. One or two pressure groups had indeed begun to prod the administration of the Luxembourg into action: Dr Tzanck's 'Society of Art Lovers and Collectors', for example, and the 'Society of Friends of Living Artists'. But the former finally abandoned its efforts and the latter resigned itself to the *status quo*.

It was the Popular Front of the mid-1930s, with Jean Cassou representing the state and Raymond Escholier the Ville de Paris, that worked to give living art its first official recognition. This happened to coincide with new concepts of leisure and education. Next, the 1937

International Exhibition in Paris helped break down the dogged resistance of academic circles. Of the 718 works commissioned, some, notably those by Delaunay, Dufy, Léger and Lipchitz, remain significant. A few purchases were made, particularly by the Jeu de Paume (Dali and Tanguy) on behalf of the new Musée des Artistes Vivants, due to be installed in its absurd building on the Quai de Tokyo. Thanks to Escholier at the Petit Palais, the Ville de Paris proved to be a good deal more dynamic than the state, making imaginative purchases and organizing a large-scale exhibition, 'The Masters of Independent Art'. Escholier welcomed the pioneering Grenoble museum, and began assembling the finest examples of what was seen in France as modern art, giving preference to the frequently rather tame progeny of fauvism and cubism. He excluded both surrealism and abstract art, which were long regarded as foreign to national sentiment and tradition. This hostility provoked Zervos, Jeanne Bucher and Kandinsky into mounting a counter-exhibition at the Jeu de Paume, entitled 'The Origins and Development of Independent International Art'.

When the Musée National d'Art Moderne opened its doors in 1947, Christian and Yvonne Zervos sought to balance this rather narrow view of modern art by organizing a magnificent counter-exhibition at the Papal Palace in Avignon to demonstrate its international diversity. Despite the efforts of Georges Salles and Jean Cassou, the help of several artists (notably Picasso and Chagall) and the generosity of a few great patrons (Paul Rosenberg and Raoul La Roche), the Musée National d'Art Moderne – this 'resolute attempt at an evaluation of modern French art' – suffered for a long time from the narrowly nationalistic ideas most clearly expressed in the critical writings of Bernard Dorival (*Les étapes de peinture française contemporaine*, 1946) and René Huyghe (*La peinture française – les contemporains*, 1949). As the first catalogue testifies, it was still felt necessary to devote several rooms to the mediocre productions of various salons. The museum acquired a new look when the generation of pioneers passed away (Brancusi in 1957, Pevsner in 1962, Robert Delaunay, Kupka and Dufy in 1963, Rouault and Gonzalez in 1964, Braque in 1965), at which time André Malraux succeeded in securing a number of comprehensive donations which greatly enriched the range of holdings. However, these acquisitions – almost mausoleum-like in their monumentality – tended to throw the collection off balance. Francis Jourdain had expressed fears about this in 1925, in the already-mentioned inquiry in *L'Art Vivant*, and they were echoed by Louis Hautecoeur when he assumed direction of the Luxembourg in 1931.

The Musée National d'Art Moderne's policies and those of the state began increasingly to attract public criticism, even from establishment figures such as François Mathey, curator of the Musée des Arts Decoratifs, Gaëtan Picon, chief administrator for the arts and literature, and the Minister of Culture himself, André Malraux. One point at issue was certainly that of the quality of the collections, but a more fundamental question concerned the state's negligent attitude towards living artists and their work. It seemed increasingly desirable to break with institutional restraints and to seek administrative flexibility and independence. This would entail separating the Musée National d'Art Moderne from the Department of Museums – with its fundamentally historical orientation – and granting it the administrative and economic autonomy necessary for the development of a consistent and dynamic policy. Elsewhere, Willem Sandberg's museum in Amsterdam called for the art of the past to be studied through the eyes of the present, while in Germany a number of Kunsthalle devoted to contemporary art became extremely active. The

Council of Europe's huge exhibition, 'The Sources of the Twentieth Century', organized by Jean Cassou at the Musée National d'Art Moderne in 1960 and 1961, had amply demonstrated the intimate relationship between art and ideas, and the importance of international exchange. This cleared the way for the great artistic events later mounted at the Pompidou Centre ('Paris–New York', 'Paris–Berlin', 'Paris–Moscow', 'Realisms', and 'Paris–Paris').

François Mathey, in his report 'Towards a Gallery of Contemporary Art' (1961), stressed the following points: the need to pay attention to the immediate present; to select work on a yearly basis with the accent on individuals; to assemble seminal collections of historical reference material; and to provide artists with the documentation, aid and facilities they had the right to expect. Two years later, in 1963, the project launched by Jean Cassou and Maurice Besset for a Museum of the Twentieth Century incorporated an 'evolutive' treatment of space based on the ideas of Le Corbusier. The museum should reflect 'the birth of the first total civilization our planet has known, one that can be understood only in the context of the worldwide renewal of forms of thought, feeling, expression and life that this civilization has provoked.' Further, such a museum 'should, through appropriate museological means, evoke the whole pattern of events that combined to form what will appear later as the style of the twentieth century.'

The Musée de la Ville de Paris set up a department for contemporary art, the 'ARC' (Animation, Research, Confrontation) in 1967–68. This was closely followed by the Centre National d'Art Contemporain ('CNAC') which called for the formulation of a coherent and diversified state policy towards artists, to embrace purchases, commissions, exhibitions and documentation. It insisted on the urgent need for an international policy regarding purchases and exhibitions. These propositions encouraged the more positive evolution of the Musée National d'Art Moderne, under its new director Jean Leymarie. They also contributed to the changes wrought by the museum's move to the architectural complex proposed by President Pompidou, to be built on the open space of the Beaubourg in the very heart of Paris. The character of this new cultural centre was profoundly marked by the personality of its first director, Pontus Hulten, who was the disciple of Willem Sandberg and the creator of a particularly dynamic museum, Stockholm's Moderna Museet.

Now that an acquisition budget was made available (recently increased by the new government), in addition to gifts from generous and enlightened patrons, the museum's collection gradually acquired a truly international scope, and the museum team procured major works that filled some of the most obvious gaps in areas such as surrealism, constructivism and postwar art in France and the United States. These fresh acquisitions sought to heighten awareness of contemporary artistic creation, and to illustrate the variety of its techniques and orientations. So great is the diversity, that the museum's selection of the most recent art is continually in a process of evolution. As Edward Lucie-Smith explains in his introduction to the present selection of works, it seemed preferable to avoid giving a biased idea of contemporary art by including areas of current growth, even though we might be offering a somewhat abbreviated view of the museum's concerns.

The notion of masterpieces contains ambiguities which Edward Lucie-Smith also discusses in his introduction. It does indeed seem incompatible with a constantly evolving present. But a choice of images such as this should not, in any case, be viewed as a kind of 'honours list'. It is far more a reflection of the pluralistic environment which a museum should ideally provide. Jean

Crotti, the brother-in-law of Marcel Duchamp, dreamed in 1925 of a museum as something which awakens people: 'Its doors must be wide open, so that a strong fresh breeze may circulate, so that light may spread unhindered. One should be able to enter it at any hour of day or night, and no restrictions of any kind should hinder its activities. Its life would be that of its era, and visitors there would find themselves living closer to the art of their own epoch.'

After fifty years of frustration and conflict, of progress defiantly and steadfastly maintained, it seems that this dream has become a reality.

Introduction

EDWARD LUCIE-SMITH

Can one use the word 'masterpiece' in connection with modern art? The whole history of modernism is that of an attempt to disrupt not only established norms, but established hierarchies. Many of the most important modern artists – Marcel Duchamp is a case in point – have mocked the pomposity of the academies by putting totally incongruous objects into a museum or exhibition context. Are these objects to be treated as sacred relics?

It is of course true that the mere passage of time drastically alters our attitudes towards works of art, focussing the limelight on some, relegating others to obscurity. The earliest paintings illustrated in this book were created during the first decade of the century, during that now almost unimaginably different epoch which preceded the First World War. There has been plenty of time for these to fall into perspective. As the works of the first years of modernism recede from us in time, we perceive not only their innovatory force, but those qualities in them which are timeless, and which unite them to the major achievements of much earlier times.

Nevertheless one must concede that 'masterpiece', in this context, is being employed in a slightly special way. It is prudent to stress, not so much the artist's determination to create a *chef d'oeuvre*, as the status of the work of art itself as a kind of landmark set up to mark the progress of the Modern Movement and the growth of the modernist sensibility. Each of the works reproduced here, if interrogated closely, has something to tell us about the development of our own attitudes towards the act of making art – what we expect the artist to do both for us and to us. This is something which becomes particularly clear as the sequence progresses. In the most recent works, one encounters not definitive masterpieces, but paintings, sculptures and objects which each in their own way seem to typify the different strategies adopted by modern creators, and to define both the opportunities made available to them by the social and intellectual patterns of Western society, and the possible limits of their activity.

It is partly in order to make this progression clearer that the works chosen have been divided into three groups, which between them give an idea of the scope of the collection. The first group contains works which range from the early years of the century to the end of the First World War. Here one sees illustrated that great upsurge of creativity which accompanied the appearance of the first art to be recognizably modern in the sense in which the term is used today. Nearly all the major pioneering movements are illustrated with splendid examples – fauvism, cubism, expressionism – together with the move towards non-representational art. The second group spans the period between 1918 and 1945, and shows the complex currents of the inter-war years, among them the surrealism which preoccupied so many leading artists at that period. It also illustrates how a number of developments which we now think of as being essentially post-Second World War were already being anticipated. Finally there is a group of works which illustrates most of the tendencies which were prominent between 1945 and 1970.

Though the Pompidou Centre collection already contains numerous works created since 1970, it has been decided not to include these here, not only because they are so recent that their exact significance is sometimes difficult to determine, but because the Pompidou Centre is currently purchasing very actively in this field, and any brief report of its holdings of the most recent art would inevitably grow quickly out-of-date.

One striking exception has been made to this decision to exclude works which are later than 1970. That is a painting by Balthus dated 1980–81. It is included for two reasons – first to show that, despite everything which has been said above, it does remain possible for a contemporary painter to attempt the creation of a masterpiece, using the term in an absolutely orthodox sense. Modern art is full of paradoxes, and almost every statement which can be made about it contains the seeds of its opposite. Here is a stunning example. The second reason for choosing this work is that it demonstrates the fact that artists are not bound by the neat patterns of development invented for them by historians and critics. They proceed according to their own rules. A painter or sculptor, having invented a style which is valid in its own right, may serenely continue to explore its possibilities and implications at a time when the art movements most in view are concerned with something totally different. Another case in point is Bonnard, one of the greatest artists of the century, whose work developed for many years in almost complete isolation from the artistic currents of the time, without ossifying or losing any particle of its originality.

Despite the chronological framework within which the works are presented, this volume is not just a potted history of modern art drawn from the resources of one museum. Though the Pompidou Centre has one of the most comprehensive collections of modern art in the world, surpassed in this respect probably only by the Museum of Modern Art in New York, it does have gaps which have not as yet been filled. One which is immediately noticeable is the absence of a major Italian futurist work in the first section. The collection makes up for these occasional absentees by having a very particular character of its own.

This character is partly due to the context within which the visitor encounters it. The Musée National d'Art Moderne at the Pompidou Centre exists as an independent entity, but also forms part of a larger whole. Housed in one of the most celebrated of all modern buildings, it supplies a background to the numerous temporary exhibitions exploring modern art and the contemporary way of life and illustrating the growth of our contemporary sensibility which the Centre presents to an immense international public. The Pompidou, during the comparatively brief span of its existence, has probably done more to explain and popularize the modern visual arts than any other institution. To this activity, the permanent collection of the Musée National d'Art Moderne supplies a necessary historical backdrop. It helps to situate the Pompidou's exhibitions in relationship to the development of modernism taken as a whole. It also does something less obvious, but perhaps equally necessary. It supplies an assurance that in all the flux of activity which the exhibitions record, there remains the possibility of something lasting, a heritage to be passed on to the generations yet to come.

Far more than this, however, the collection at the Pompidou Centre owes its flavour to the city where it has been formed, and to the particular circumstances which have affected the growth of modern art. Far more than any of the art movements which have preceded it, with the sole exception perhaps of the mannerism of the sixteenth century, modernism is an international

style. It has flourished, though sometimes intermittently, in all the nations of Western Europe, and also in the United States. It has made deep inroads into the culture of Latin America, is accepted as the dominant idiom in Canada and Australia, and has had an impact in many of the countries of the so-called Third World. Recent international exhibitions of graphics, for example, show how artists in Africa and in Asia are trying to reconcile what they find in their own cultural heritage with modernist attitudes.

Yet there is a real sense in which all this activity can be traced back to one place – to Paris. Those of the early modernists who were not French looked towards Paris for enlightenment and instruction. Having determined to revolutionize the state of Italian art, the futurists chose the French newspaper *Le Figaro* as the appropriate medium for their first manifesto. The ambition of all avant-garde artists was to make a pilgrimage to Paris, just as devout Moslems made the journey to Mecca. Brancusi came on foot, all the way from his native Romania. Once they had arrived, many of these foreign artists settled in Paris, or at any rate in France. This was the spot where it was easiest to make the kind of art they wanted to create. When one speaks of the Ecole de Paris, one does not speak of Frenchmen alone – it comprises artists whose origins are widely scattered – Russian Jews like Chagall and Soutine; Spaniards like Picasso and Juan Gris. Even those artists who could not come, or who visited the city only briefly, looked towards Paris as a centre of artistic energy. This was particularly true, for example, of the gifted men and women who revolutionized Russian art just before and just after the political Revolution of October 1917. Newly rich Russian collectors such as Sergei Shchukin brought together collections of the most advanced French art of the time and made these available to young Russian artists. The impact of Shchukin's collection on young Muscovites was tremendous. It brought into focus possibilities which they had previously only guessed at. For many years modern art throughout Europe spoke with a French accent. The coherence of the works reproduced in the first section of this book, whatever the national origins of the artists themselves, is largely due to this fact.

In the inter-war years Paris continued to exert its spell. It was the headquarters of surrealism, the most influential art movement of the period. As the political horizon darkened, France, with its tradition of hospitality to exiles, became the refuge not only of artists who were already well known, such as Kandinksy, but of those whose reputations were yet to be made, among them Hans Hartung. The painting by Hartung reproduced in this book is particularly interesting because of its date – 1935. It shows, already fully developed, a way of making art which most people associated with a period which falls fully ten years later (Pl. 72).

It was only after the Second World War that Paris seemed somehow to be displaced by New York as the place where the most exciting art was made. Or this is the view now put forward by the majority of historians. Yet I believe the works reproduced in the third section of this book show that it is a notion to be accepted only with great caution. The relationship between American modernism and what was happening in France is even more interesting, and certainly more complex, than the relationship between the French avant-garde and its Russian equivalent. Throughout the nineteenth century American artists looked towards Paris as a fountainhead of instruction. Many, and among them Thomas Eakins, the greatest nineteenth-century American painter, came to France to study under the leading Salon artists of the time. Eakins received his technical grounding from Gérôme and Bonnat. The great American

collectors, enriched by the rapid expansion of American industry, were always enthusiasts for French art. Major works by the French impressionists arrived in American collections very early.

Where modernism itself was concerned, the initial impact was made by the New York Armory Show of 1913, where American modernists were exhibited beside their French counterparts. But it was the foreigners who caught the attention of the public. Marcel Duchamp's *Nude descending a staircase* became for Americans an immediately recognizable emblem of the revolution taking place in the visual arts. For many years American modernists had to struggle against an ingrained prejudice among their own compatriots – a feeling that whatever they produced was automatically provincial and inferior. The basic principles of modernism were, however, welcomed in the United States as almost nowhere else. Katherine S. Dreier's 'Société Anonyme, Incorporated', founded in 1920 and advised by Man Ray and Duchamp, pioneered American institutional collecting in this field. It was followed a decade later by the Museum of Modern Art in New York, which the combination of American wealth and American enthusiasm made into a kind of Uffizi of the Modern Movement.

The tide did not turn for American artists until the outbreak of the Second World War. The leading surrealists fled almost *en masse* to New York, bringing their American colleagues into direct contact with the latest modes of modernist thinking. Americans became conscious of their status as the greatest world power and began to feel that American art must, and probably could, match up to national expectations. When the war itself was over, Europeans were impressed by the vitality and self-confidence of the new American art.

The collection at the Pompidou Centre enables the visitor to trace this turn of events. There are fine examples of major American artists of the post-war period – Pollock, Barnett Newman, Robert Rauschenberg and Andy Warhol are all represented with first-class specimens of their work. Also included is an especially beautiful painting by the American abstract expressionst Sam Francis, long resident in France, and typical of the continuing dialogue between French and American art. One gets another perspective on this relationship from the dashing calligraphic canvas by Mathieu, the French artist who perhaps did most to introduce the new American art to a European audience.

Though the Pompidou Centre owns fine works by leading Americans, these are not the centre of gravity of the more recent part of the collection, and the choice made for this book acknowledges the fact. The Centre's holdings of art post-1945 give a unique view of the way in which the European tradition continued to develop and to assert its own identity. It is possible to see how the free abstraction of artists like Nicolas de Staël, Poliakoff and Soulages differed from that produced at the same period in America through its more luxurious surfaces, its greater feeling for the actual materials used by the artist, as well as its irrepressible interest in more complex patterns of composition than the Americans would permit themselves. It is also possible to see how apparently similar impulses transmuted themselves when filtered through a European rather than an American sensibility. The 'New Realism' of artists like César and Arman was born at about the same time as American pop art, and has its roots in the same kind of urban society – wasteful and consumer-oriented. The way in which the artists concerned embody their feelings about the context they inhabit is nevertheless entirely different.

European art, post-1945, has a claim to be much more varied than its American counterpart, and this too is reflected in the selection made for this book. It ranges from the severe, hard-

edged geometric abstraction of the veteran Auguste Herbin, represented by a major late work which surely has all the absolute authority evoked by the word masterpiece, to the complex mechanical sculpture by Jean Tinguely, which so perfectly expresses, with its fusion of humour and irony, its creator's attitudes towards the ramshackle world that surrounds him. There are also certain figures who seem peculiarly European not merely because of what they produce, but because of what they are. As personalities, both Jean Dubuffet and the late Alberto Giacometti evoke the sense of alienation which pervaded intellectual circles in Europe immediately after the war. Dubuffet is a master of dislocation. He uses what seem to be inappropriate materials for equally inappropriate ends, finding melancholy satisfaction in the way his work betrays him by turning inexorably into art. Giacometti struggles to seize an elusive reality which constantly evades his grasp. Both artists can be identified with a broader intellectual and philosophical context in a manner which is typical of the visual arts in France and surprisingly rare elsewhere.

The newest age of European art has had one tendency which I believe is peculiar to itself. It reverts to the very origins of art in producing men who are not so much artists, in any conventional sense of the term, as shamans – tribal medicine men performing ceremonies on behalf of the collective psyche. The objects they produce are totems, mysteriously impressive, but at the same time by-products of activities which are more transitory and more hermetic. Two cases in point are Yves Klein and Joseph Beuys. Beuys' rituals produce a totally different effect from the 'happenings' staged by American artists, and there is a tremendous clash of atmospheres in the confrontation between his *Homogeneous infiltration for grand piano* and Andy Warhol's *Electric chair* (Pl. 118–19). Warhol makes the sinister banal; Beuys takes the apparently commonplace and makes it suggestive of the mind's darker reaches. Each man deliberately acts out a role as a public figure – Warhol's inert negativism is in striking contrast to Beuys' passionate preaching and search for direct human contact with his audience. In an American context Beuys seems exotic, just as Warhol does in Europe.

The confrontation of Beuys and Warhol on facing pages is of course deliberate, and (within the limits imposed by a desire to maintain fairly strict chronological sequence) there are many other extremely instructive confrontations in this book. Sometimes they are designed to point up the similarities between certain works of art, whether or not they come from the same school; sometimes they are meant to demonstrate differences, and to show how one work extends the statement made by another. Early in the first section, for example, one finds a fauve portrait by Friesz opposite one by Marquet (Pl. 2–3). Towards the end of the same section two more portraits confront one another. There is the little sculpture in plaster by Raymond Duchamp-Villon depicting Professor Gosset, who treated the artist for septicaemia during the First World War when he contracted typhoid at the Front; and there is Matisse's wonderful and until now virtually unknown portrait of Pellerin, recently acquired for the collection (Pl. 36–37). Here both style and medium are very different, yet the similarity remains striking. Each artist has chosen to interpret a highly intellectual sitter in the same way, by reducing his head to a simplified mask dominated by a high domed forehead. Matisse is also the subject of another and even subtler confrontation – his *Violinist near the window* appears opposite Malevich's suprematist *The black cross* (Pl. 32–33) painted about a year earlier. Here the contrast is between two different kinds of simplification – the kind which reduces what is observed to its most authoritative form;

and the kind which rejects representation altogether. Matisse remains here, as elsewhere, a supreme colourist; Malevich renounces colour altogether. Yet one notes that the stark geometric form which is the whole substance of Malevich's painting plays an important subsidiary role in the *Violinist*, since it is the cross-bars of the window which bind the design together.

Matisse and Malevich are again paired in the second section, where the former's monumental *The dream* can be found opposite the agitated hieroglyph of Malevich's *Man running* (Pl. 70–71), itself the very substance of a dream. This painting, possibly Malevich's last, may refer at once to the artist's imprisonment in 1930, to the condition of the Russian peasantry under Stalin, and to Malevich's own struggle to escape the cancer which was to kill him in 1934. At first sight it seems very different from *The dream* in its improvised character, but a close examination proves that it is not impulsive at all. A number of pentimenti show how carefully and laboriously the painting was put together, and a preparatory drawing survives which shows considerable differences from the finished result. The quality the two paintings have in common is something which underlies their superficial contrast in style – each is an attempt to penetrate to the heart of a mystery.

The *Man running* is worth comment in another respect. Together with the *Man and horse*, also at the Pompidou, it is almost the only example of Malevich's very late style in a Western collection. The Centre's holdings are rich in items which are one-of-a-kind. Among the most famous are Picabia's *Cacodylic eye* (Pl. 44), and Giacometti's surrealist sculpture *Sharp point in the eye* (Pl. 65). Here, in each case, the creator seems to break free of anything one might have predicted for him, to reach painfully into his own subconscious for an image whose meaning remains partly veiled even from himself. One cannot say that one knows a finer Picabia or a finer Giacometti in another collection, because both works are strictly *sui generis*.

Their presence in the collection offers a clue to its character taken as a whole. The other great collections of modern art – in America, Germany and Switzerland – tend to have a systematic air. They offer a survey of the subject as it has been mapped out by critics and specialists, or at least of some aspect of the subject. The Musée National d'Art Moderne, despite its official title, is not like that. It is not a stamp album, but an accumulation of family photographs. It gives an intimate view of the way art has evolved in this century such as can be obtained nowhere else. This intimacy is something strongly felt, for example, in one of the collection's chief glories – the reconstruction of Brancusi's studio. Here one catches a glimpse of the private life of the man whom many think of as the greatest sculptor modernism has produced.

The Pompidou is extremely rich in paintings and sculptures with evocative associations. One instance among quite a number reproduced in this book is Giorgio de Chirico's *Premonitory portrait of Guillaume Apollinaire* (Pl. 35). The great poet and propagandist for modernism is shown as a profile from a fairground shooting gallery, a hole neatly drilled in his temple. The picture was painted in 1914, and the bullet-hole marks the spot where Apollinaire was later to be wounded during the War – a wound which, in turn, led to his death in the great Spanish influenza epidemic after the Armistice. This prophetic image must surely give a kind of *frisson* to anyone interested in the growth of modern art. And Giacometti's portrait of the writer Jean Genet, though less tragic in its implications, evokes a later epoch with great precision – the intellectual ferment of Paris in the 1950s, and the search for extremes which was typical of the

period. Genet is the link between the *âmes damnées* of French nineteenth-century literature, such as Baudelaire and Nerval, and the moral libertarianism of our own time.

Finally I must mention a very striking characteristic of the Centre's holdings, which is the extent to which they have been enriched by the generosity of artists, their widows and their descendants. The Pompidou Centre has one of the most comprehensive collections of Kandinsky's work in the world, covering all phases of this seminal artist's development. Fifteen superb oils and fifteen watercolours were selected and given to the collection in 1976 by the artist's widow, Nina Kandinsky, who left practically everything else to the Museum after her tragic death. There is an almost equally comprehensive group of works by Victor Brauner, and a large and comprehensive group of sculptures covering the career of Jacques Lipchitz. In this sense the Pompidou is becoming a collection of collections as well as a collection of works of art.

It is clear that these magnificent gifts are prompted first by a sense of appropriateness – the idea that an artist who has played an important role in the evolution of modernism ought to be well represented in the city which, more than any other, is associated with the Modern Movement – and secondly by a sense of gratitude for what Paris has given to the artists who have either inhabited or visited it.

The collection as it now exists offers endless opportunities for enrichment to the visitor who comes to see it, and this power will grow as it is continually enlarged by new acquisitions. A book such as this can give only a taste of the marvels it contains.

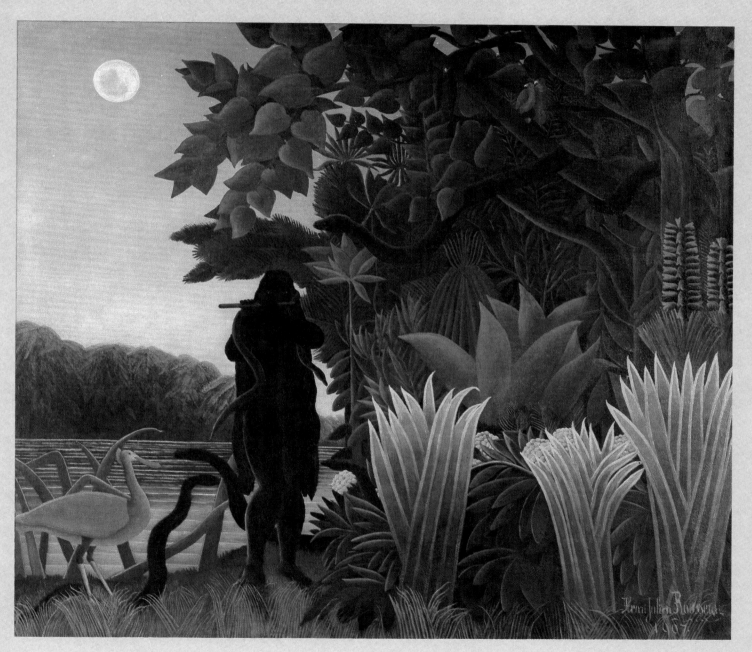

1 Henri Rousseau *La charmeuse de serpent* 1907

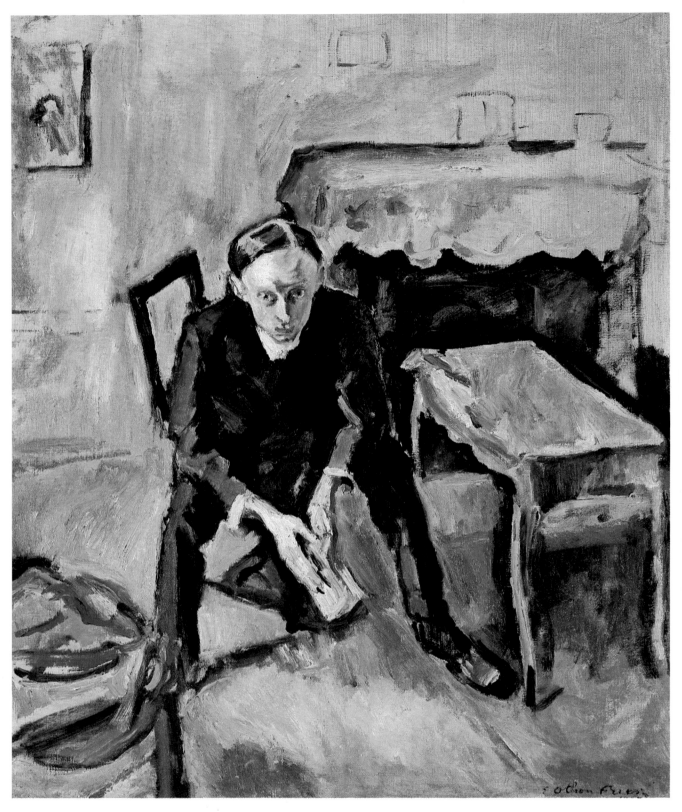

2 Othon Friesz *Portrait de Fernand Fleuret* 1907

3 Albert Marquet *Portrait d'André Rouveyre* 1904

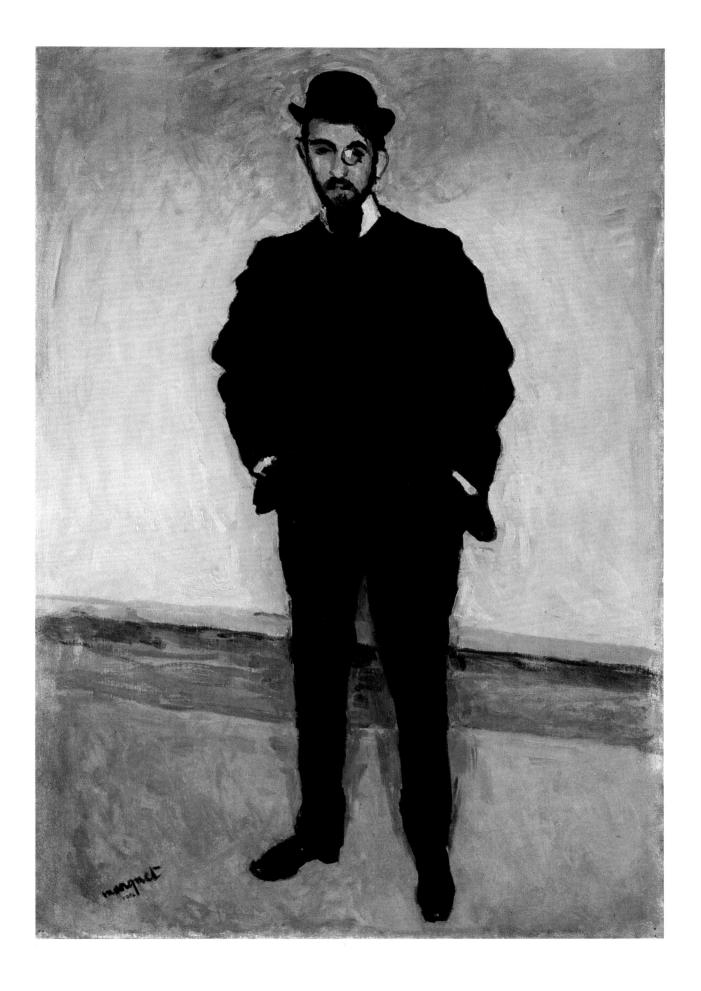

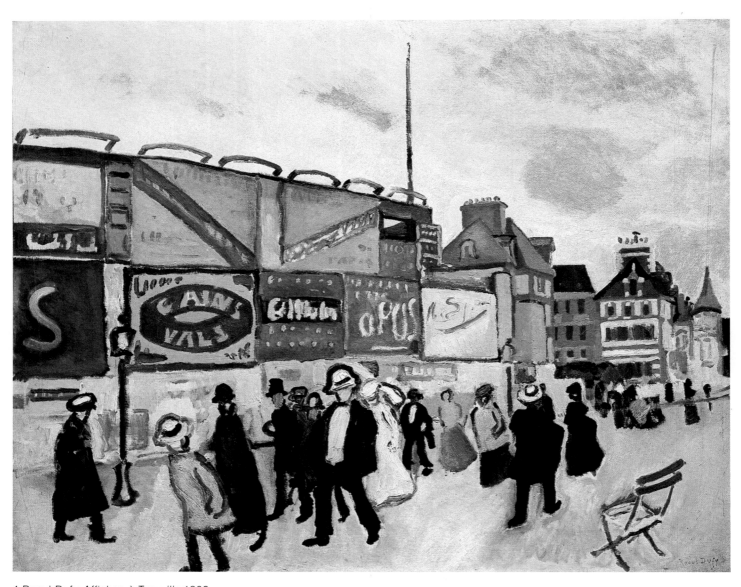

4 Raoul Dufy *Affiches à Trouville* 1906

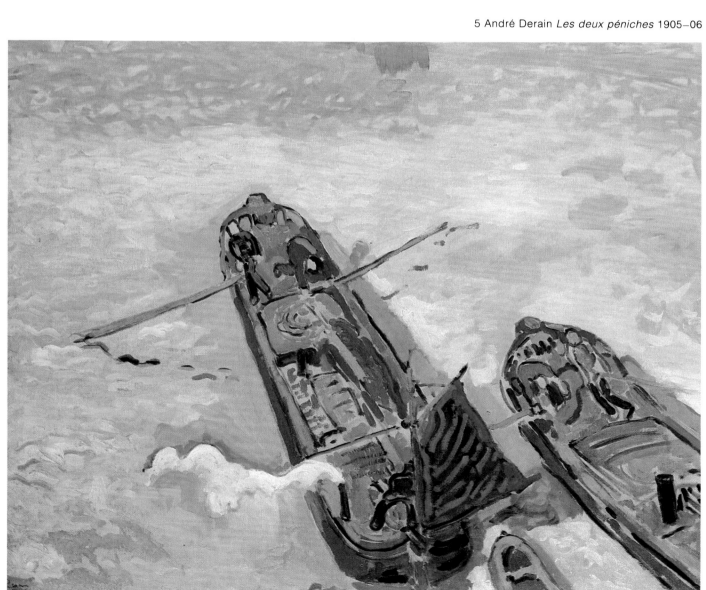

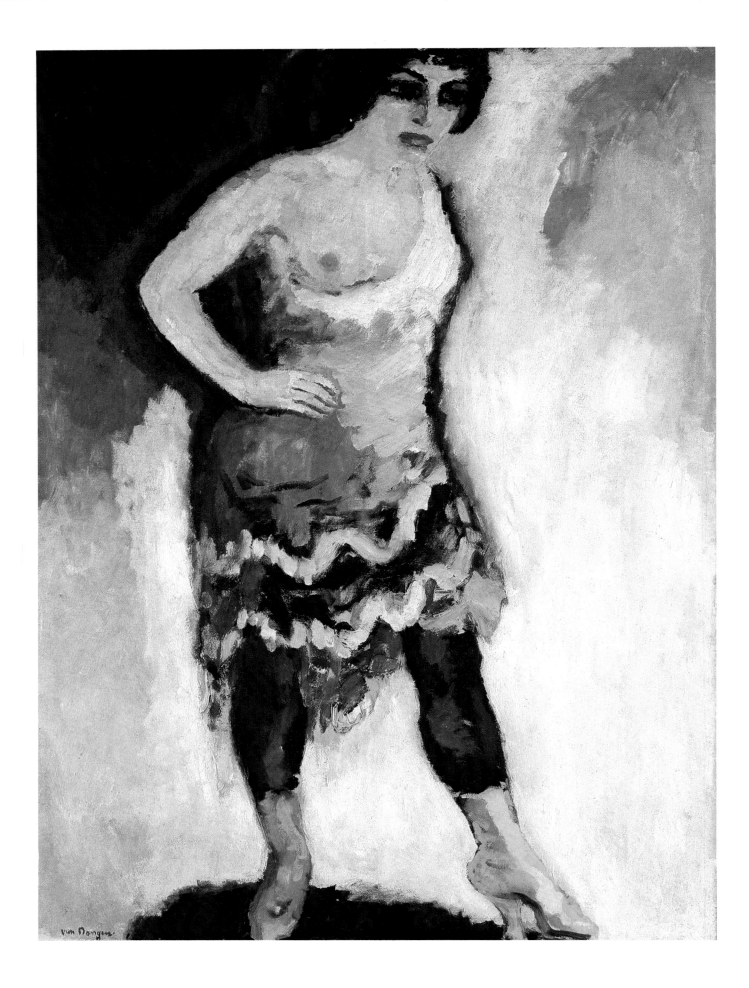

6 Kees van Dongen *Saltimbanque au sein nu c.* 1908

7 Georges Rouault *La fille au miroir* 1906

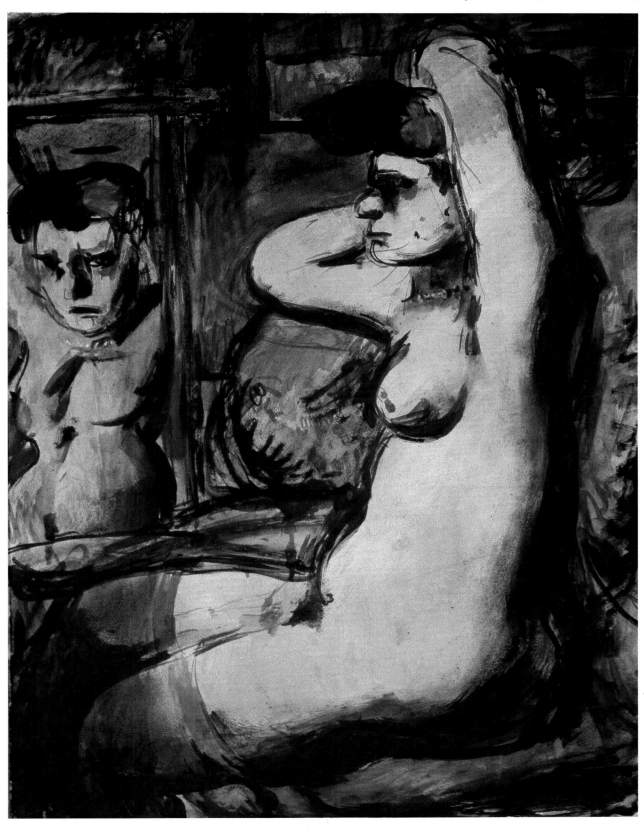

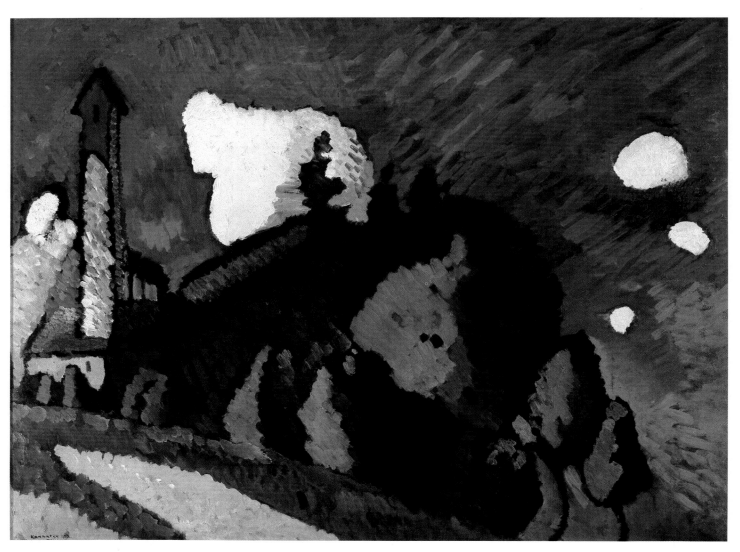

8 Wassily Kandinsky *Landschaft mit Turm* 1908

9 Sonia Delaunay *Philomène* 1907

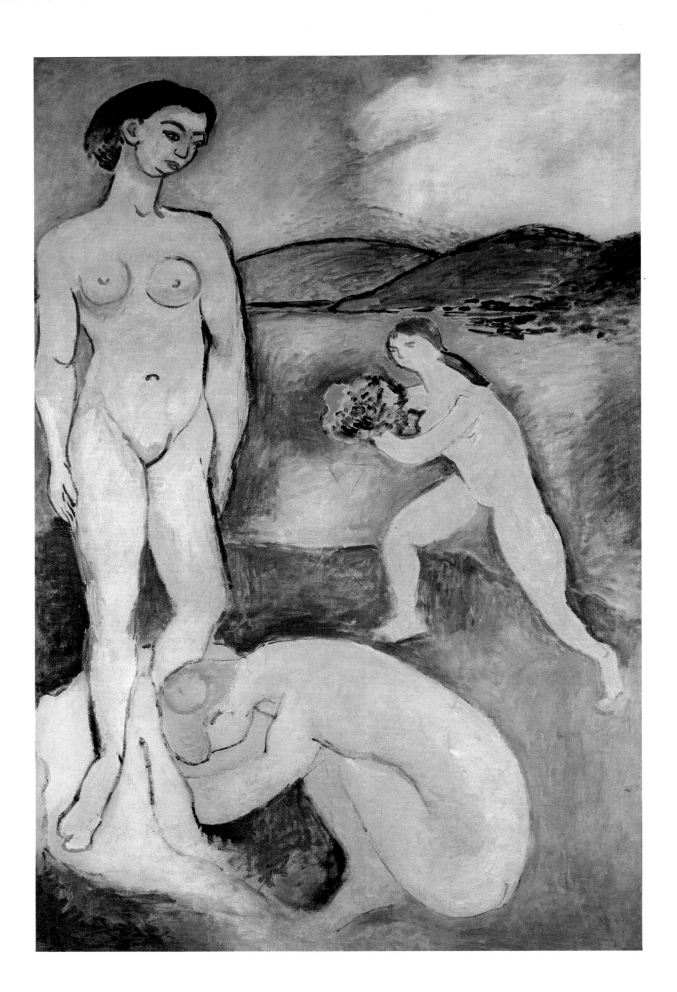

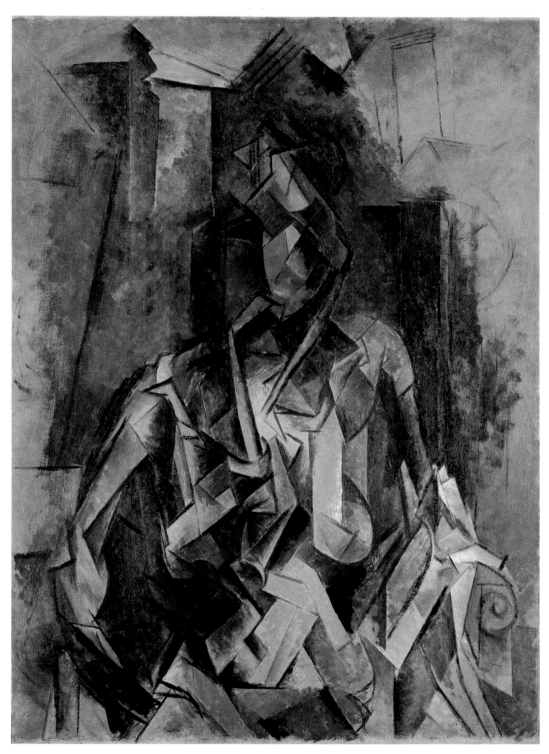

11 Pablo Picasso *Femme assise* 1909

10 Henri Matisse *Le luxe – I* 1907

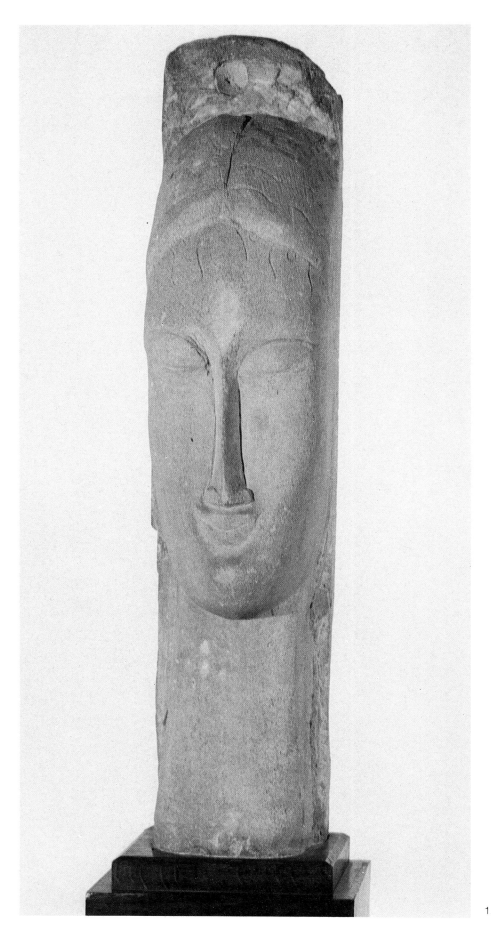

12 Amedeo Modigliani *Tête de femme* 1912

13 Constantin Brancusi *Muse endormie* 1910

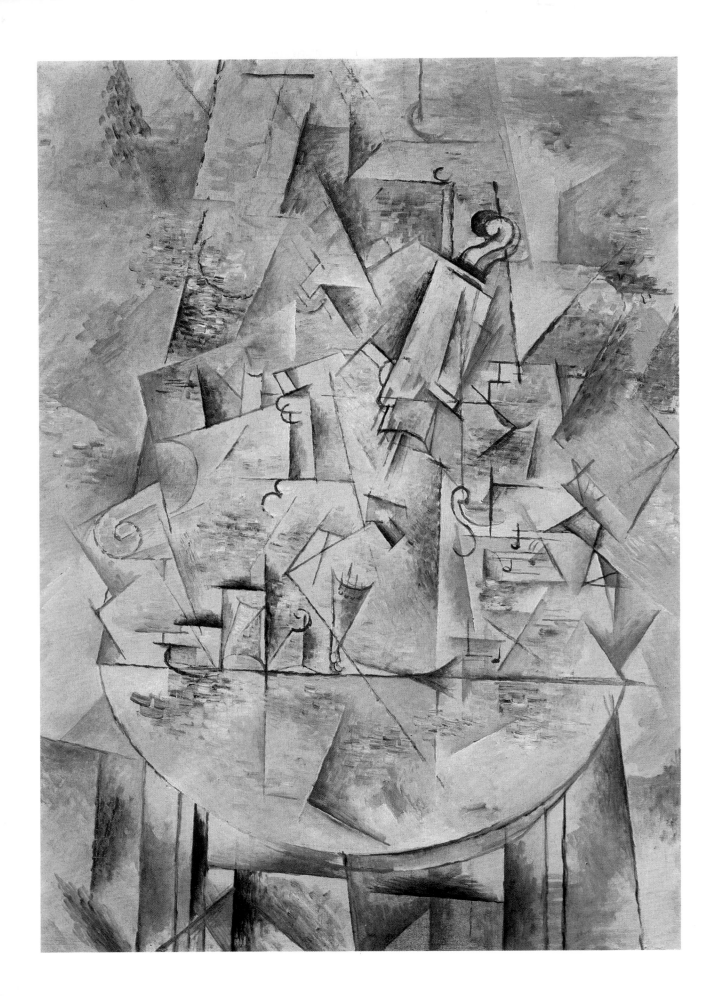

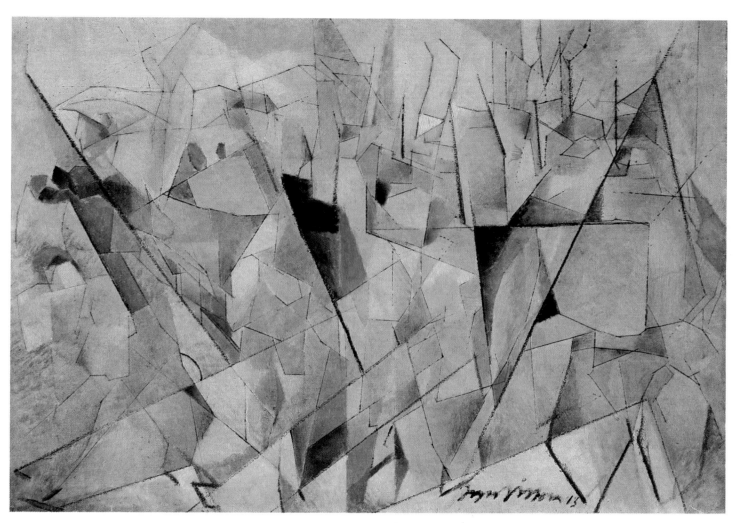

15 Jacques Villon *Soldats en marche* 1913

14 Georges Braque *Le guéridon* 1911

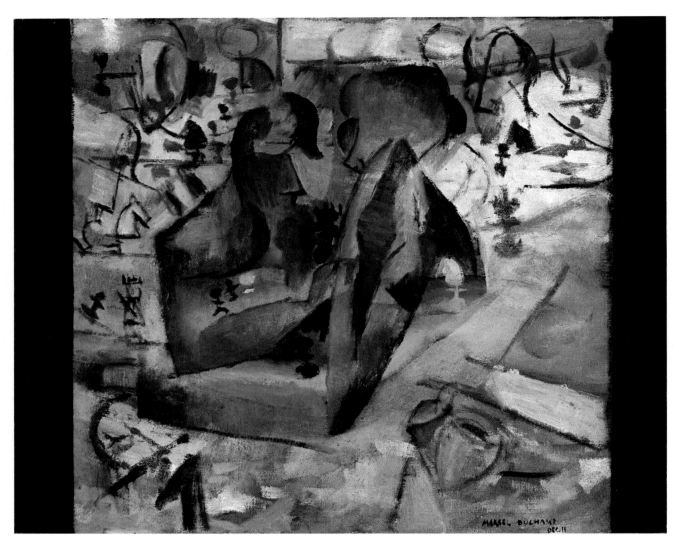

16 Marcel Duchamp *Les joueurs d'échecs* 1911

17 Fernand Léger *La noce* 1911–12

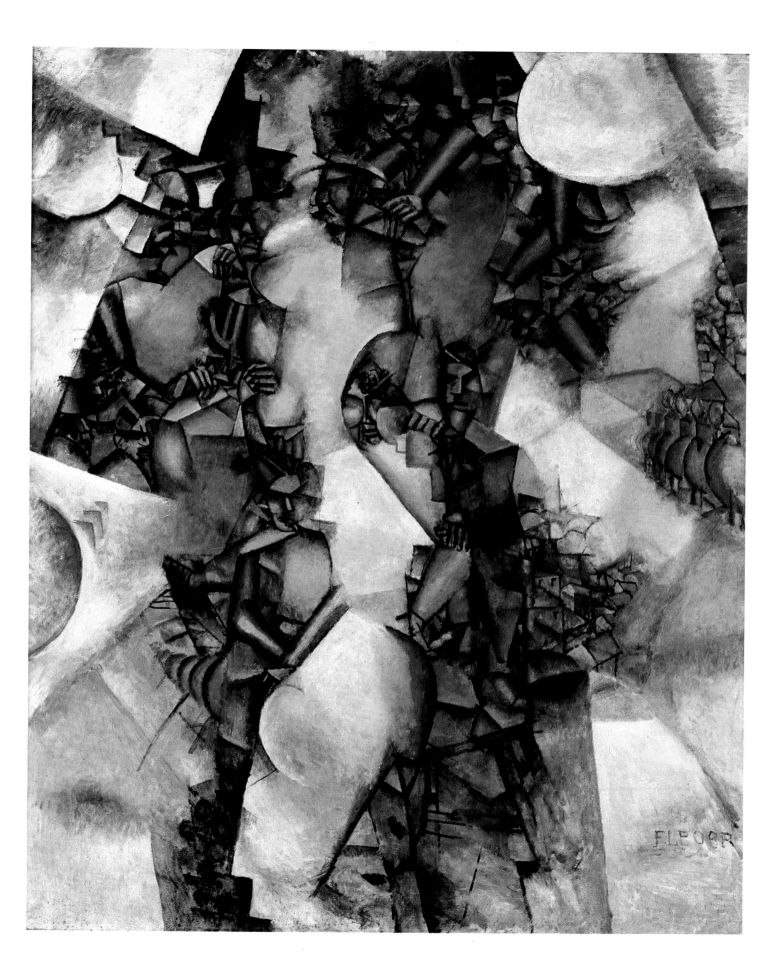

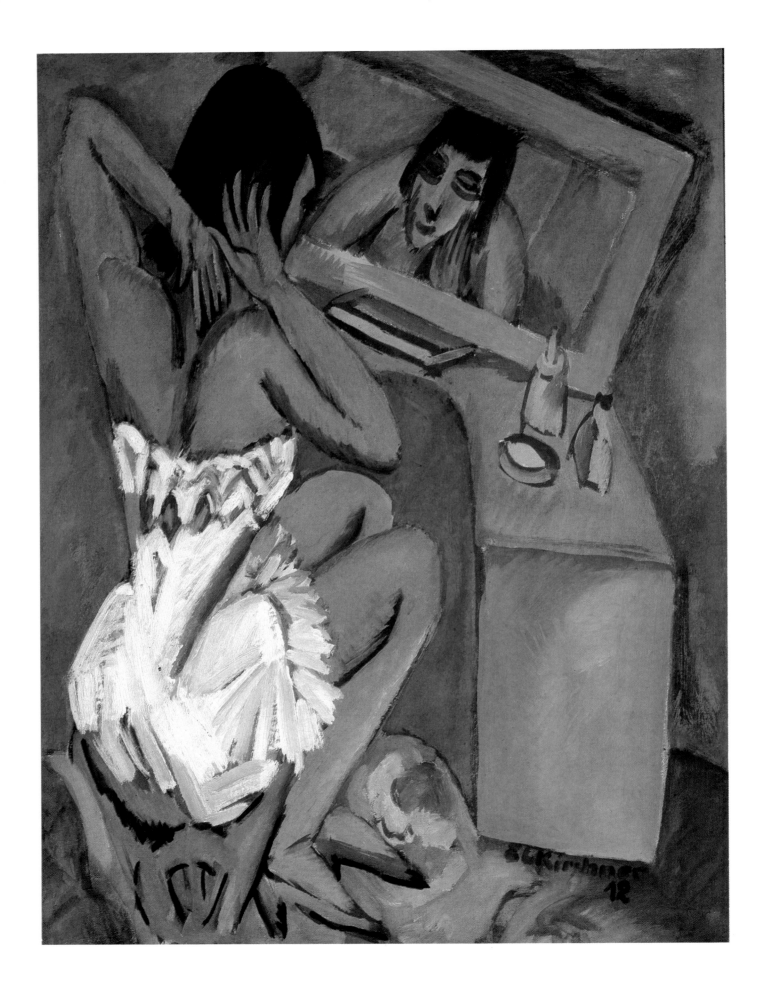

18 Ernst Ludwig Kirchner *Frau vor dem Spiegel (Toilette)* 1912

19 Michail Larionov *Portrait de Tatlin* 1911

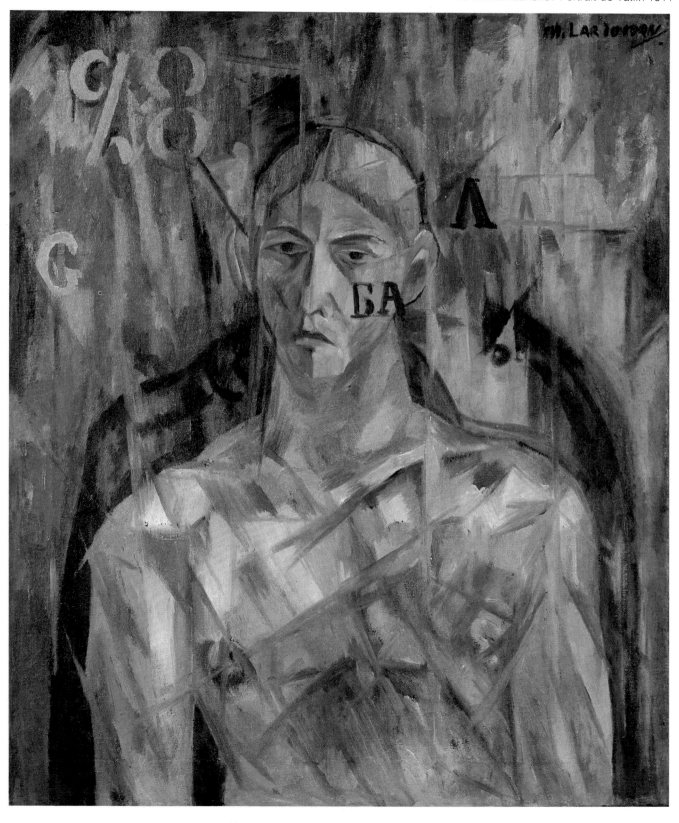

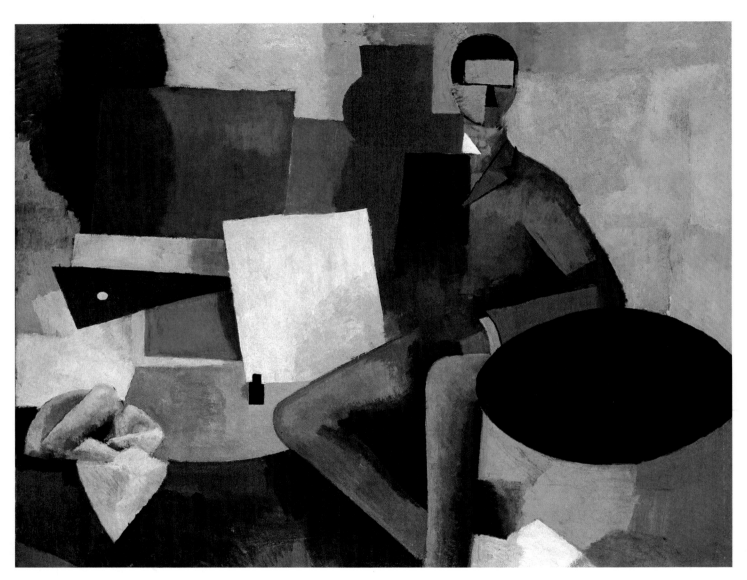

20 Roger de La Fresnaye *Homme assis* 1913–14

21 Juan Gris *Le petit déjeuner* 1915

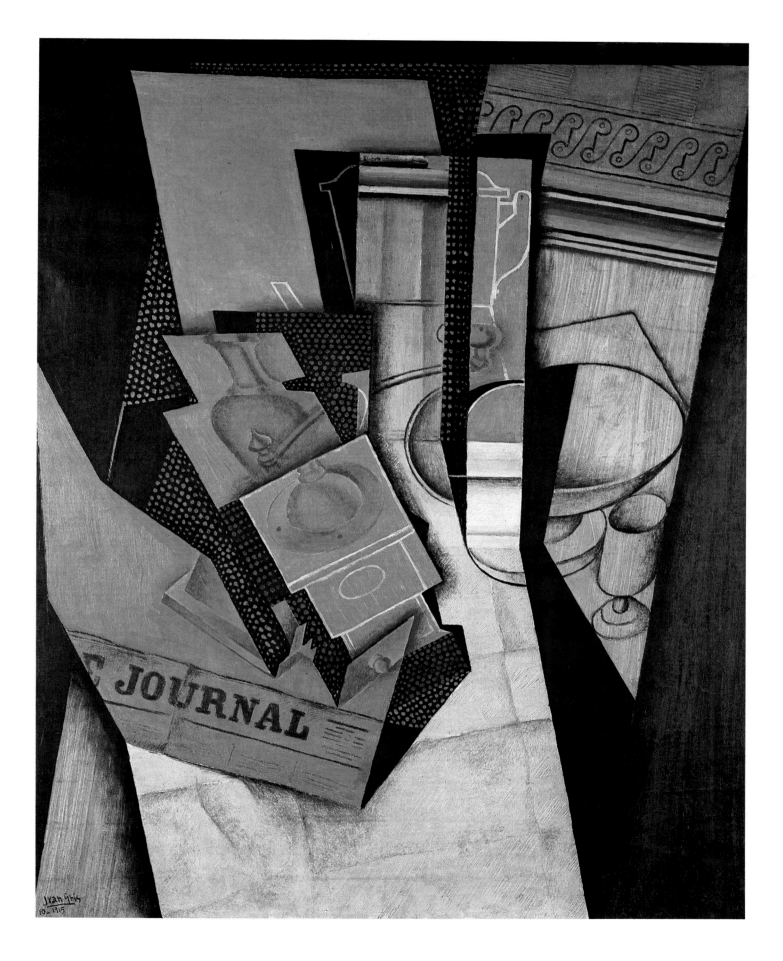

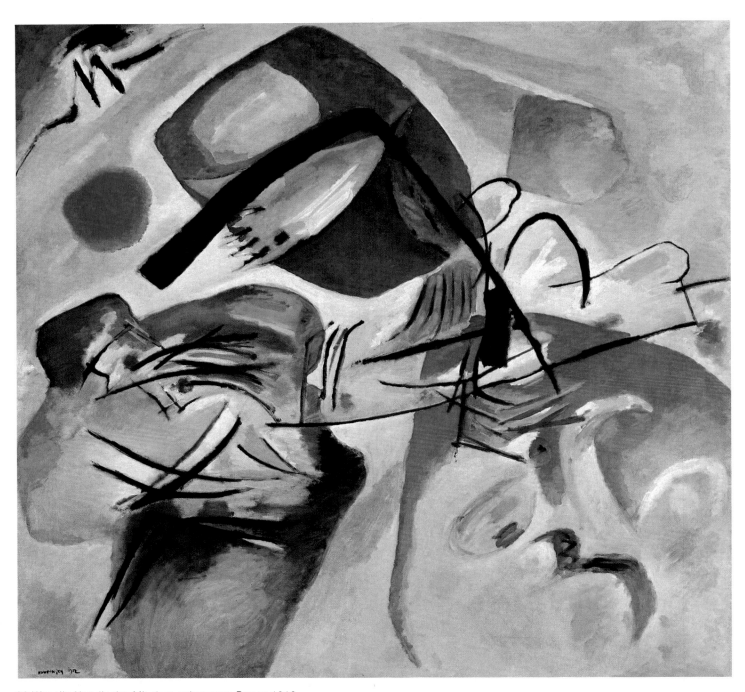

22 Wassily Kandinsky *Mit dem schwarzen Bogen* 1912

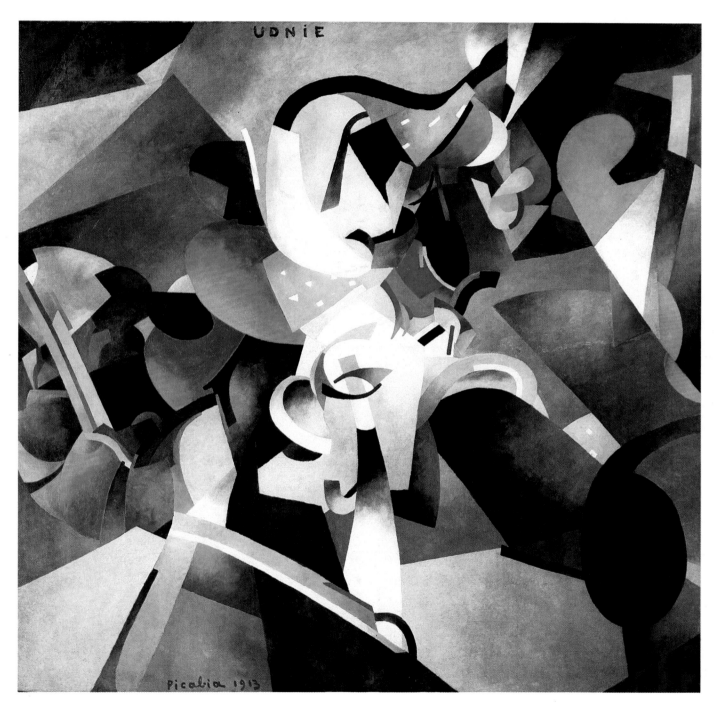

23 Francis Picabia *Udnie* 1913

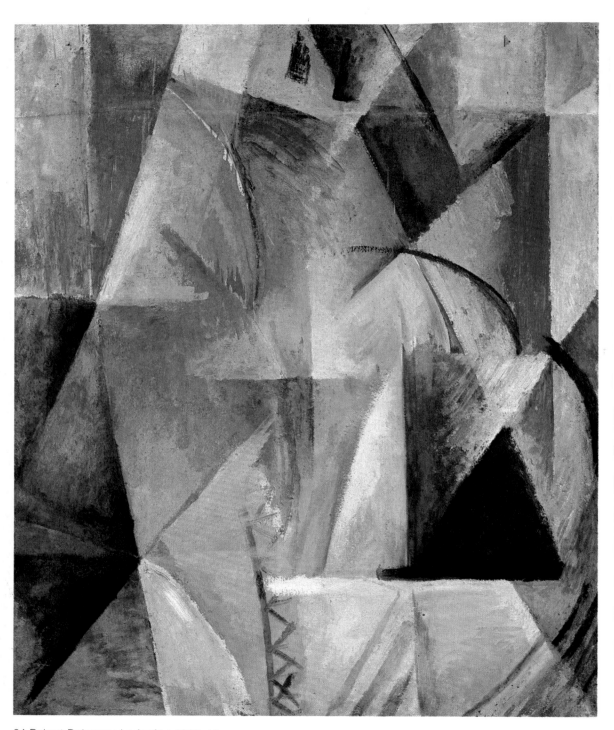

24 Robert Delaunay *La fenêtre* 1912–13

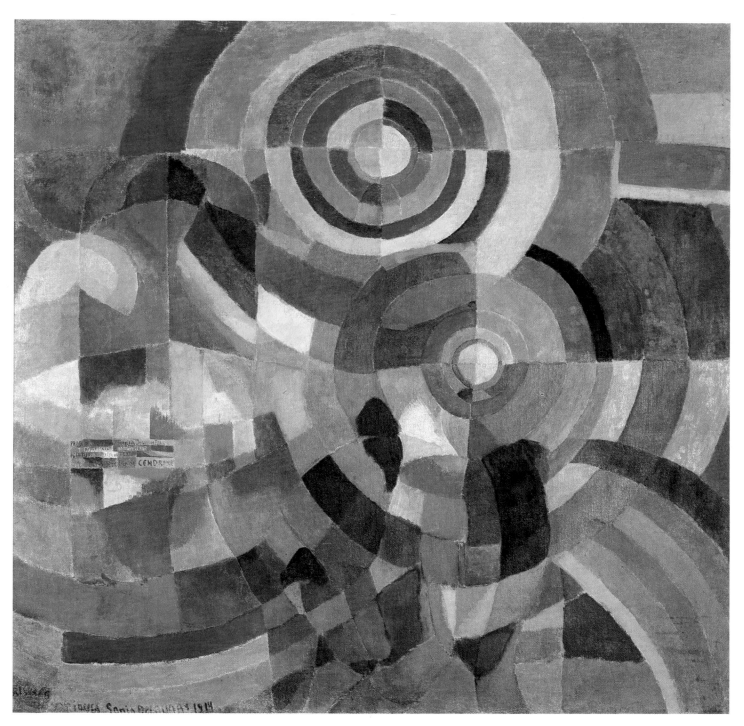

25 Sonia Delaunay *Prismes électriques* 1914

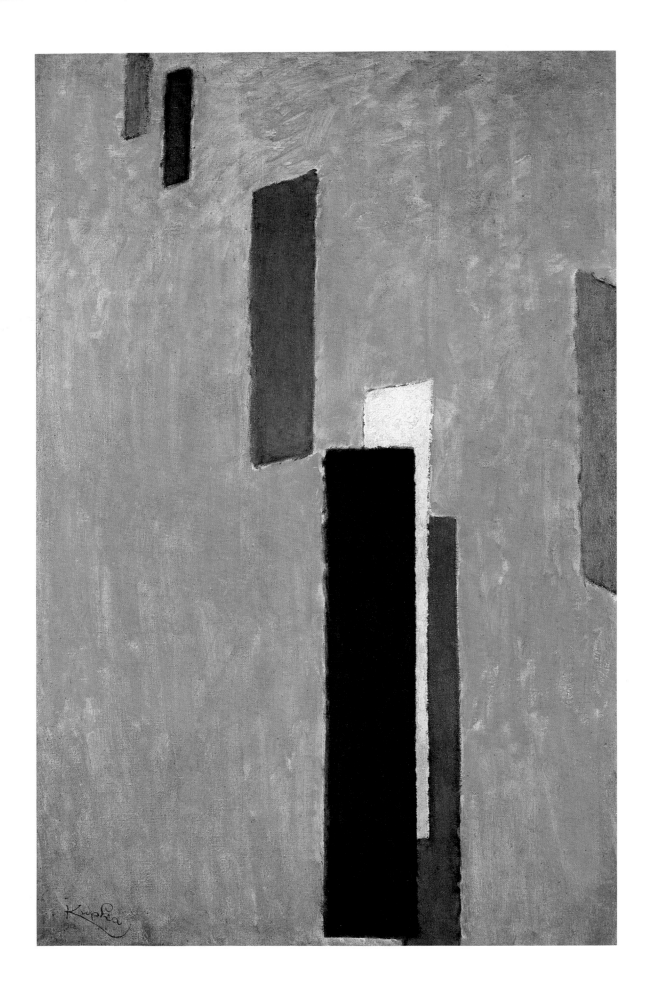

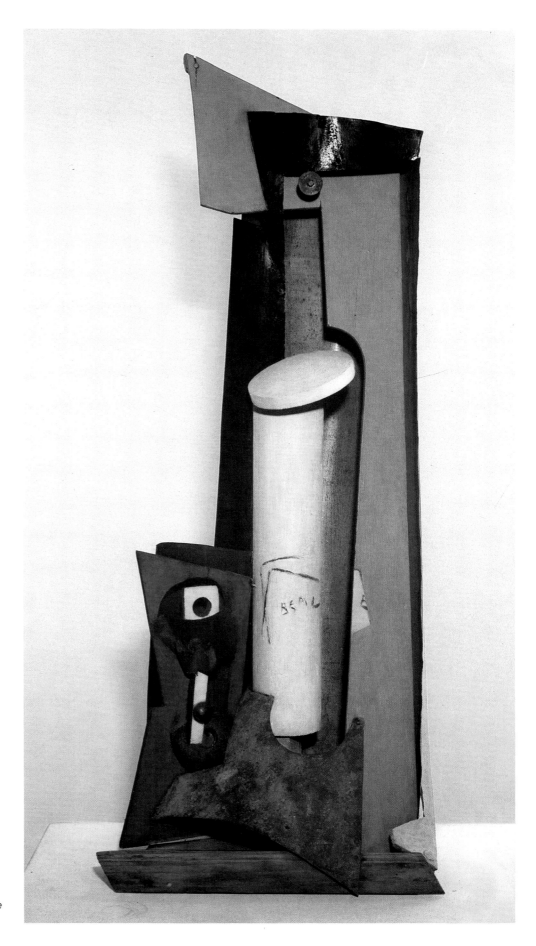

26 Frank Kupka *Plans verticaux – I*
1912–13

27 Henri Laurens *La bouteille de Beaune*
1916

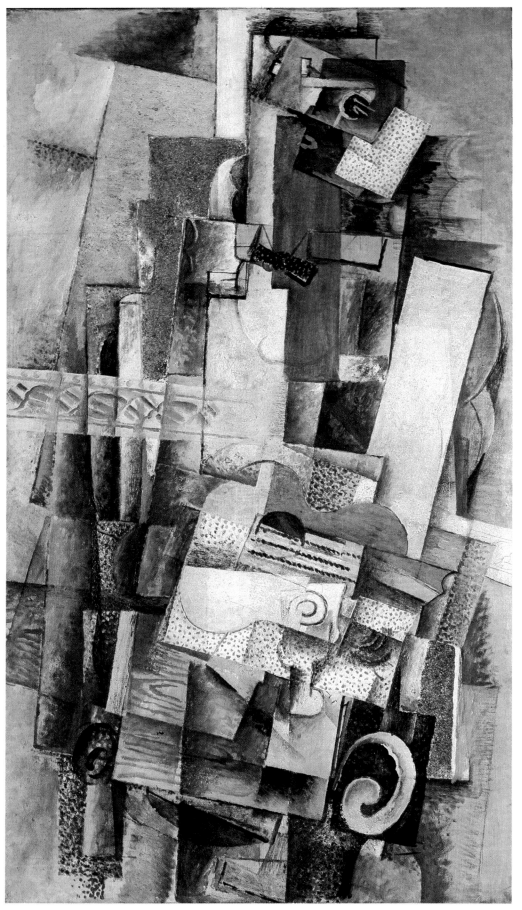

28 Georges Braque *L'homme à la guitare* 1914

29 Pablo Picasso *Portrait de jeune fille* 1914

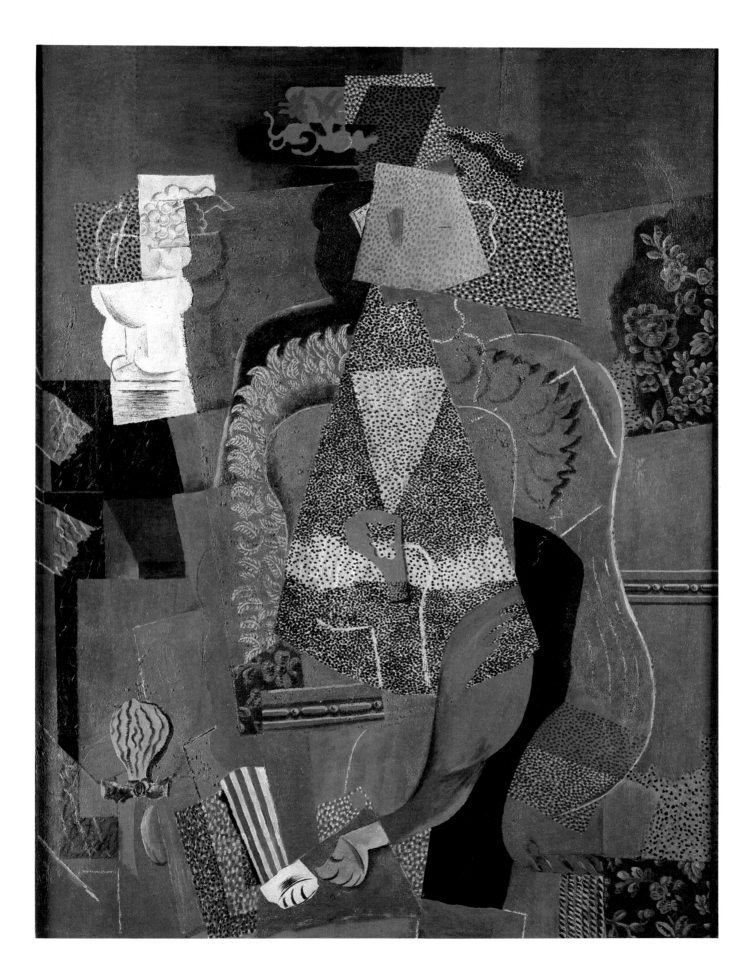

30 Alberto Magnelli *Ouvriers sur la charrette* 1914

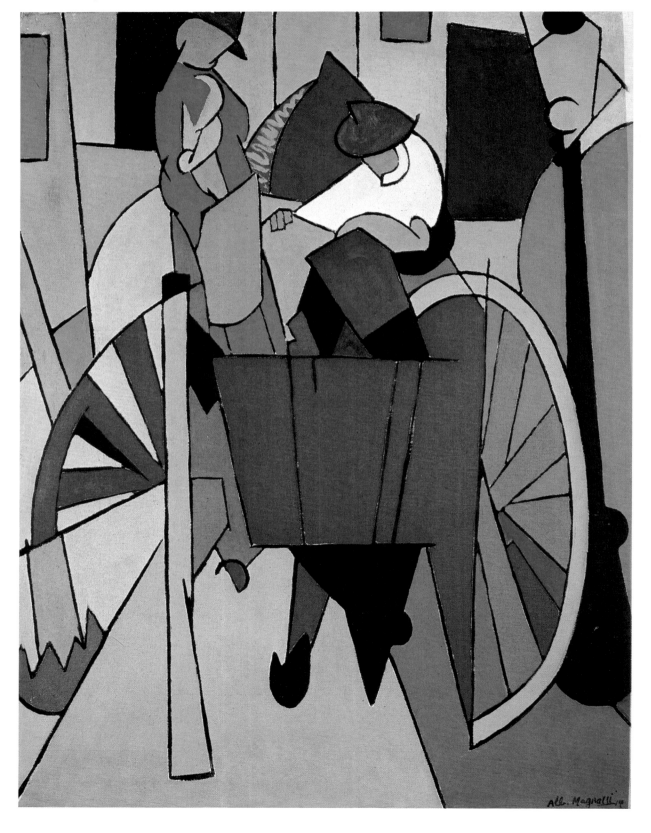

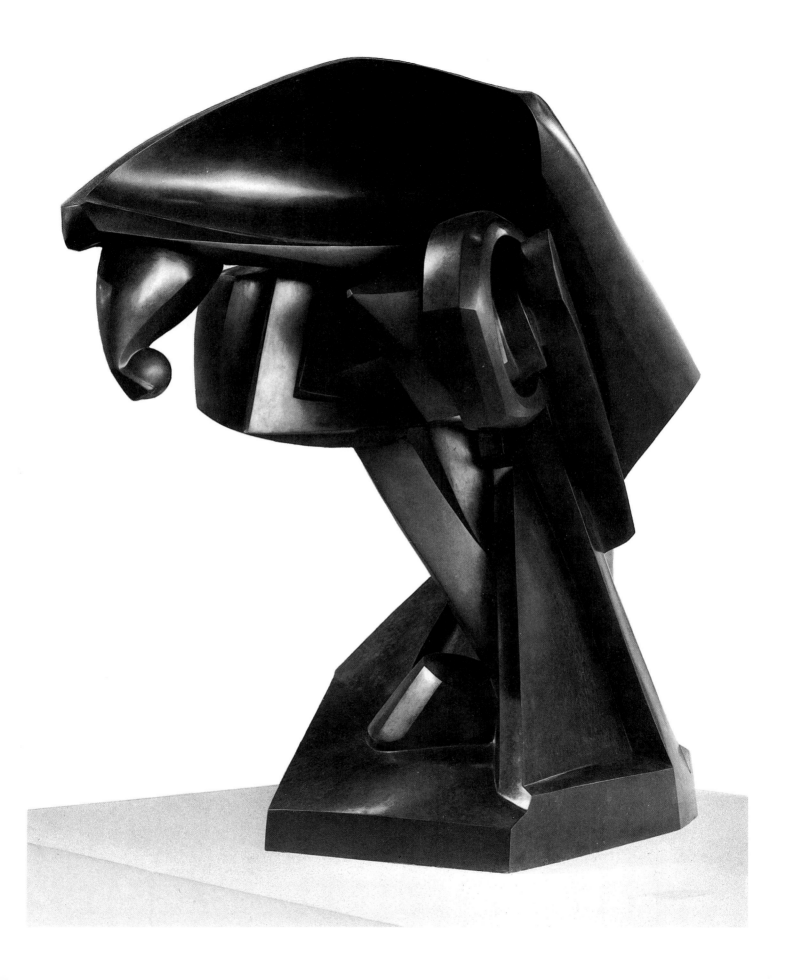

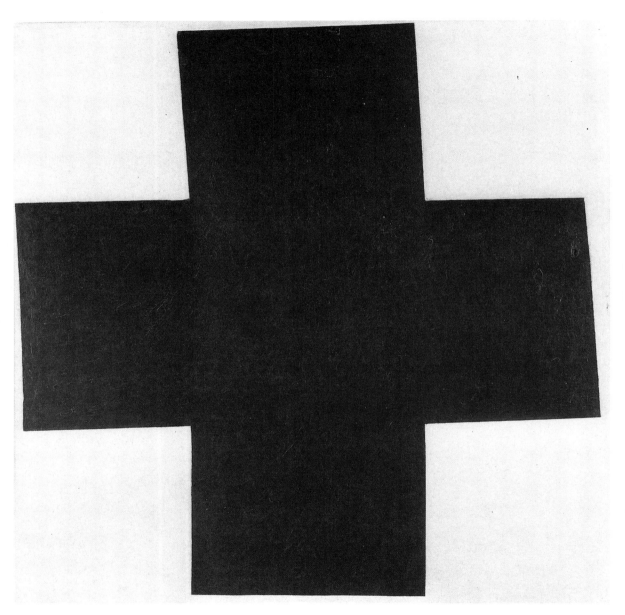

32 Kasimir Malevich *La croix noire* 1915

33 Henri Matisse *Le violoniste à la fenêtre* 1917—18

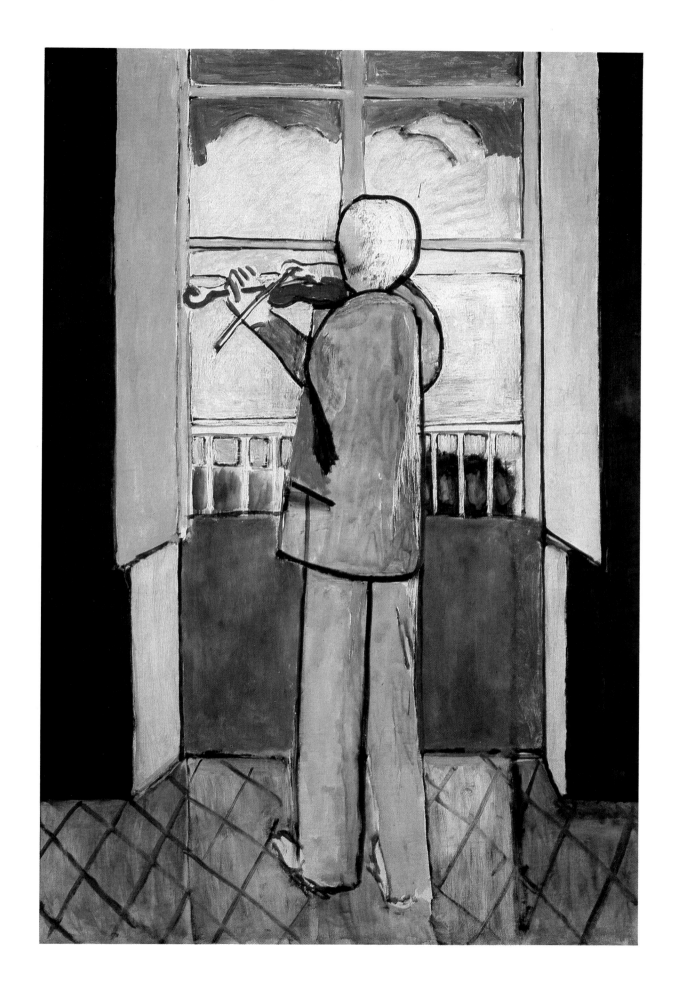

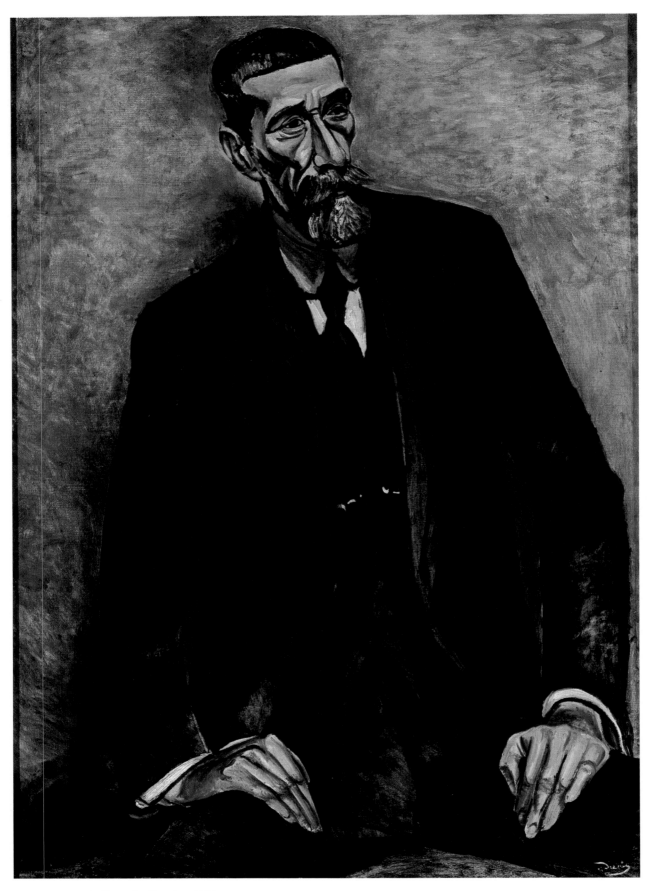

34 André Derain *Portrait d'Itturino* 1914

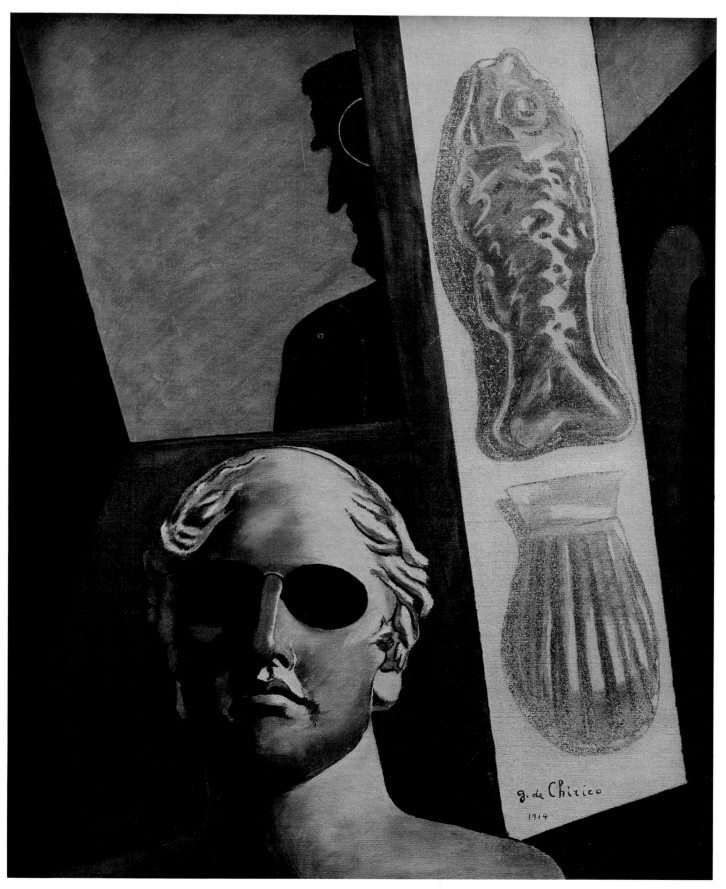

35 Giorgio de Chirico *Portrait prémonitoire de Guillaume Apollinaire* 1914

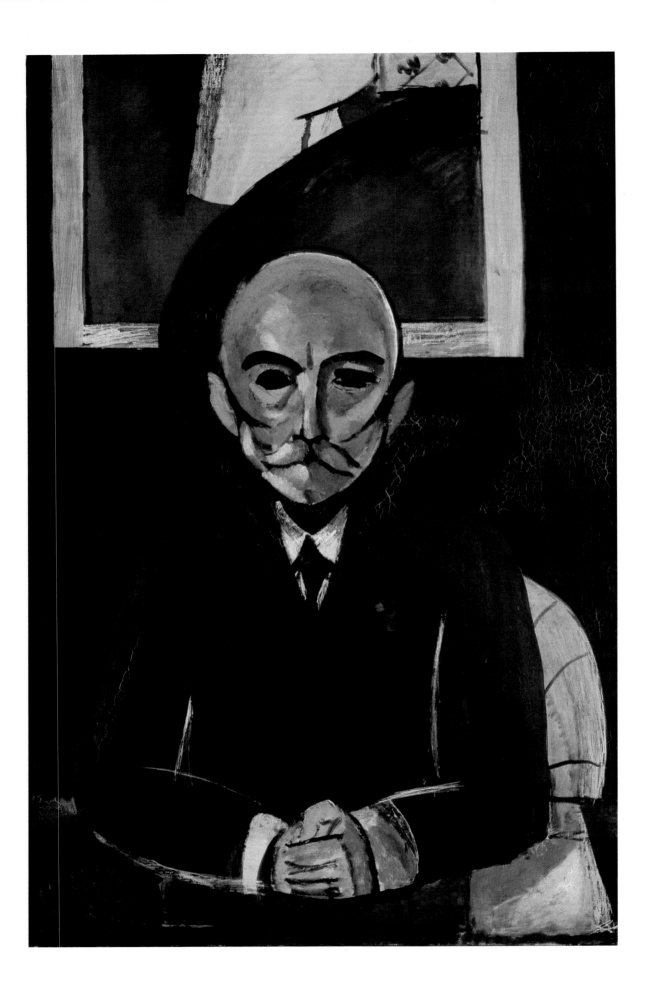

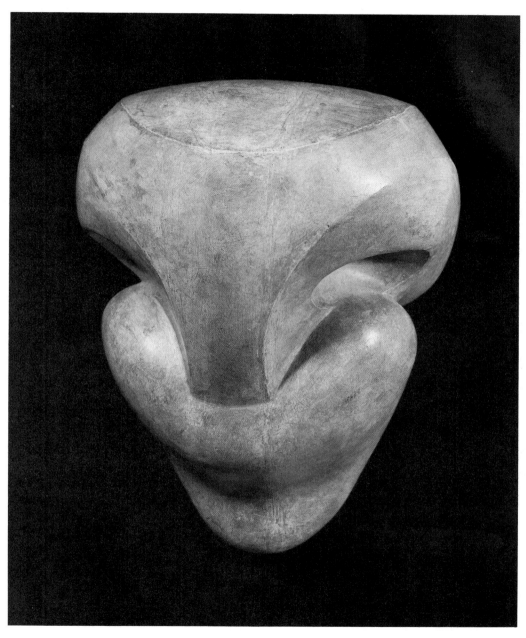

37 Raymond Duchamp-Villon *Portrait du Professeur Gosset* 1918

36 Henri Matisse *Portrait d'Auguste Pellerin* 1916

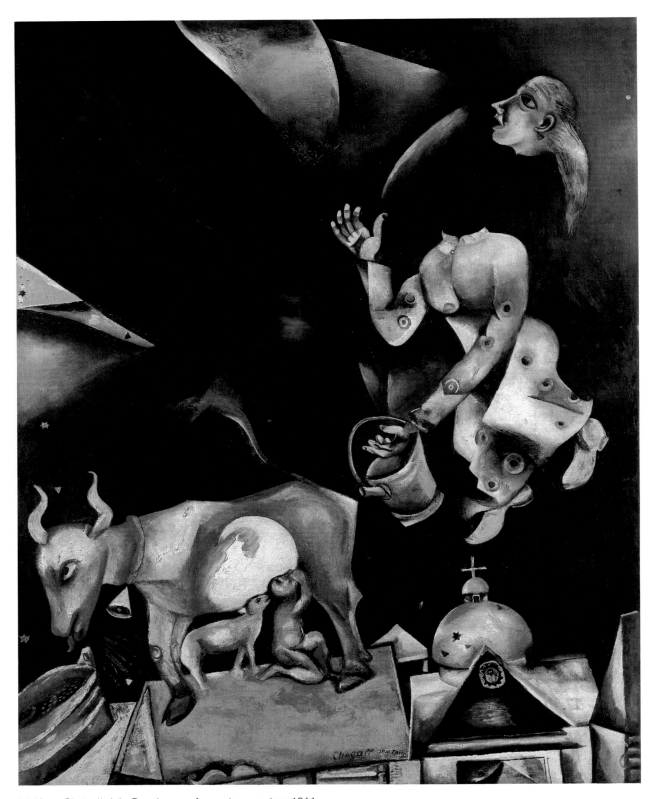

38 Marc Chagall *A la Russie, aux ânes et aux autres* 1911

39 Marc Chagall *Double portrait au verre de vin* 1917

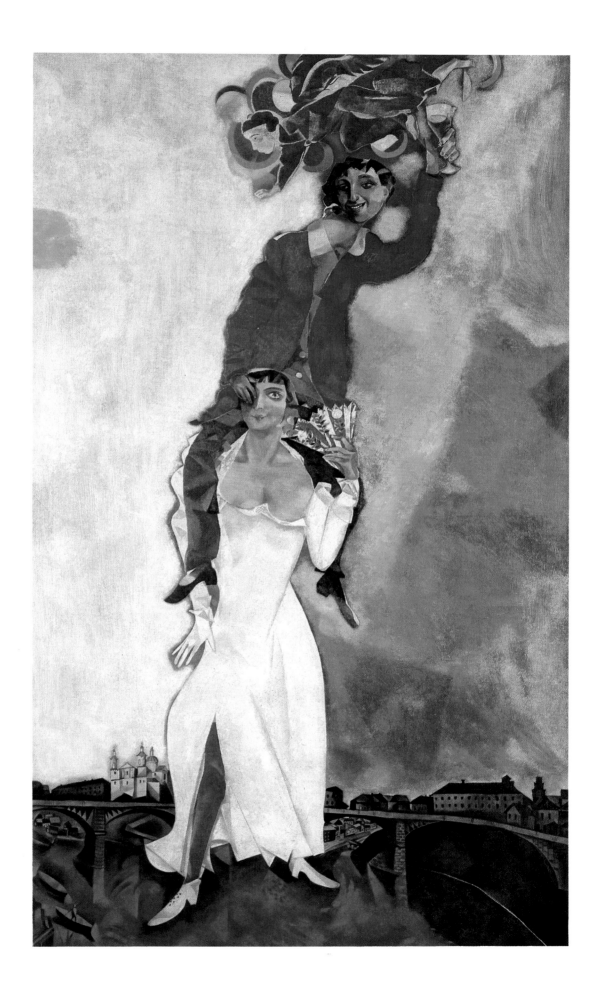

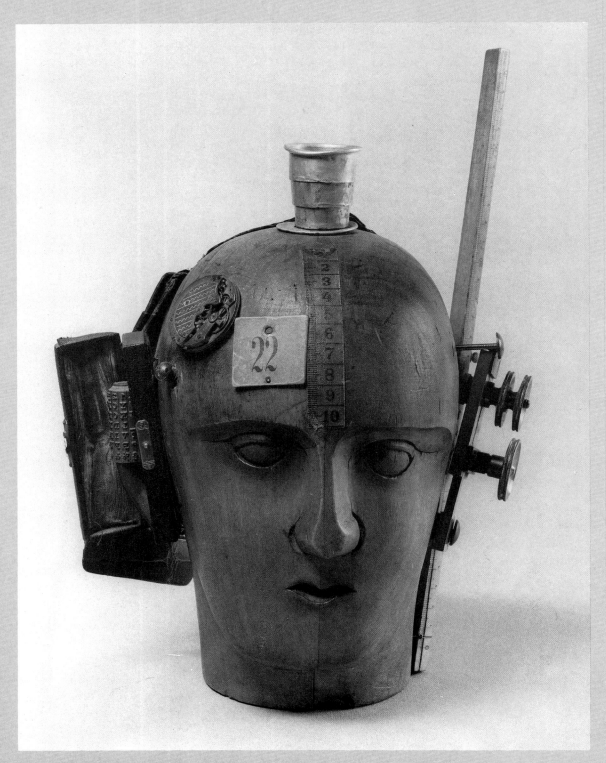

40 Raoul Hausmann *L'esprit de notre temps. Tête mécanique* 1919

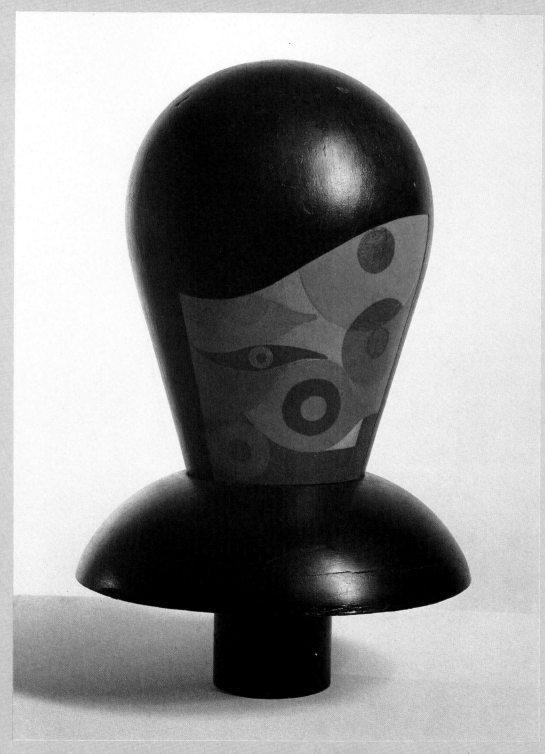

41 Sophie Taeuber-Arp *Geschnitzter Kopf (Porträt von Jean Arp)* 1918–19

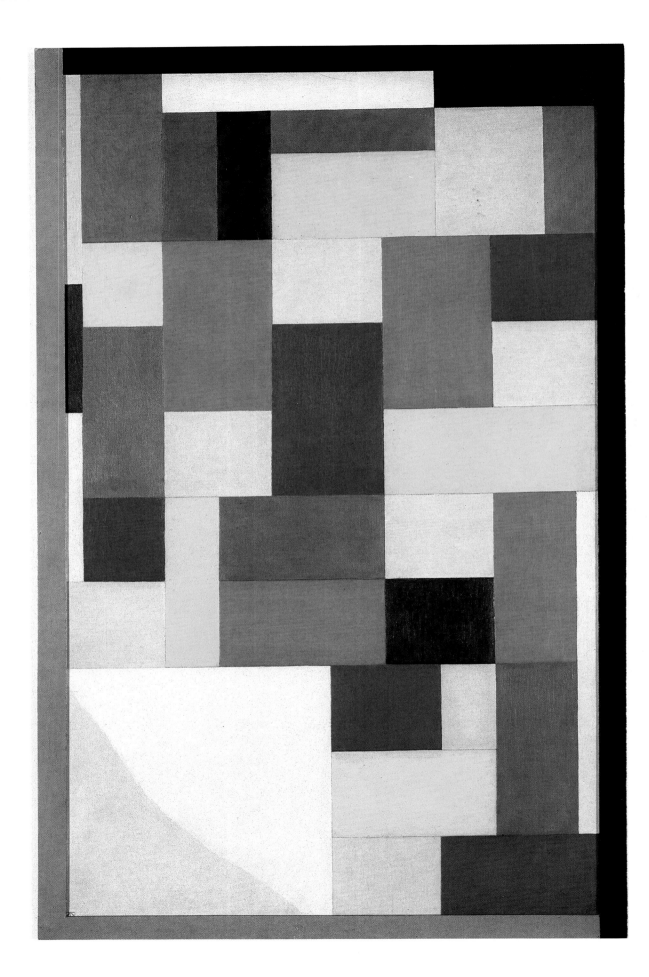

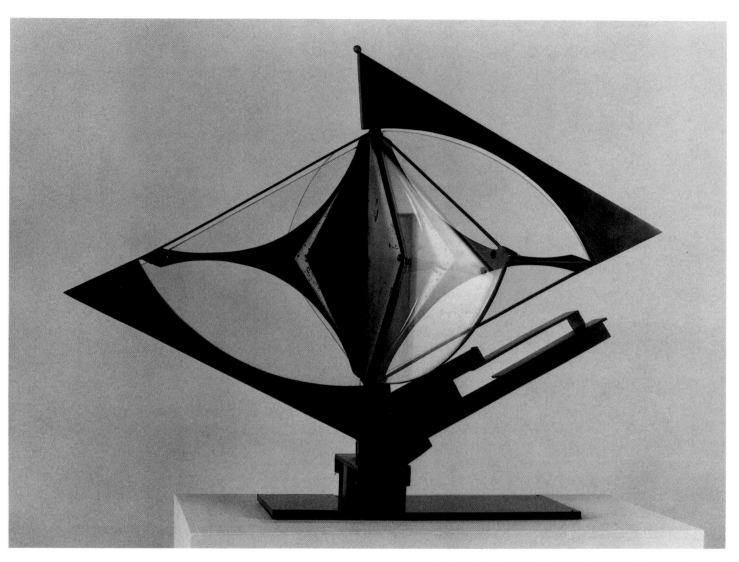

43 Antoine Pevsner *Construction dans l'espace* 1923–25

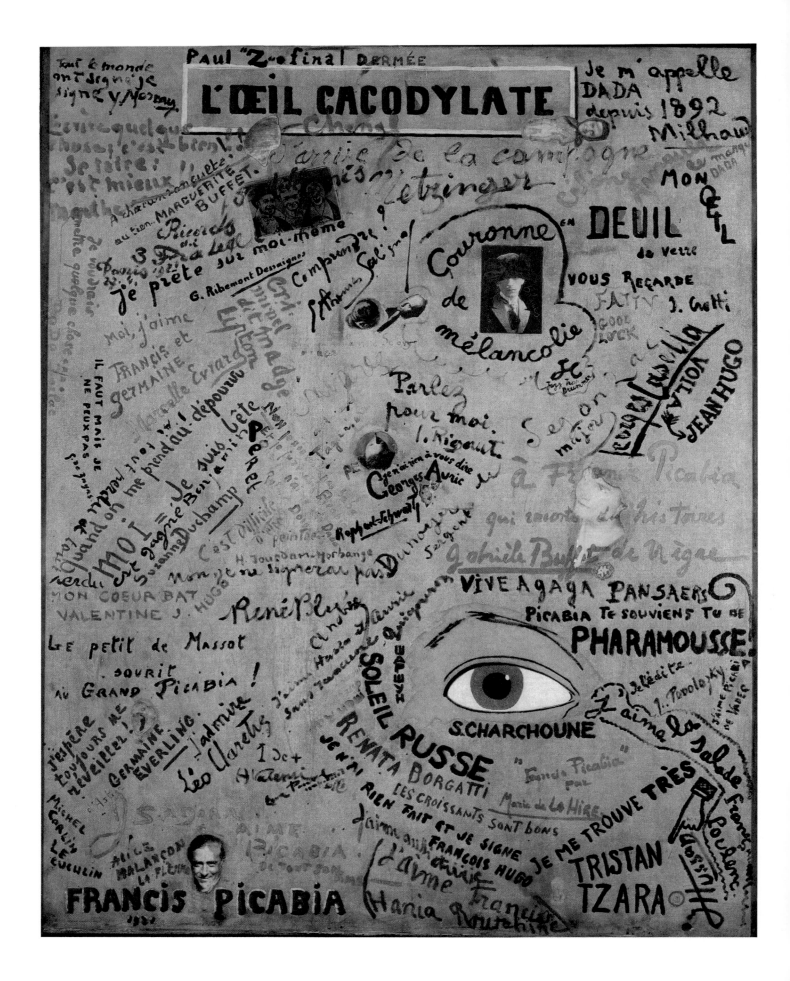

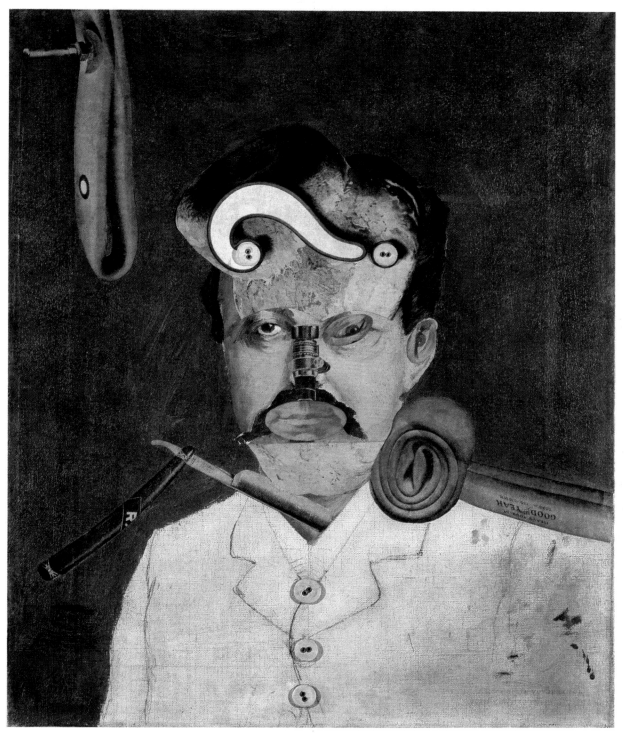

45 George Grosz *Remember uncle August, the unhappy inventor* 1919

44 Francis Picabia *L'oeil cacodylate* 1921

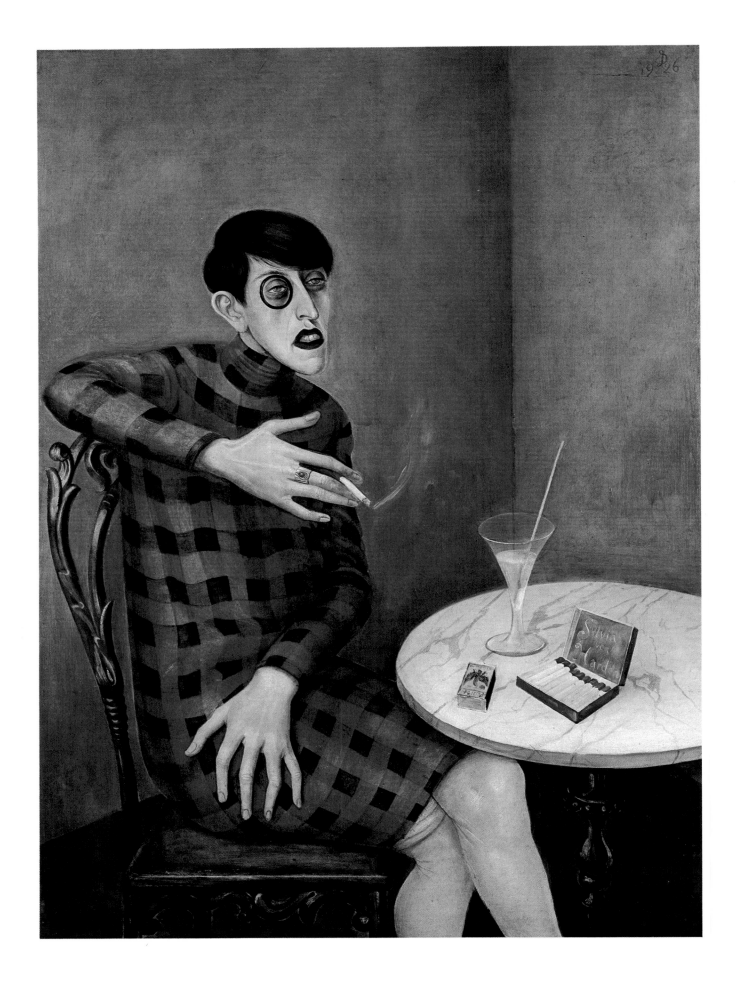

46 Otto Dix *Die Journalistin Sylvia von Harden* 1926

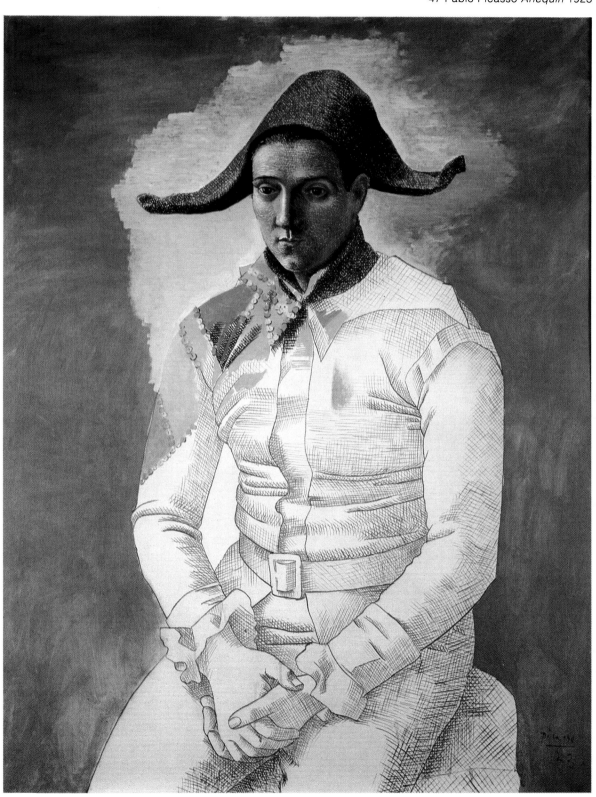

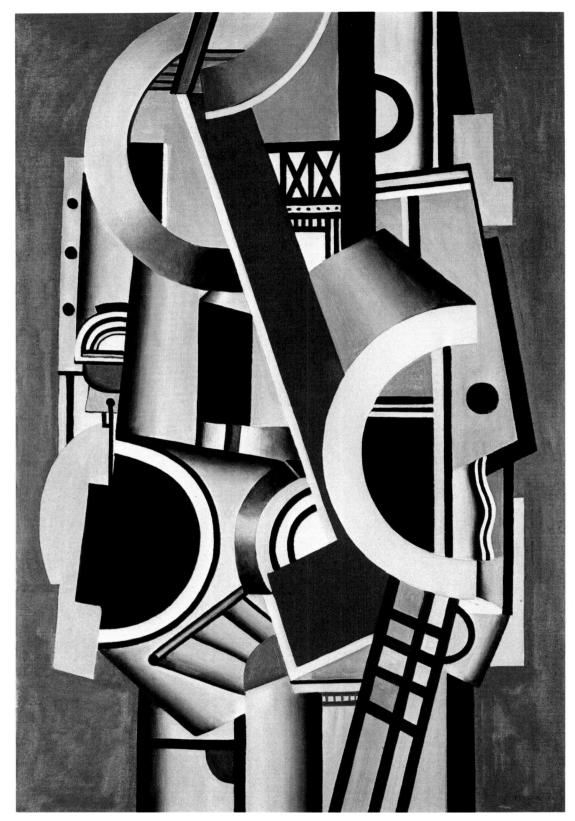

48 Fernand Léger *Elément mécanique* 1924

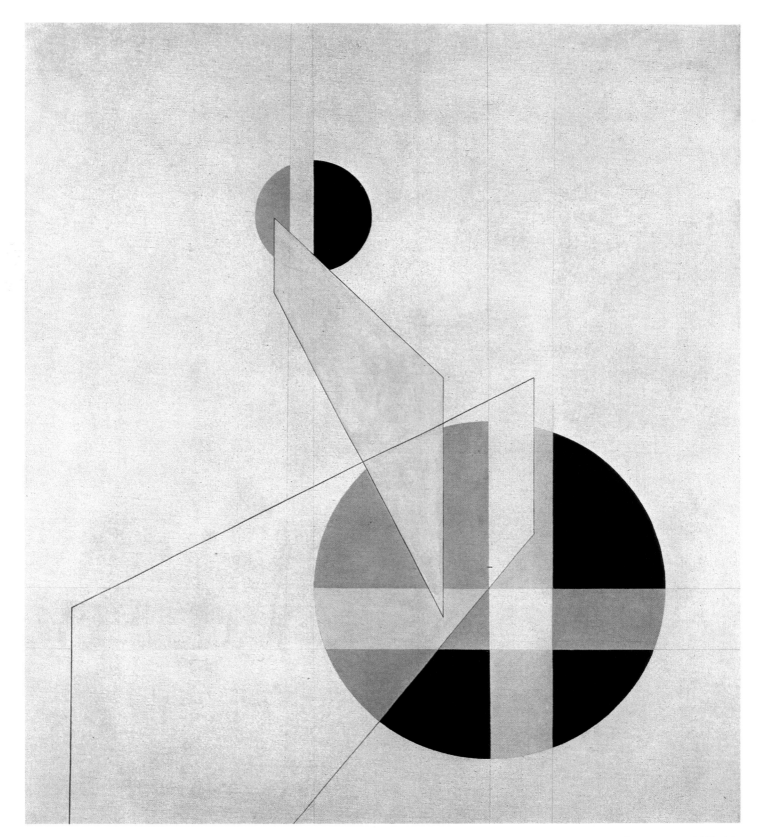

49 László Moholy-Nagy *Composition A XX* 1924

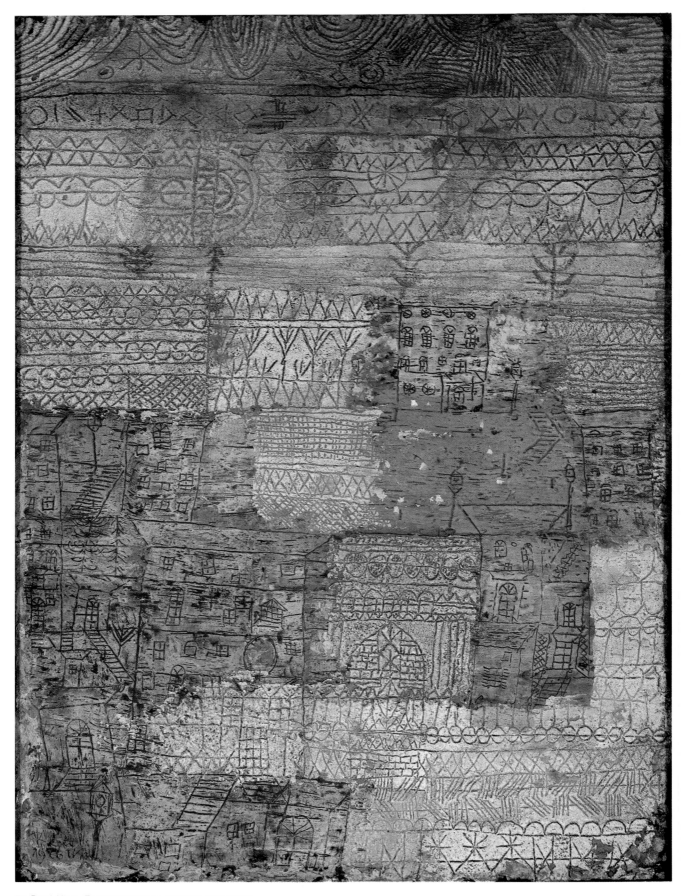

50 Paul Klee *Florentinisches Villenviertel* 1926

51 Wassily Kandinsky *Akzent in rosa* 1926

52 Pablo Picasso *Nature morte à la tête antique* 1925

53 Fernand Léger *La lecture* 1924

54 Jacques Lipchitz *Figure* 1926–30

55 Alexander Calder *Josephine Baker* 1926

56 Jules Pascin *Portrait de Flechtheim en toréador* 1927

57 Chaim Soutine *Le groom c.* 1928

58 Joan Miró *La sieste* 1925

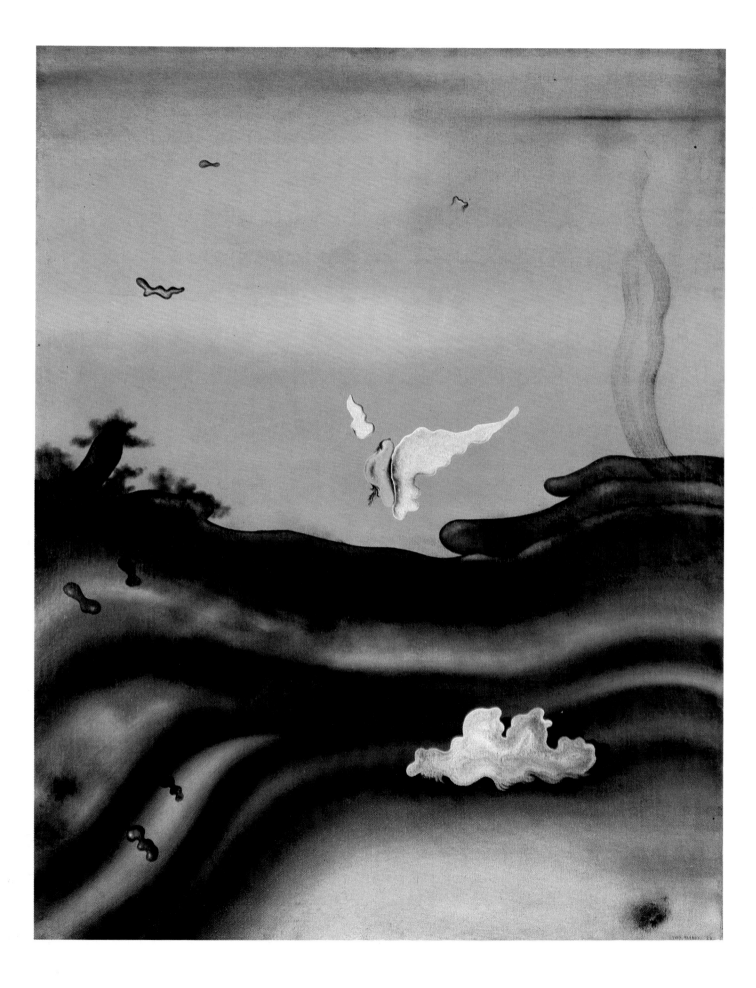

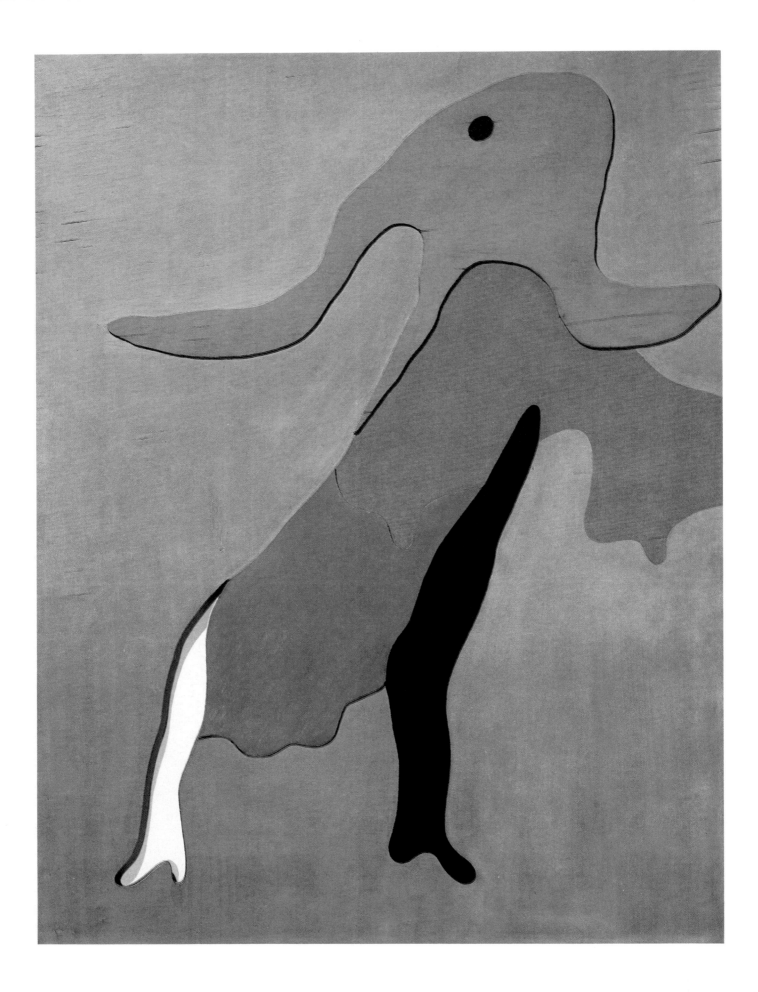

60 Jean (Hans) Arp *Danseuse* 1925

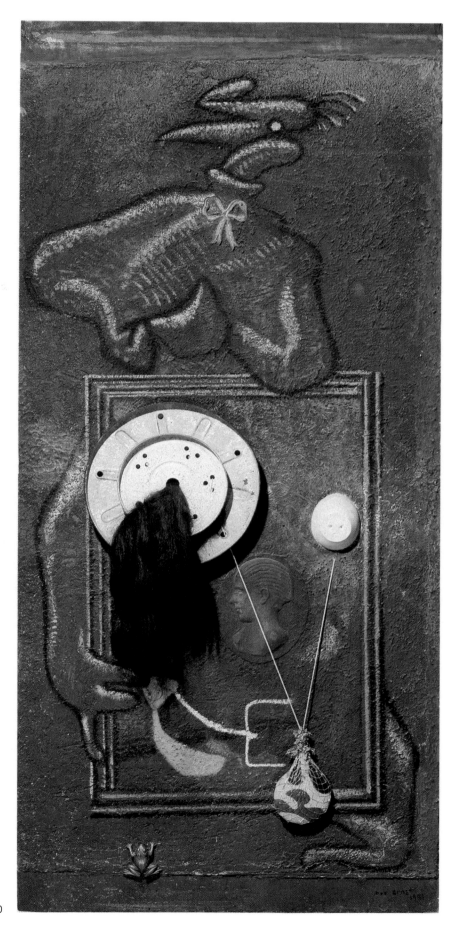

61 Max Ernst *Loplop présente une jeune fille* 1930

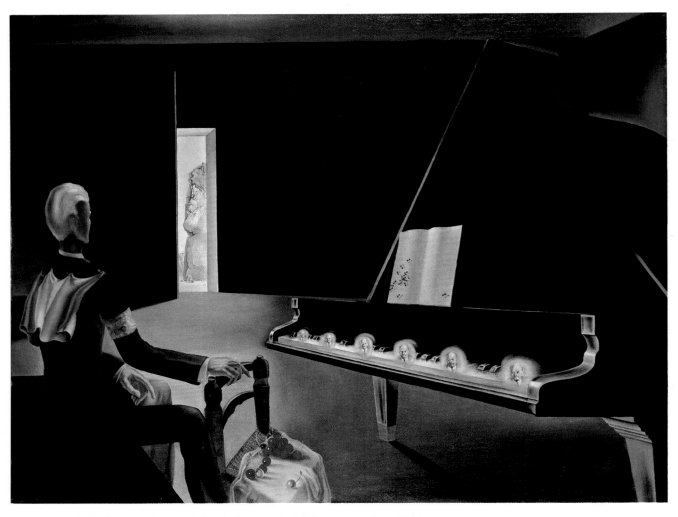

62 Salvador Dali *Hallucination partielle, six images de Lénine sur un piano* 1931

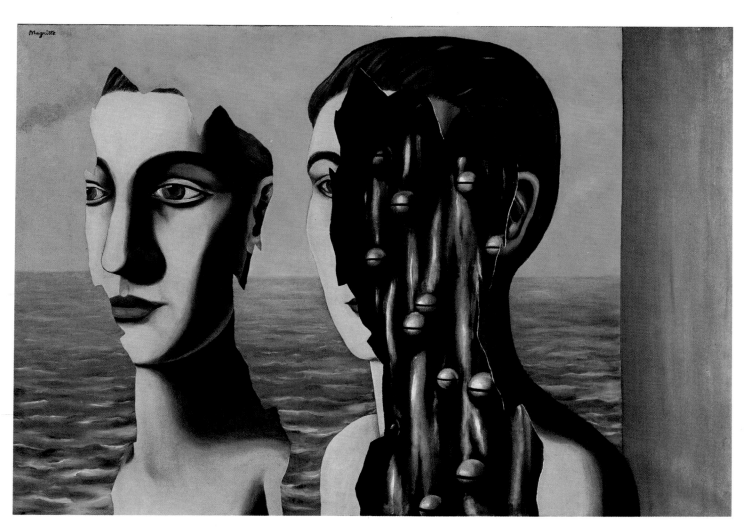

63 René Magritte *Le double secret* 1927

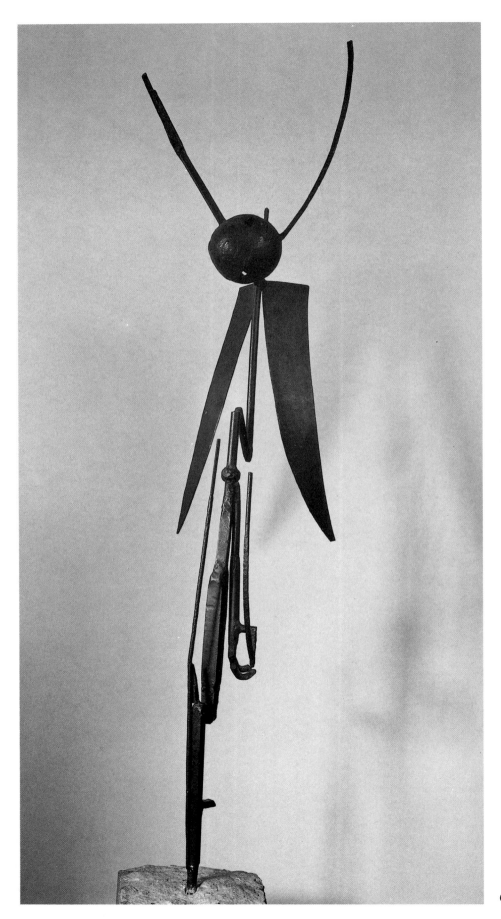

64 Julio Gonzalez *L'ange* 1933

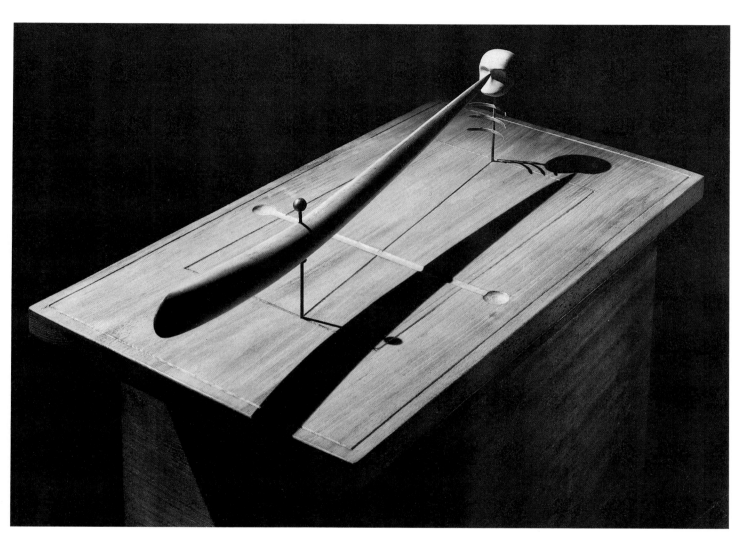

65 Alberto Giacometti *La pointe à l'oeil* 1931

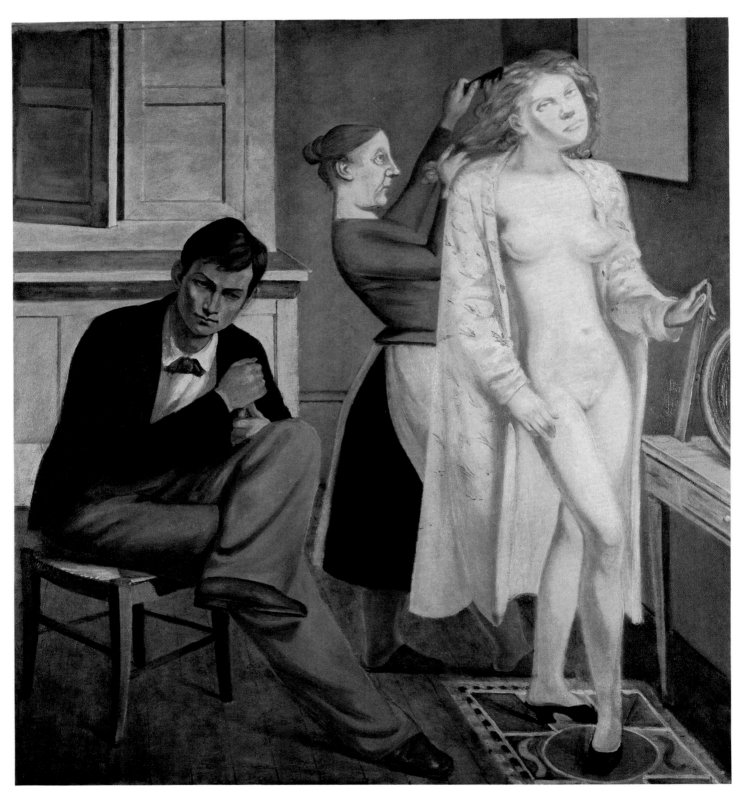

66 Balthus (Balthazar Klossowski de Rola) *La toilette de Cathy* 1933

67 Hans Bellmer *La poupée* 1934—37

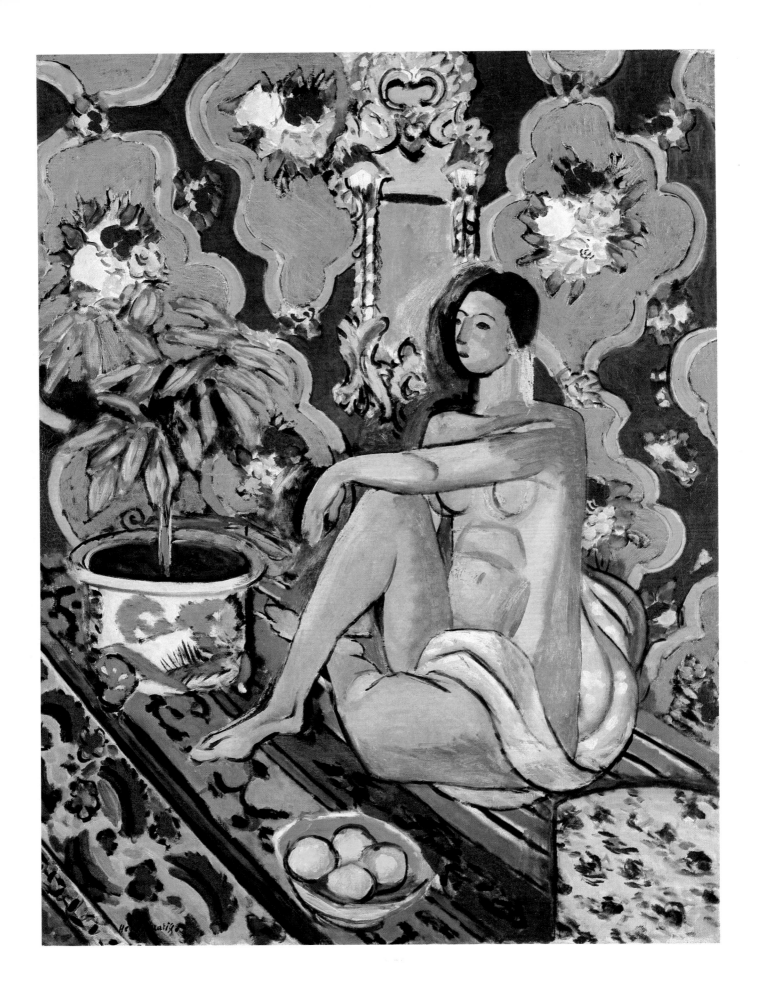

68 Henri Matisse *Figure décorative sur fond ornamental* 1925–26

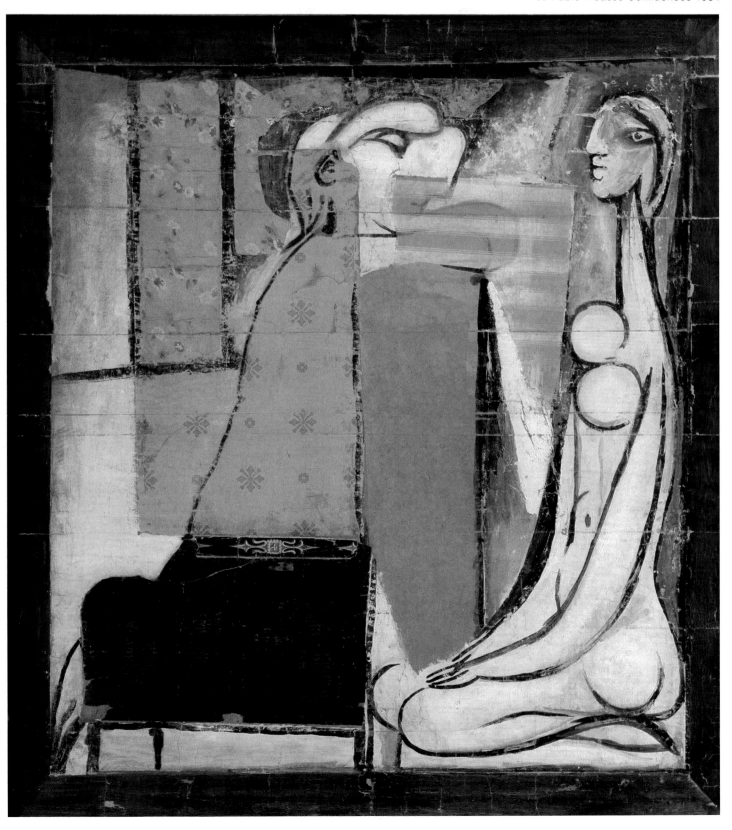

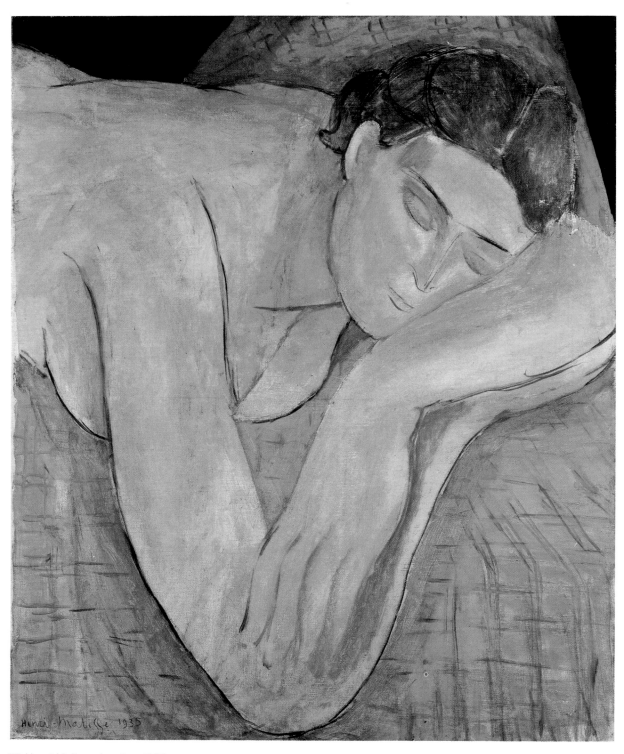

70 Henri Matisse *Le rêve* 1935

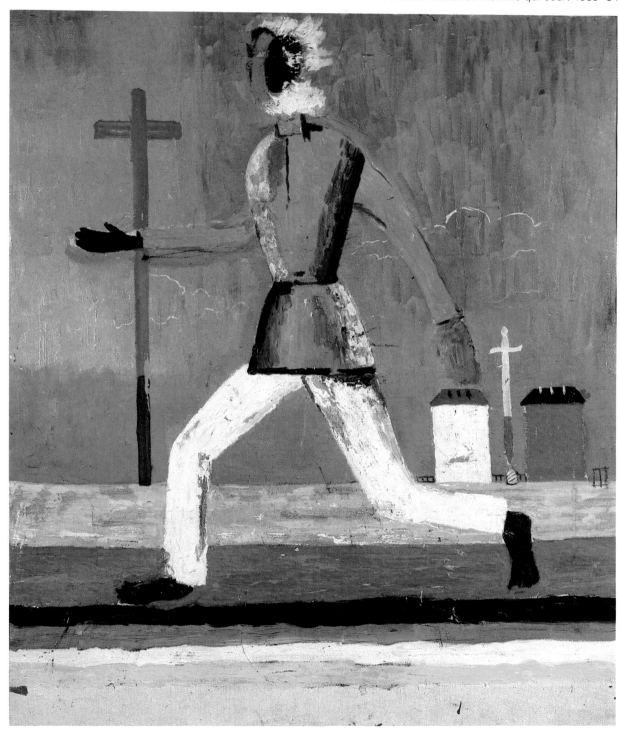

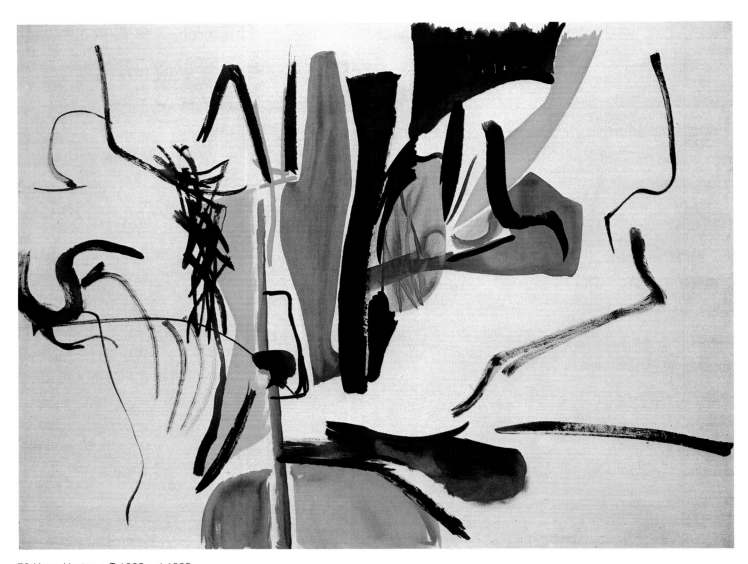

72 Hans Hartung *T 1935 – 1* 1935

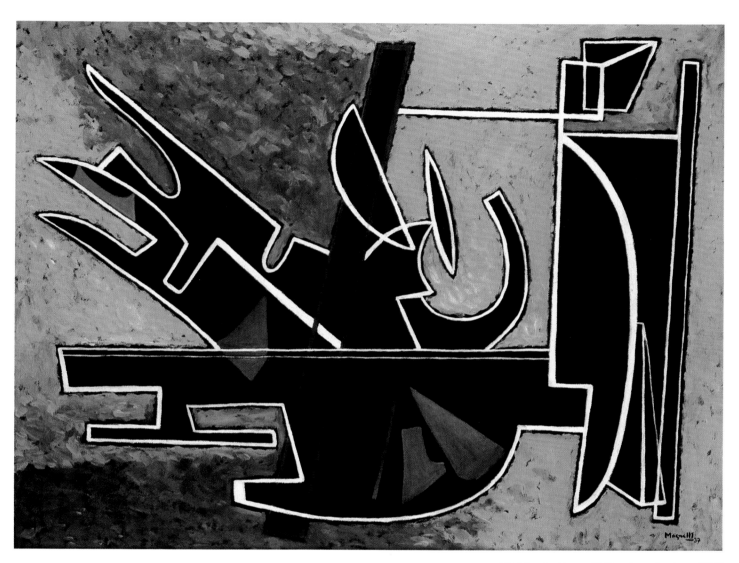

73 Alberto Magnelli *Ronde océanique* 1937

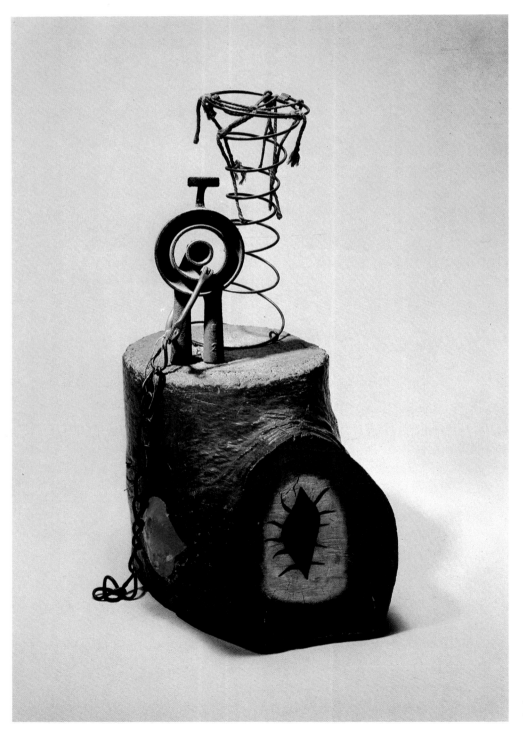

74 Joan Miró *L'objet du couchant*
1937

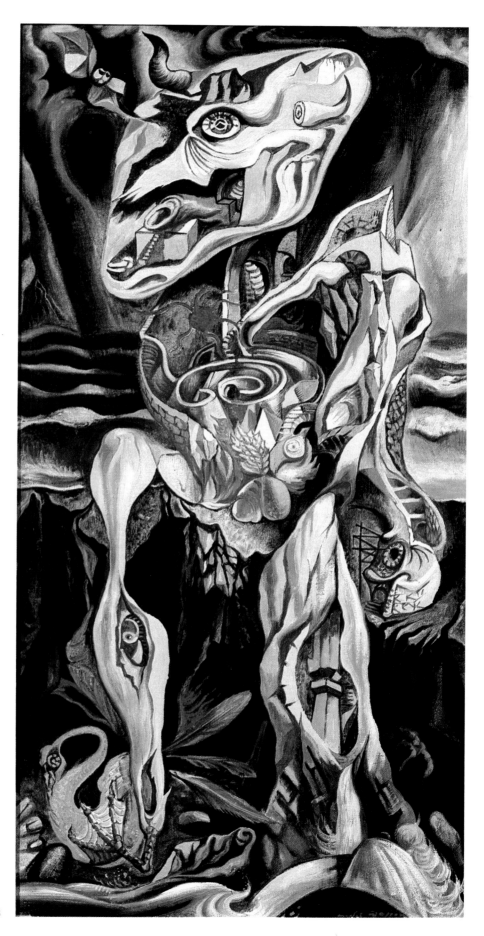

75 André Masson *Le labyrinthe* 1938

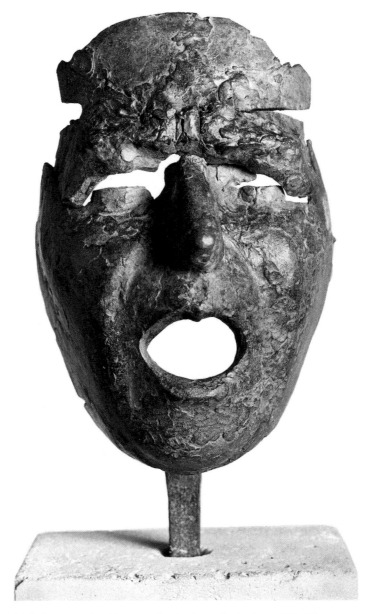

76 Julio Gonzalez *Masque de Montserrat criant c.* 1935–36

77 Henri Laurens *La grande musicienne* 1938

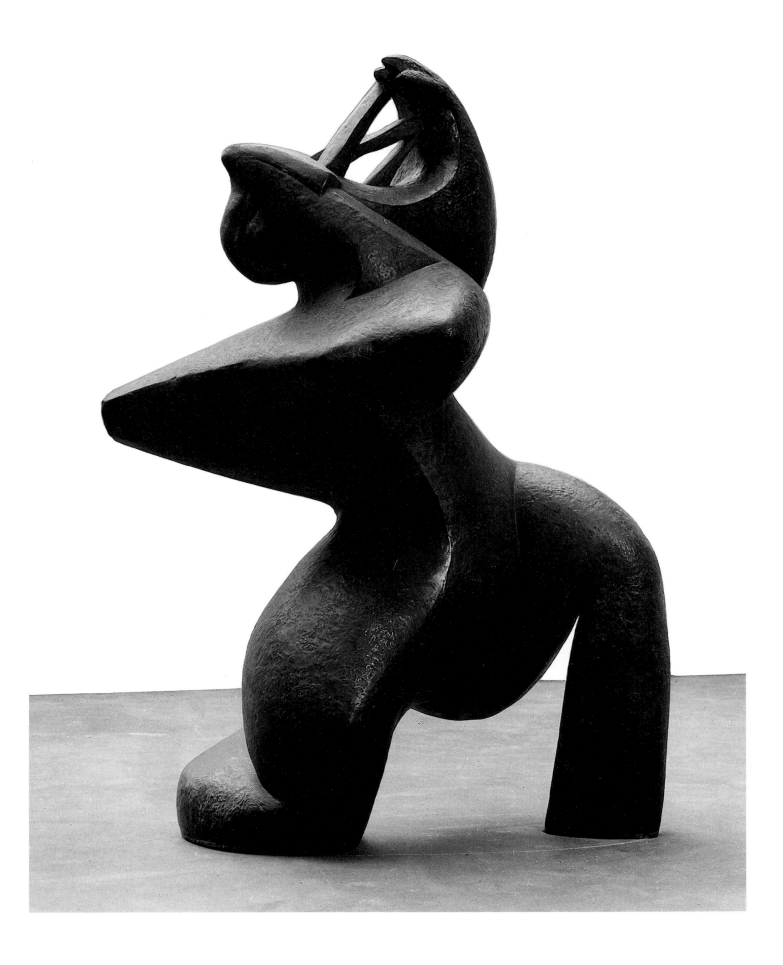

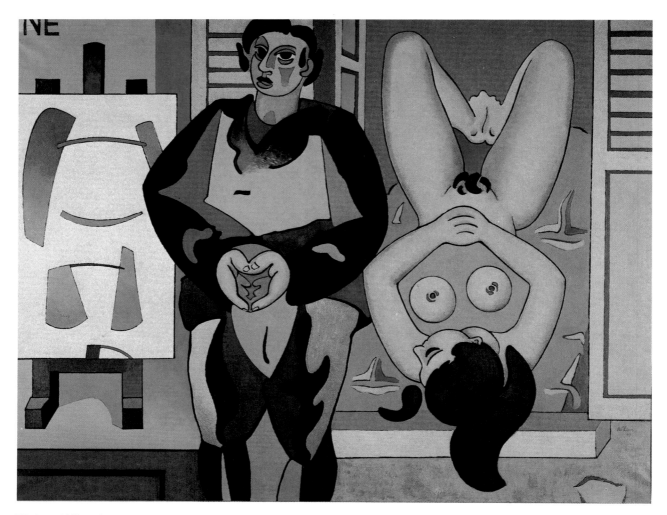

78 Jean Hélion *A rebours* 1947

79 Fernand Léger *Les acrobates en gris* 1942–44

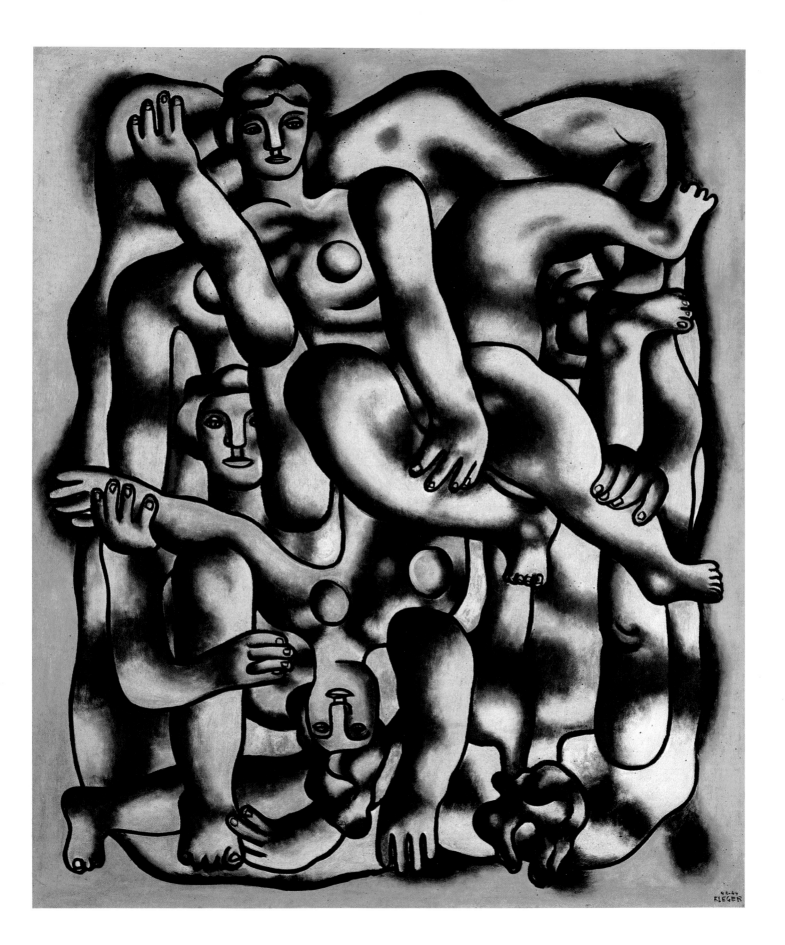

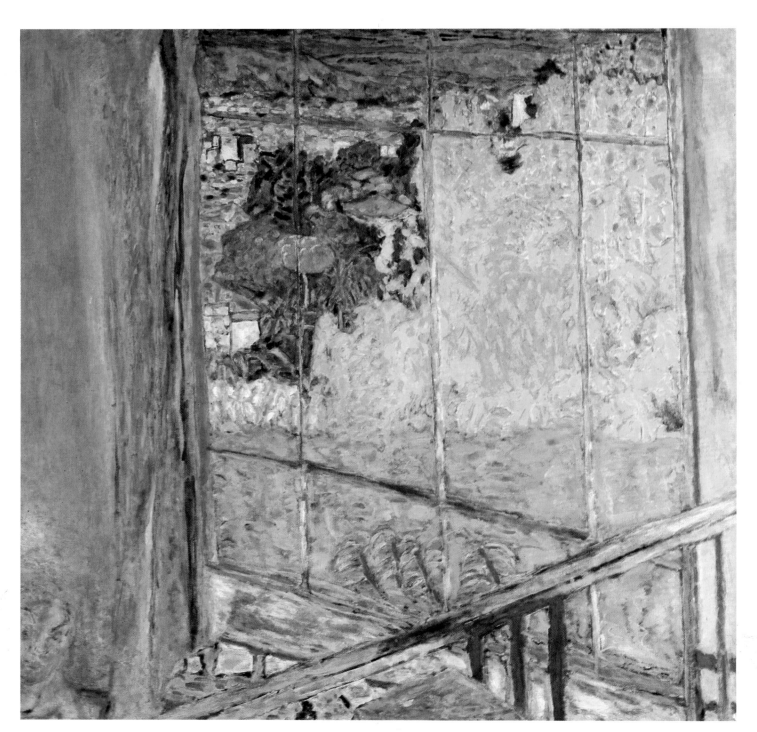

80 Pierre Bonnard *L'atelier au mimosa* 1939–45

81 Constantin Brancusi *L'atelier*

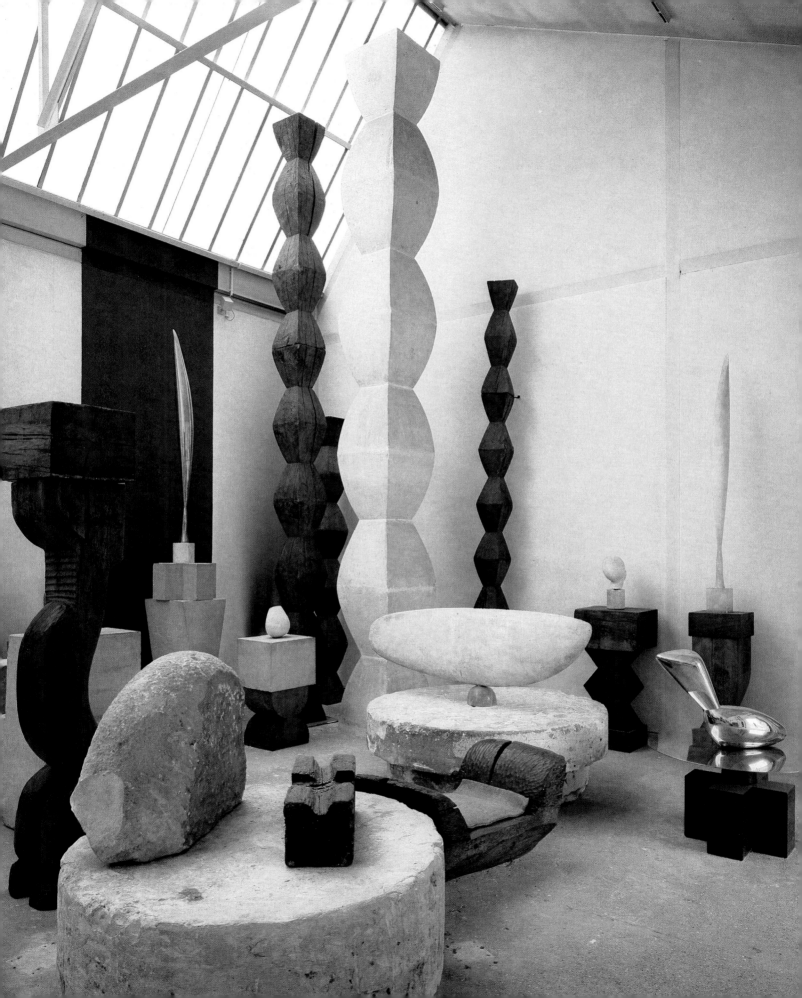

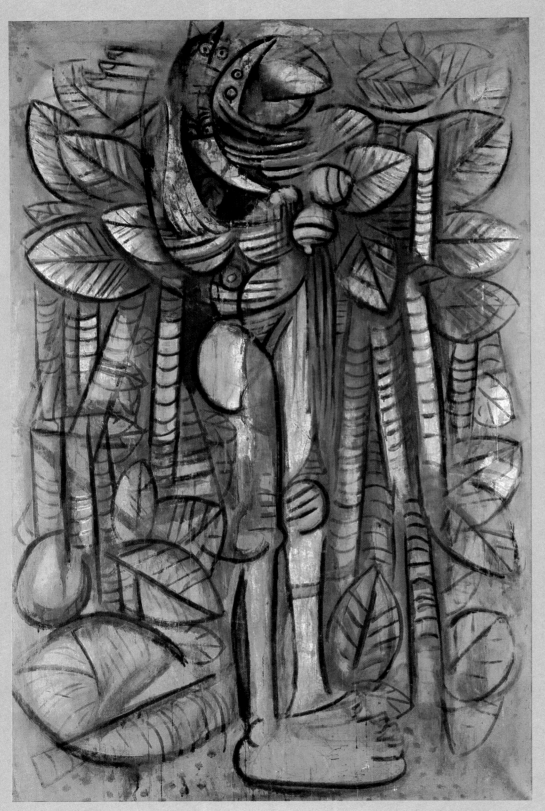

82 Wifredo Lam *Lumière dans la forêt (ou La grande jungle)* 1942

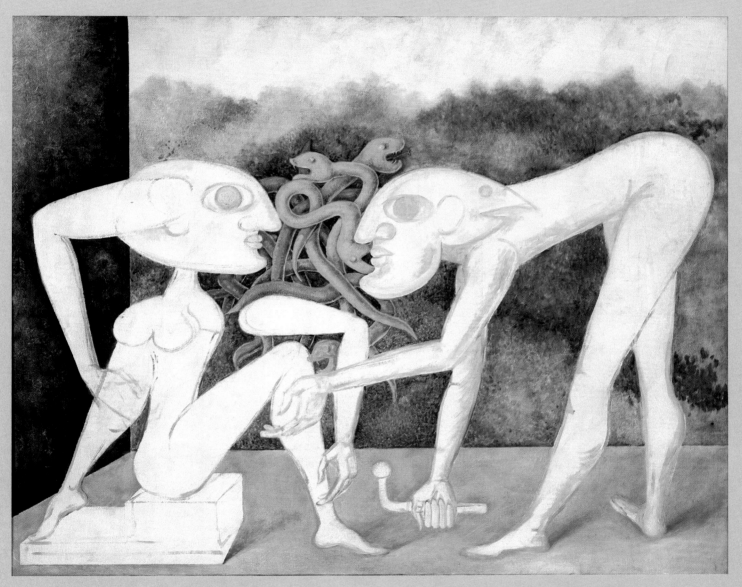

83 Victor Brauner *Composition sur le le thème de 'La Palladiste'* 1943

85 Nicolas de Staël *La vie dure* 1946

84 Jean Dubuffet *Campagne heureuse* 1944

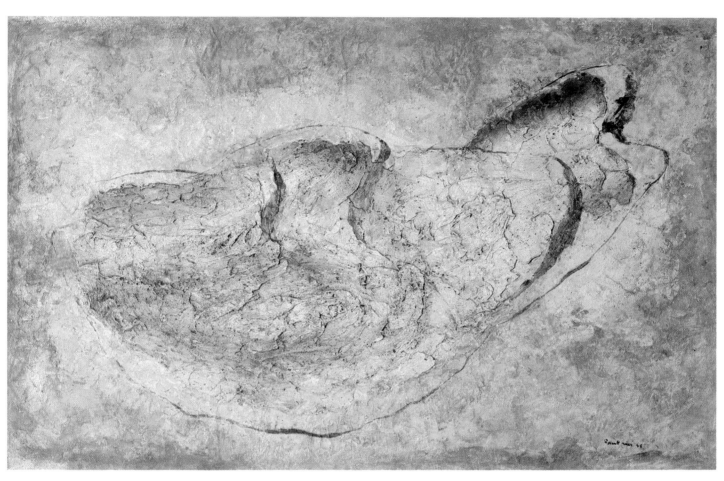

87 Jean Fautrier *La femme douce* 1946

86 Jean Dubuffet *Le Métafisyx* 1950

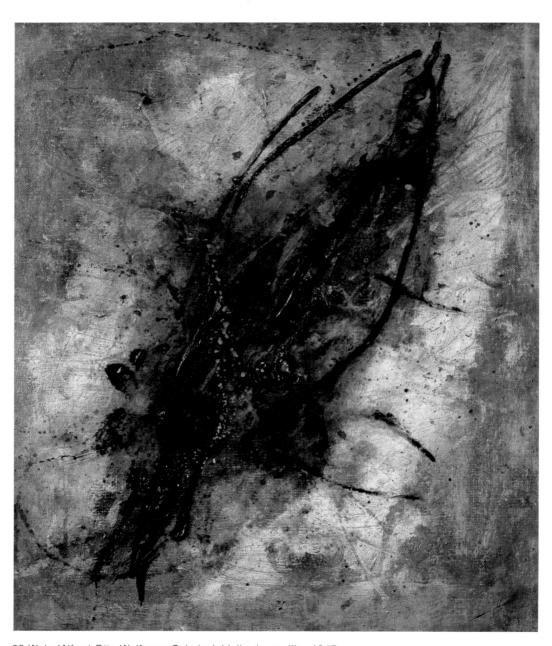

88 Wols (Alfred Otto Wolfgang Schulze) *L'aile de papillon* 1947

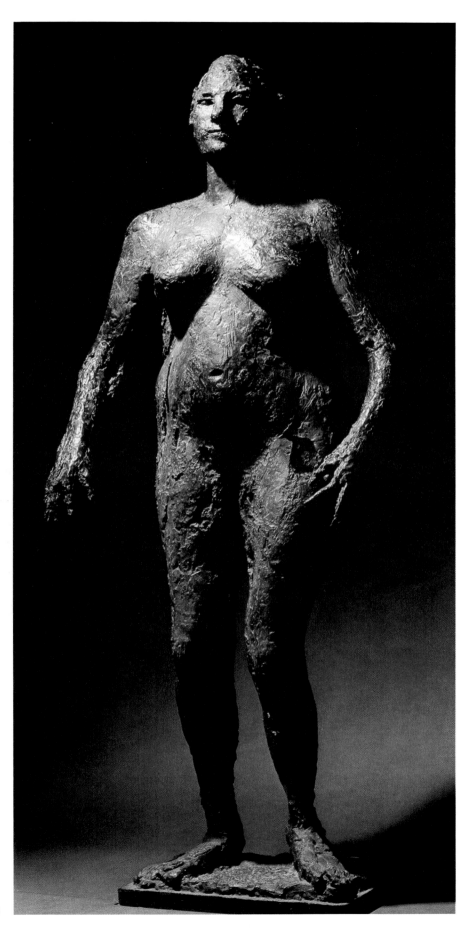

89 Germaine Richier *L'ouragane* 1948–49

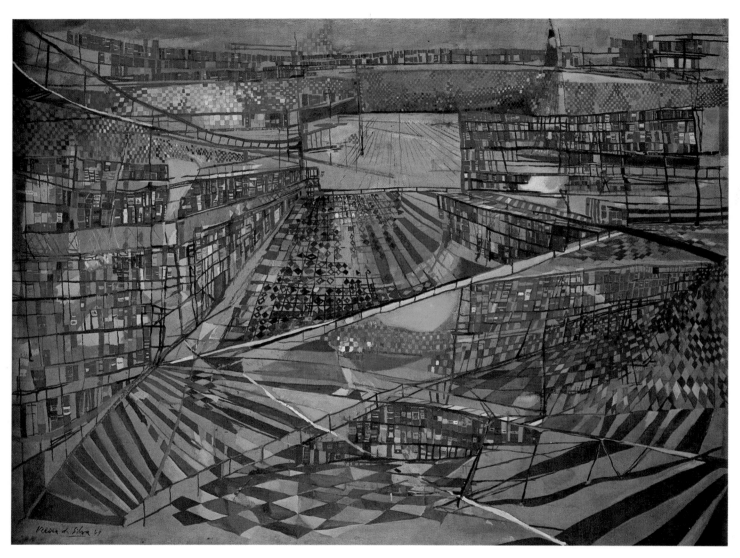

90 Maria Elena Vieira da Silva *La bibliothèque* 1949

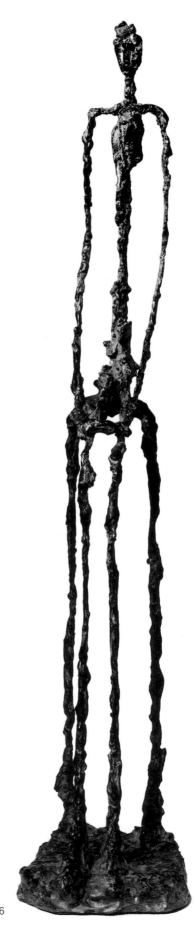

91 Alberto Giacometti *Femme assise* 1956

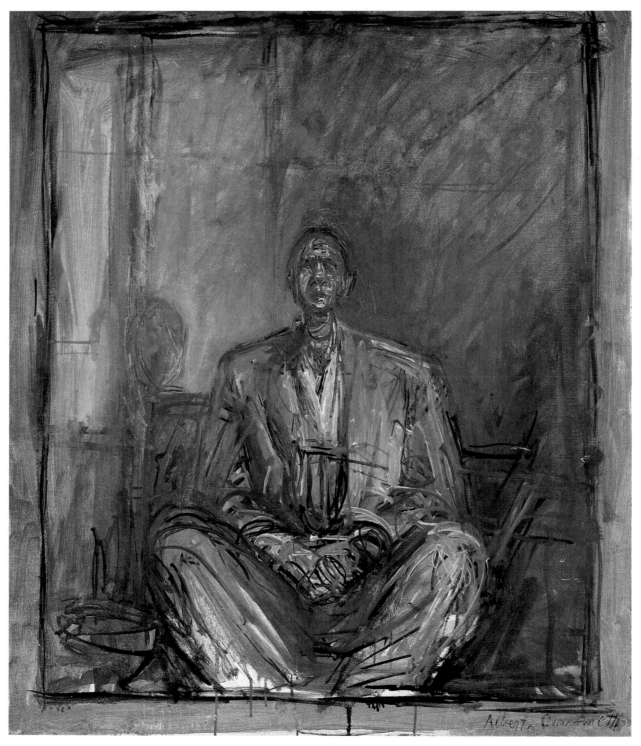

92 Alberto Giacometti *Portrait de Jean Genet* 1955

93 Francis Bacon *Van Gogh in landscape* 1957

94 Auguste Herbin *Vendredi – I* 1951

95 Jean Dewasne *Tombeau d'Anton Webern* 1952

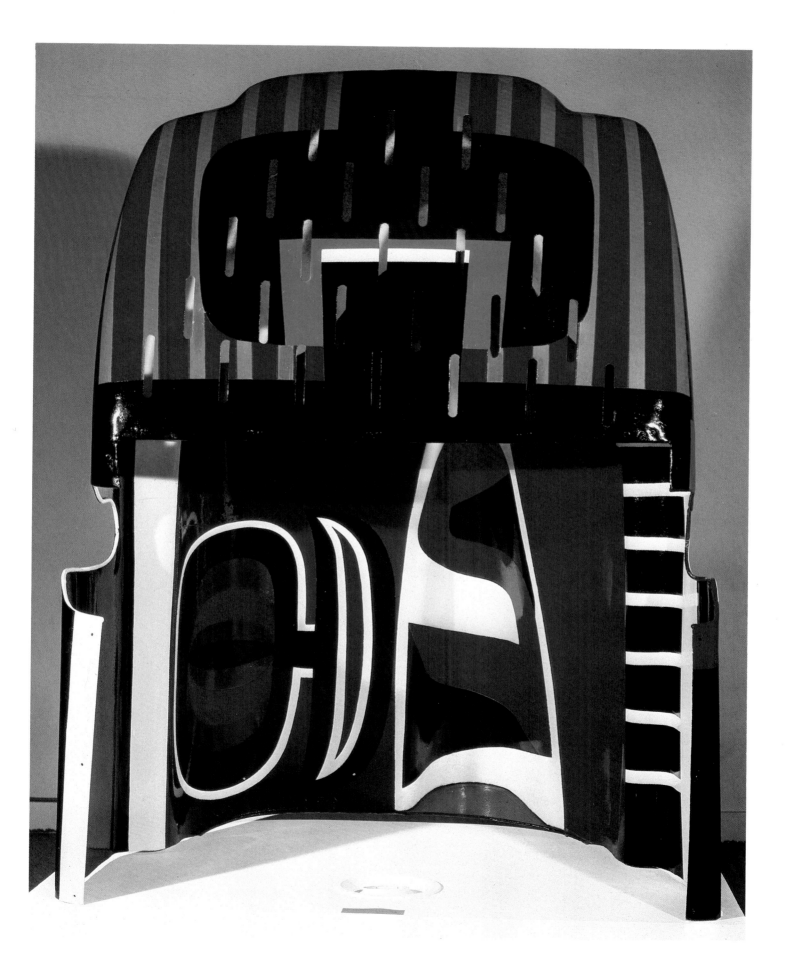

96 Jesus-Rafael Soto *Rotation* 1952

97 Jean Tinguely *Sculpture méta-mécanique-automobile* 1954

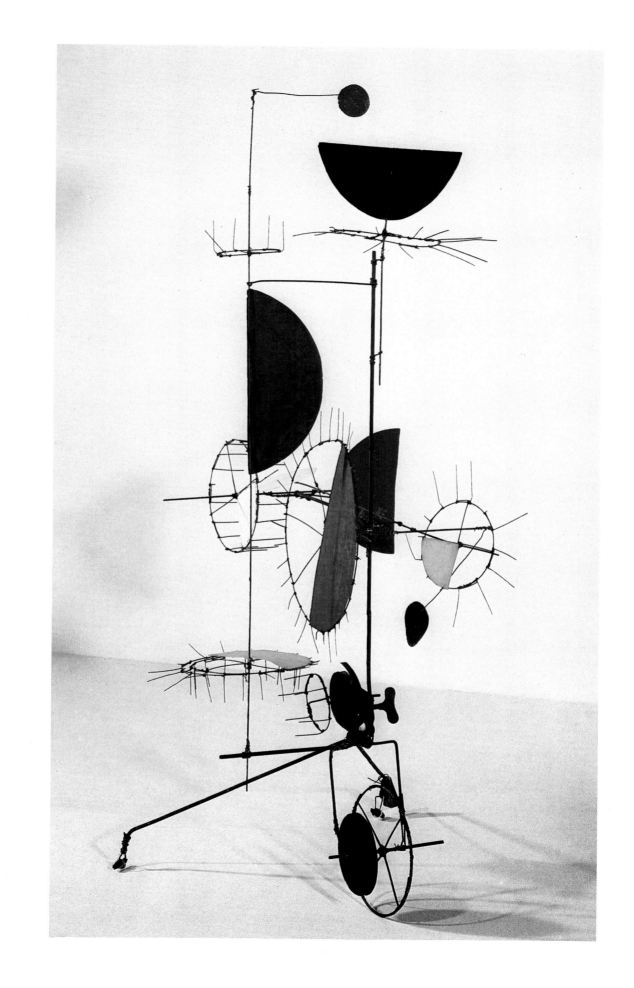

98 Sam Francis *Other white* 1952

99 Jackson Pollock *The deep* 1953

100 Georges Mathieu *Les Capétiens partout* 1954

101 Pierre Soulages *Peinture* 1956

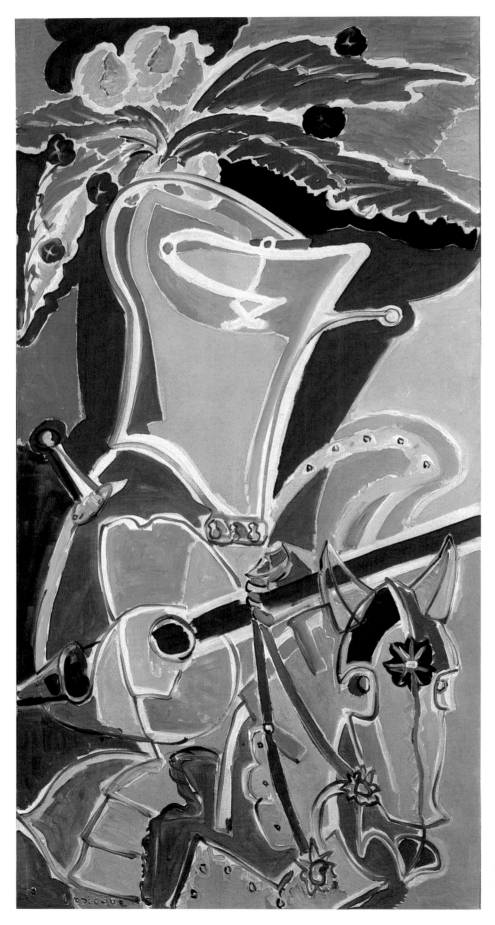

102 Charles Lapicque *Portrait du duc de Nemours* 1950

103 Asger Jorn *Dovre Gubben* 1959

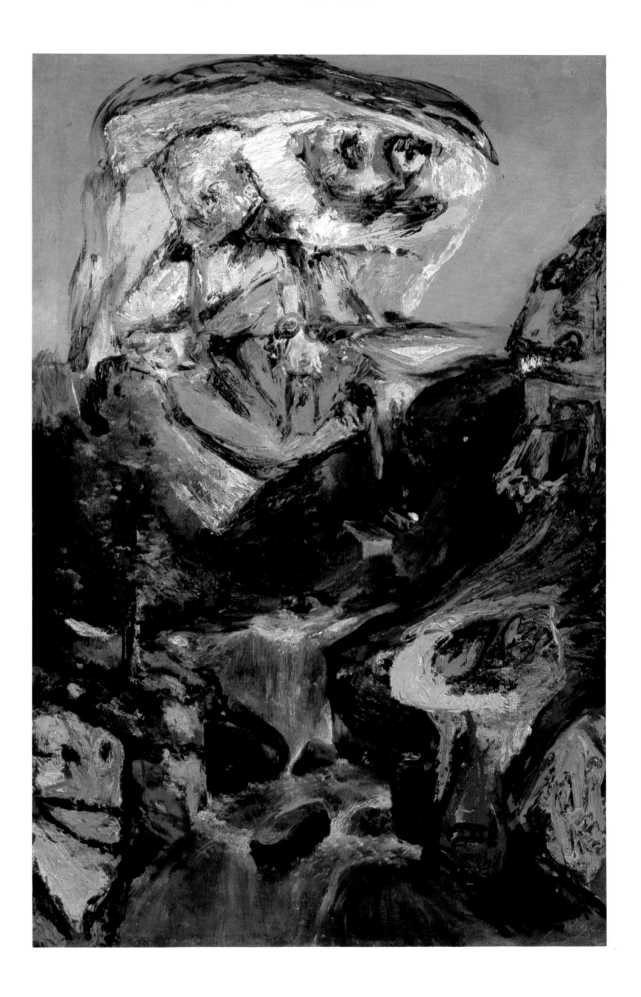

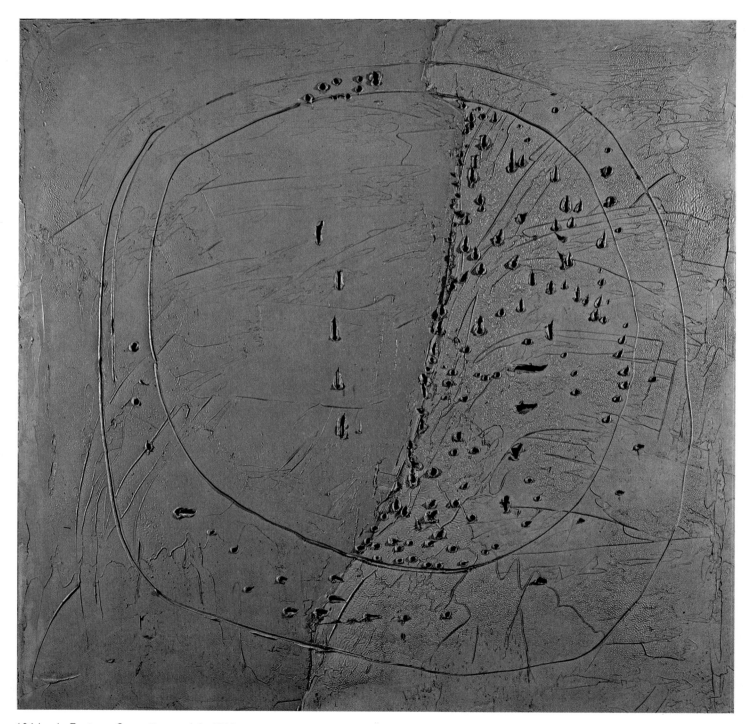

104 Lucio Fontana *Concetto spaziale* 1960

105 Yves Klein *Ci-gît l'espace* 1960

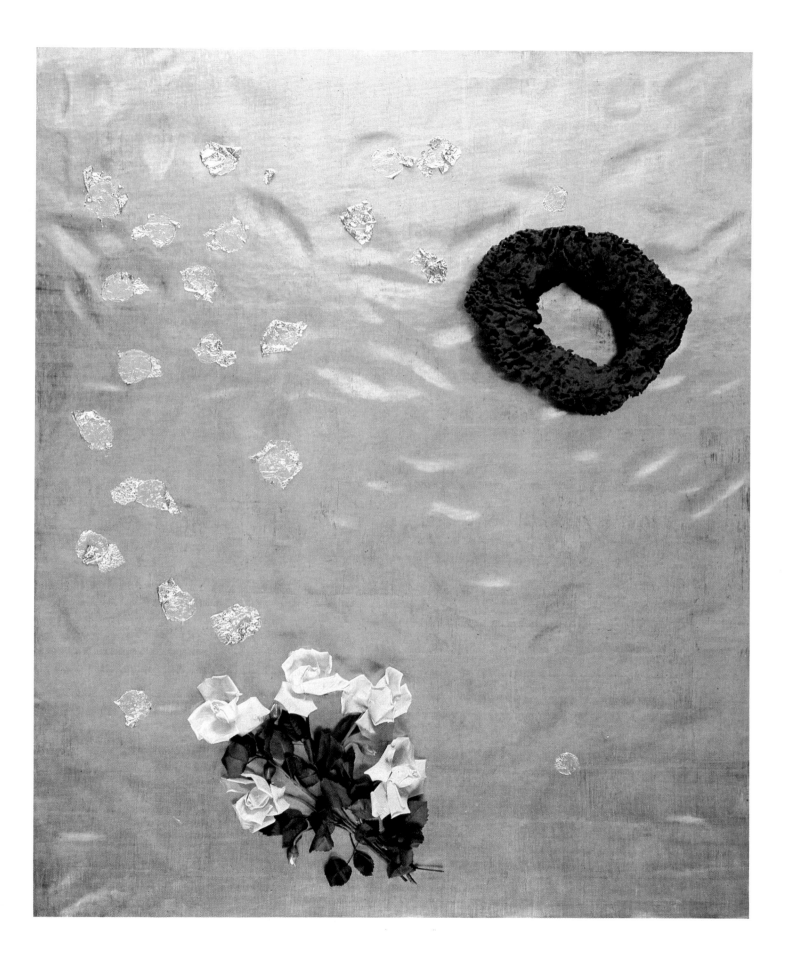

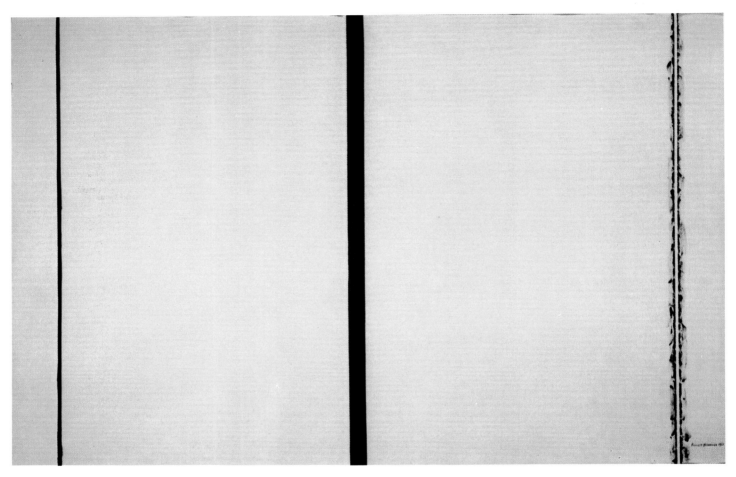

106 Barnett Newman *Shining forth (to George)* 1961

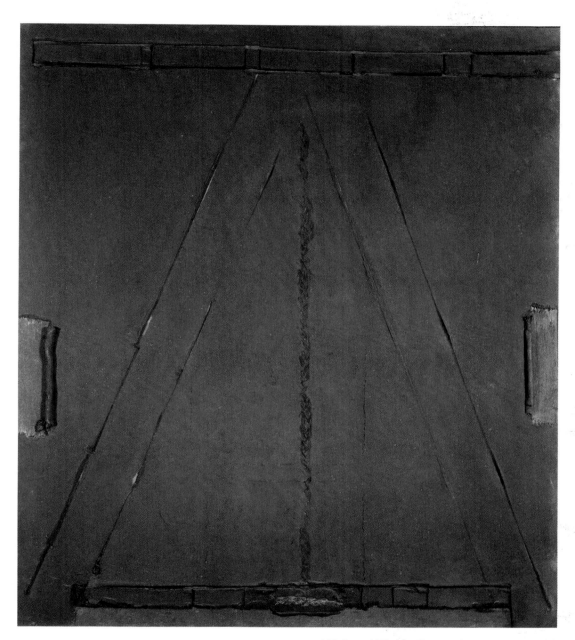

107 Antoni Tàpies *Grand triangle marron* 1963

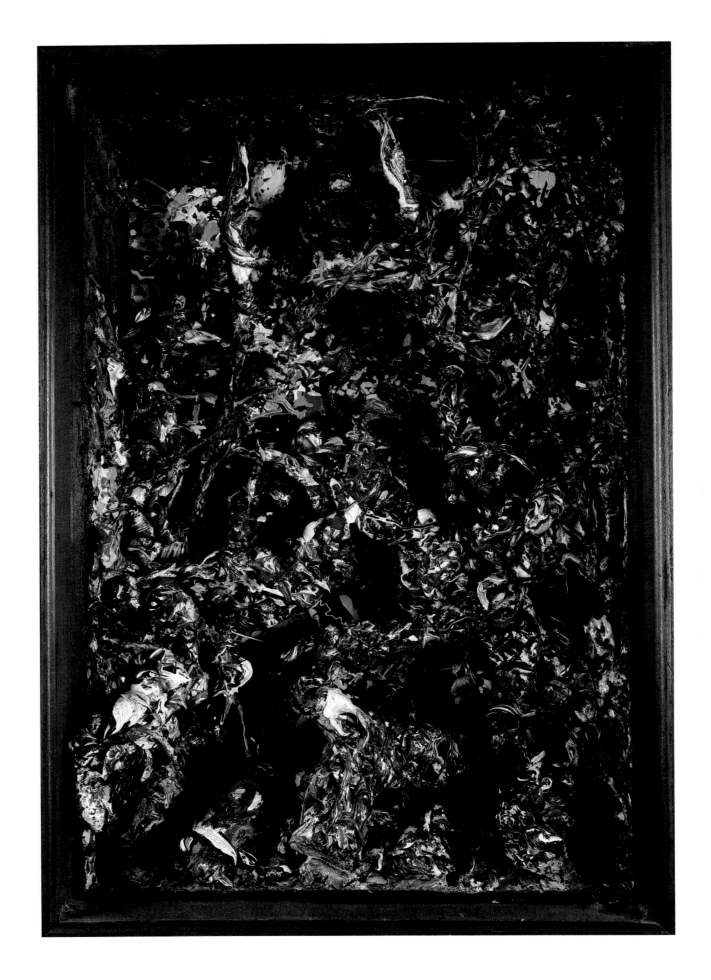

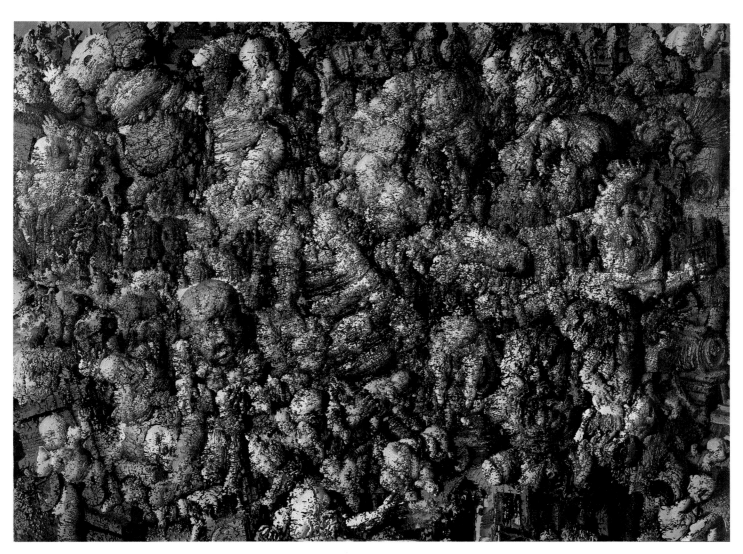

109 Dado (Miodrag Djuric) *Le massacre des innocents* 1958–59

108 Bernard Réquichot *Le reliquaire de la forêt* 1957–58

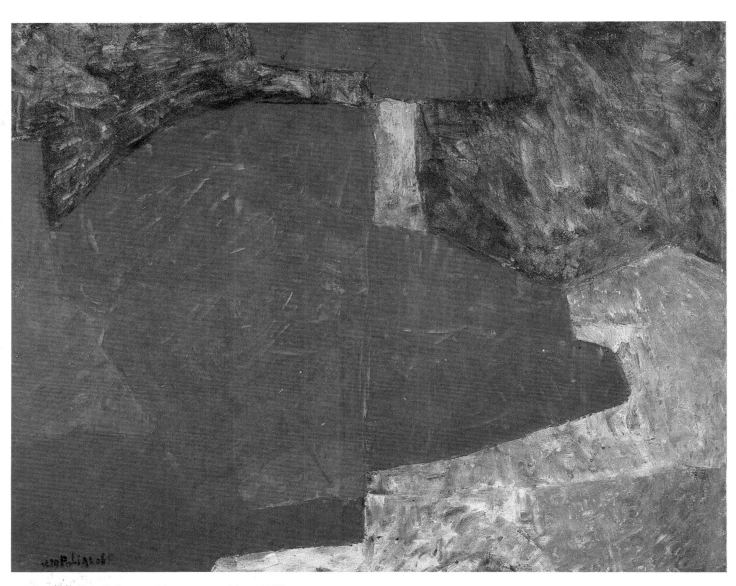

110 Serge Poliakoff *Composition rouge et bleue* 1965

111 Simon Hantaï *Sans titre* 1969

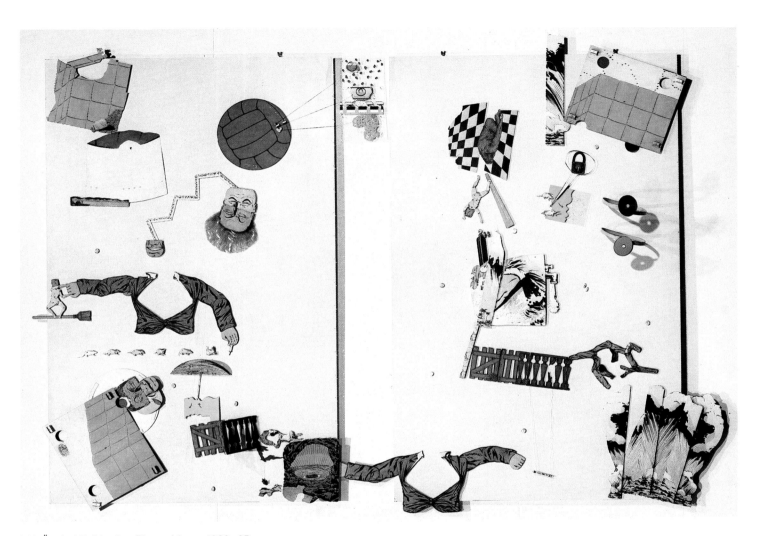

112 Öyvind Fahlström *The cold war* 1963—65

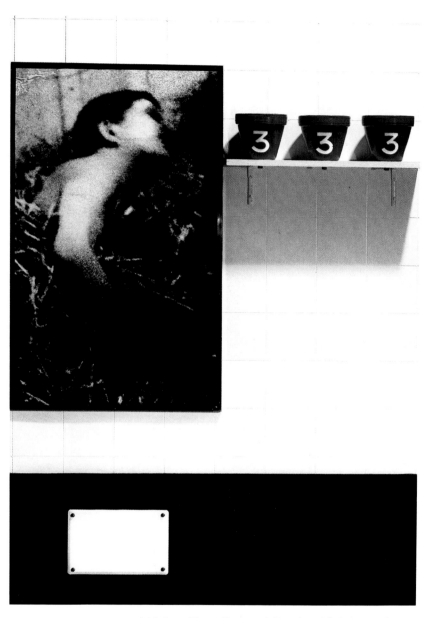

113 Jean-Pierre Raynaud *Psycho-objet, 3 pots 3* 1961

114 Arman (Fernandez Arman) *Chopin's Waterloo* 1962

115 César (César Baldaccini) *Compression de voiture; Ricard* 1962

116 Etienne-Martin (Martin Etienne) *Le manteau* 1962

117 Robert Rauschenberg *Oracle* 1965

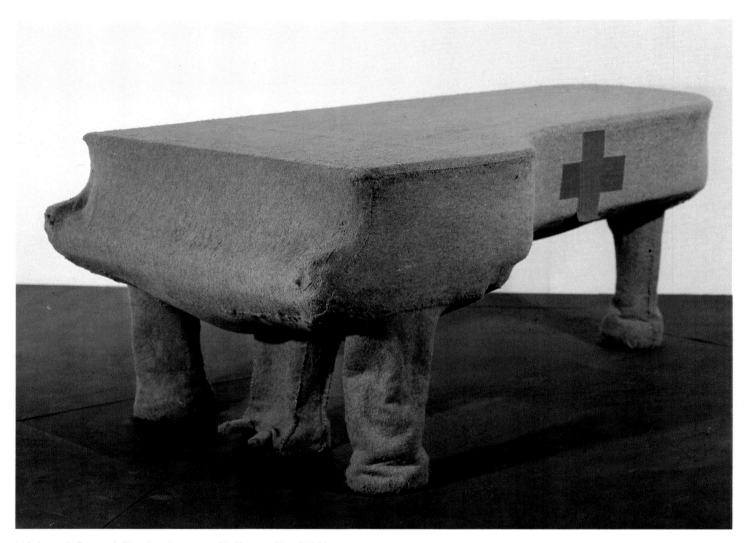

118 Joseph Beuys *Infiltration homogen für Konzertflügel* 1966

119 Andy Warhol *Electric chair* 1966

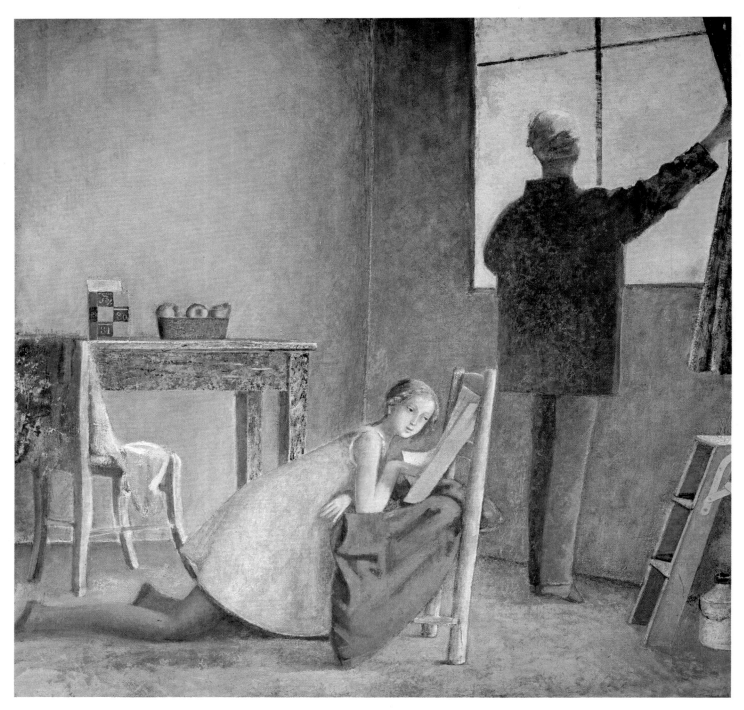

120 Balthus (Balthazar Klossowski de Rola) *Le peintre et son modèle* 1980—81

Commentaries

The commentaries are by Claude Laugier, Claire Stoullig, Claude Schweisguth and Germain Viatte.
All measurements are given in centimetres and inches, height followed by width.

1 HENRI ROUSSEAU (1844–1910)
The snake charmer 1907
Oil on canvas, 169 × 189 (66½ × 74)
Gift of Jacques Doucet to the Musée du Louvre, 1937

It may seem strange to place a work by the Douanier Rousseau at the head of this volume. But the sheer emotive force flowing from this painting surely reaches to the very roots of universal art, transcending all aesthetic categories. Indeed, this 'Sunday painter' was admired by the greatest artists of his era – Picasso, Léger, Kandinsky, and in particular Robert Delaunay, whose mother commissioned *The snake charmer*.

According to a brief autobiographical note he once wrote, Rousseau began to paint only in 1885, 'after many disappointments, alone, with no teacher other than nature and some advice from Gérome and Clément.' Although he was in touch with all the avant-garde movements of the time, and could study their work at the Salon des Indépendants where he himself exhibited every year, he always remained faithful to his inner universe, 'combining the greatest possible realism with the greatest possible abstraction', as Kandinsky put it. Rousseau never set eyes on the exotic landscapes he loved so much and painted so often. But such was the care and love with which he delineated a blue flower, a pink flamingo, an undulating body (Gauguin thought Rousseau's black figures the most beautiful ever seen), that we can easily believe that we had always been there, gazing at that deep forest and that placid river, dreaming of eternity.
(C. Sc.)

2 OTHON FRIESZ (1879–1949)
Portrait of Fernand Fleuret 1907
Oil on canvas, 73 × 60 (29 × 23½)
Purchase of the Musées Nationaux, 1949

This portrait of Fleuret, one of Friesz's best-known works, shows a poet and art critic who was, at the beginning of this century, one of the most distinguished figures in Parisian arts and letters.

Apart from its documentary value, the picture situates Friesz perfectly within the framework of the fauvist movement. Influenced initially by Pissaro and Guillaumin, Friesz later made colour his chief preoccupation, but he never abandoned the principle of direct observation of reality. In this portrait, for instance, the artist's use of whites to intensify the colour is fairly reticent. His chief aim is to evoke the personality of the poet, shown in a characteristic pose. Pensive, the restless face with its domed forehead encapsulates the subject's mercurial nature. This is enhanced by plunging perspective and by nervous brush strokes.

Although he remained faithful to the spirit of fauvism, Friesz gradually abandoned its more exaggerated tendencies in favour of the restraint, balance and harmony so well demonstrated in this 1907 composition. *(C. S.)*

3 ALBERT MARQUET (1875–1947)
Portrait of André Rouveyre 1904
Oil on canvas, 92 × 61 (36 × 24)
Purchase of the Musées Nationaux, 1939

The portrait by Marquet differs importantly from Friesz's portrait on the opposite page. The image is more classical, the technique harsher. This standing figure achieves added authority through the contrast between the black splash of his suit and the rest of the composition. Rouveyre, like Fleuret, became famous at the beginning of this century as a writer, critic and graphic artist, a close friend not only of Marquet but of Matisse, whose portrait of him is also in the museum's collection.

The *Portrait of André Rouveyre* demonstrates that Marquet, although the co-founder, together with his friend Matisse, of the fauvist movement in 1898, never allowed himself to be restricted to one school, even during the most active years of fauvism. For both artists, fauvism represented not so much the exploitation of intense colour as the reduction of painting to arabesque, tone and manner. Marquet seems more receptive here to the relatively simplified vision of Manet than to Van Gogh. *(C. S.)*

4 RAOUL DUFY (1877–1953)
Posters at Trouville 1906
Oil on canvas, 65 × 88 (25½ × 34½)
Purchase of the Musées Nationaux, 1956

A native of Le Havre, Dufy spent part of the summer of 1906 in Normandy with his friend Albert Marquet. Both set up their easels in front of a wall of placards near the beach at Trouville. The fauvist preoccupations they had at this time were stimulated by the advertising posters' vivid clash of colours. Dufy completed two studies of the same subject, the second (shown here) being closer to the style of Marquet. The slanting hoarding gives a great sense of depth, while the figures strolling along the poster-clad wall suggest comical silhouettes.

This same year, Dufy painted a number of still lifes in the ports of Normandy. His palette grew brighter, but lost none of its freshness. *(C. L.)*

5 ANDRÉ DERAIN (1880–1954)
Two coal barges 1905–06
Oil on canvas, 80 × 97 (31½ × 38)
Purchase of the Musées Nationaux, 1972

This painting so perfectly represents Derain's fauve period that it is illustrated in many works devoted to the movement. Derain's meeting and subsequent friendship with Maurice Vlaminck was a seminal influence in his early work. Yet the composition of this picture betrays a confident originality,

with its two coal barges seen from above as though they had just emerged from beneath a bridge. The intensity and boldness of the colours relate them to the art of Derain's friend Matisse around the turn of the century. The transparency and buoyancy of the water recalls the misty tones of Turner and Monet, painters whom the artist especially admired. In 1906 Derain visited London and painted several views of the city, such as the *Pool of London* (Tate Gallery), which also shows a foreshortened boat seen from the same plunging perspective. Derain's work was to evolve in various directions, and his later sculptures, engravings and paintings were composed in a very different style. (*C. L.*)

6 KEES VAN DONGEN (1877–1968)
Acrobat with bare breast *c.* 1908
Oil on canvas, 130 × 97 (51 × 38)
Gift of Jean Aron, 1948

Between 1906 and 1908 van Dongen occupied one of the studios in the celebrated 'bateau lavoir' ('washerwomen's boat') in Montmartre, with Picasso for friend and neighbour, among others. Later he moved into a studio adjoining the Folies Bergères, made friends with the dancers there, and used some of them as models. It was these women whom the critic Louis Vauxcelles described as 'the warmest, most dazzling nudes to be celebrated in paint since Renoir.' Van Dongen was an early convert to fauvism, a movement which echoed his own enthusiasm for violent colours and contrasting tones. As he put it: 'a painting should be something exciting and life-exalting, all the more so because life is basically sad and gloomy.' During this period he painted music hall scenes. His nudes have a glowing sensuality in which the contrasts between black and white, and the strongly delineated features accentuate the sculptural and voluptuous qualities of the female body. His paintings, exhibited in 1908 in Düsseldorf, persuaded the Brücke to invite him to join their group. (*C. L.*)

7 GEORGES ROUAULT (1871–1958)
The girl with a mirror 1906
Watercolour on cardboard, 70 × 60 (27½ × 23½)
Purchase of the Musées Nationaux, 1951

Georges Rouault, first seen as an independent with 'expressionist' tendencies, was, in fact, a religious painter.

Before his series of 'Judges' and 'Clowns', the theme of the prostitute dominated his artistic output during the years 1905–06. At that time Rouault was working in a studio in Montmartre, and being unable to afford a model he used to invite girls off the streets to relax and get warm.

This theme, so dear to Degas, Toulouse-Lautrec and van Dongen, achieved a different dimension and a new sense with Rouault. The scornful, ironic point of view has given way to a certain compassion and even nobility. The *fille de joie* is a symbol of corruption through money. In this composition the model's ugliness is amplified by her reflection in the mirror. The contrast between blues and blacks, the heaviness of form, the realism and the use of thick strokes all bring the work close to the spirit of expressionism. (*C. L.*)

8 WASSILY KANDINSKY (1866–1944)
Landscape with tower 1908
Oil on cardboard, 74 × 98 (29½ × 38½)
Gift of Mme Nina Kandinsky 1976

After spending two years in Paris and a few months in Tunisia and Italy, Kandinsky finally settled down in 1907 in the Munich region, where he

remained until 1914. These were artistically decisive years for him. He found constant inspiration in the Bavarian countryside, especially the little town of Murnau with its white churches and its meadows, all set off by the distant mountains.

Kandinsky witnessed the birth of the fauvist movement and participated in the famous 1905 Salon d'Automne, where he continued to exhibit during the following years. But he had learned long before this to 'move within colour', when he visited the churches and *isbas* (small country houses) of his native Russia during the early 1890s. *Landscape with tower* with its intense contrasts of light, its vigorous manner and its abrupt perspective, already shows the dramatic and cosmic sense underlying his evolving artistic universe. Kandinsky claimed that his first abstract composition, in 1910, came to him almost by chance, but the rhythmic audacities of this painting of 1908 already foreshadow the forthcoming transformation (Plates 22 and 51). And even before this, his discovery at the 1895 impressionist exhibition in Moscow of Monet's haystacks must have given him a premonition that the object was not the most important element in painting. (*C. Sc.*)

9 SONIA DELAUNAY (1885–1979)
Philomène 1907
Oil on canvas, 92 × 54 (36 × 21)
Purchase of the State, 1974

Sonia Terk, who later married Robert Delaunay, first arrived in Paris in 1905, eager to acquaint herself with the land of the impressionists. That same year saw the first exhibition of the fauvist painters at the Salon d'Automne, a celebrated and, at the time, scandalous event. But Sonia Delaunay had brought from her native Ukraine a memory of the dancers' red and green costumes, and she adapted herself easily and naturally to these new currents, as can be seen from the many portraits she painted during this period. Here, the reds, greens, blues and yellows, laid on in thick impasto and outlined with bold strokes, sculpt a nose, a jaw, and vibrate with a violence which Robert Delaunay termed 'barbaric'. Only the floral decor of the background and the model's remote gaze bring an element of calm to this riot of colour. (*C. Sc.*)

10 HENRI MATISSE (1869–1954)
Le luxe – I 1907
Oil on canvas, 210 × 138 (82½ × 54½)
Purchase of the Musées Nationaux, 1946

Le luxe – I was one of the first paintings to be purchased by the Musée National d'Art Moderne. It was executed in the same year that Picasso created his *Demoiselles d'Avignon* and Braque his *Large nude*, and was first shown the following year at the Salon des Indépendants. By this time Matisse was already well known, having exhibited frequently, especially with his friends Derain, Marquet and Vlaminck, with whom he had created the fauvist movement. But his classical training, in Gustave Moreau's studios and masterpiece-copying sessions at the Louvre, soon led him beyond the fauvist style. *Le luxe – I* is a fine example of that progression.

This is the first time that Matisse depicts larger-than-life-size figures; here in a landscape inspired by the small Catalan port of Collioure, where he had spent his summers from 1905 onwards. The style of the picture is rather unexpected, for although he chose two favourite fauvist themes – landscape and the human figure – he does not treat them with the violence characteristic of other fauvist works of that period. The outline of the standing figure in the foreground recedes in relation to the contours of the other two figures, which are sketched rather than drawn. The colours are thin and gentle, and the composition's intensity springs from the vibrant touch reflecting his love for the decorative. (*C. S.*)

11 PABLO PICASSO (1881–1973)
Seated woman 1909
Oil on cardboard, 100 × 73 (39½ × 29)
Georges Salles Bequest, 1967

Seated woman was probably painted towards the end of 1909, at the time when Picasso left the 'bateau lavoir' to instal himself with Fernande Olivier in a studio on the boulevard de Clichy. The composition belongs to a cubism which has ceased to be Cézanne-like and has become analytical. The outline remains clear and well defined, but the proliferation of faceted planes and the breaking up of volumes are already in evidence. A barely sketched-in architectural scheme provides the only background. In Picasso's later cubist paintings, perspective would disappear altogether. Here, the subject still derives from the past, but the limited palette of sombre colours already heralds a new style.

This painting is one of twelve works by Picasso – paintings, drawings and *papiers collés* – which entered the museum's collection through a bequest from Georges Salles, former director of the museums of France and a close friend of the painter. (C. L.)

12 AMEDEO MODIGLIANI (1884–1920)
Head of a woman 1912
Sculpture in stone, 58 × 12 × 15 (23 × 4¾ × 6)
Purchase of the Musées Nationaux, 1949

Modigliani's sculpture is far less well known than his paintings. Yet he first intended to be a sculptor, and sculpted so little only due to a lack of funds. Brancusi, a friend since 1909, initiated him into 'direct' carving, and there resulted a whole series of heads and caryatids, of which about twenty still survive. Like all the artists of his time, Modigliani had made the discovery of African sculpture, seen here in the long triangular nose.

Although he was in close touch with the whole Parisian artistic avant-garde, Modigliani remained aloof from all theorizing, preferring his own vision of plasticity (derived, perhaps, from his Italian origins). Certainly, this head contains all the features which contribute to the originality of his paintings: the refined planes and lines, the slender supple model, the almond eyes with their lost gaze, the elongated neck, and above all, this impression of a remote peace which Modigliani's work constantly evokes, despite his tragic life. (C. Sc.)

13 CONSTANTIN BRANCUSI (1876–1957)
Sleeping muse 1910
Gilded bronze, 16 × 18 × 27 (6 × 7 × 10)
Gift of Baronne R. I. Frachon, 1963

The output of this sculptor of Romanian origin is that of a solitary creator. Although proclaiming the plastic abstraction that characterizes the evolution of modern sculpture, Brancusi's work followed a highly personal and coherent approach. Rodin may have influenced his early style, but there are far stronger ties with the cubists. Like them, Brancusi sought a new plastic reality and was attracted by the eloquent simplifications of black African art which was just then being discovered by the artistic avant-garde. However, the natural cosmic world which underlies his whole oeuvre distances him from the cubists' more intellectual preoccupations. The elemental, flawless shapes with which Brancusi attempts to re-create natural order are governed by the nature of the material itself – wood, stone or marble – which he carved 'directly', without preliminary sketches, like an artisan.

While Brancusi continued to maintain a subtle balance between the concrete and the geometric in his sculptures, he evolved gradually from his first still-naturalistic studies (*Children's heads*, 1906–08) towards an ever greater paring away of forms. In 1910 he abstracted from reality the refined volumes of the *Sleeping muse*. Brancusi liked to return repeatedly to the same theme but, within a particular series, he would introduce into the

plaster and bronze versions of a single original some alteration so subtle that at first glance it was scarcely perceptible.

The many motifs that Brancusi invented may be thought of as microcosms, reductions of the world of nature, and more specifically of the world at the moment of creation. That primordial and symbolic form, the oval, is to be found in most of his sculptures deriving from the human figure. (C. S.)

14 GEORGES BRAQUE (1882–1963)
The side-table 1911
Oil on canvas, 116 × 81 (45½ × 32)
Gift of Raoul La Rouche, 1952

Following a fauvist period while living in Ceret in the south of France, Braque elaborated – simultaneously with Picasso – a new, more severe style: cubism. *The side-table* derives from the so-called analytical phase of cubism, and was probably also produced in Ceret, where both Braque and Picasso were still living. During this period their compositions were very close in style and technique, sharing similar themes, breaking volumes down into a succession of facets, and constructing pyramidal forms in ochre, brown and grey tones. The side-table constituted a favourite theme for Braque over a period of many years; it brought him the 'tactile' space he needed for the disposition of his objects.

This painting, together with two other works by Braque, *The black side-table* and *Woman with guitar*, was a gift from the distinguished Swiss collector Raoul La Roche. (C. L.)

15 JACQUES VILLON (1875–1963)
Marching soldiers 1913
Oil on canvas, 65 × 92 (25½ × 36)
Purchase of the Centre Georges Pompidou, 1976.

In 1912 Jacques Villon became the prime mover in the foundation of the Section d'Or group, whose members took exception to the new 'classicizing' tendencies of cubism. These included Raymond Duchamp-Villon and Marcel Duchamp (Villon's brothers), La Fresnaye, Léger, Picabia and Kupka. They met in the atelier shared by Jacques and Raymond in Puteaux, near Paris (which is why the Section d'Or is sometimes referred to as the Puteaux group). Villon's knowledge of art theory made him the group's spokesman. In particular, his advocacy of Leonardo da Vinci's system of perspective based on 'pyramidal vision' and the principle of the 'Golden Mean' provided the group with its chief theoretical weapon in its search for a dynamic cubism incorporating a perspective based on harmonious proportions. Villon's own work was now guided constantly by the aesthetic considerations of proportion, linear relationship and movement.

In October of the same year, Villon exhibited with the Section d'Or in their only collective show, at the Galerie La Boëtie in Paris, where Duchamp's *Nude descending a staircase* was the main sensation. The Italian futurists had held their first Paris exhibition a few months previously, showing some clear affinities with the aims of the Section d'Or. And Jacques Villon's researches, in particular, endorsed Duchamp's declaration that 'The movement of a form within a given time involves one inevitably in geometry and mathematics. It is exactly the same when one constructs a machine.' *Marching soldiers* provides a good example. It originated during a period of military service when Villon made sketches of marching men, with the aid of compasses, joining the different points with a straight line. (C. L.)

16 MARCEL DUCHAMP (1887–1968)
The chess players 1911
Oil on canvas, 50 × 61 (19½ × 24)
Purchase of the Musées Nationaux, 1955

This work, painted in December 1911 at Neuilly, is derived from a number of ink and charcoal studies which also prompted Duchamp to execute a more

concentrated and more complete version, the *Portrait of chess players* of the same date (Philadelphia Museum of Art, Arensberg collection). The artist evokes here his own passion for chess, a passion which was soon to persuade him to lay aside his brushes for good. The scene represents Duchamp's two brothers, Raymond Duchamp-Villon and Jacques Villon, seated round a table in the manner of Cézanne's *Card players*. Marcel was a member of the Section d'Or group founded by Jacques, and in *The chess players* the breaking down of the figures' constituent elements and the use of sombre colours make it his personal expression of cubism. The vertical black bands framing each side of the composition reappear in the first version of *Nude descending a staircase*, of the same period, but exploring only movement and thus typically futurist. (C. L.)

17 FERNAND LÉGER (1881–1955)
Nuptials 1911–12
Oil on canvas, 257 × 206 (101½ × 81½)
Alfred Flechtheim Bequest to the State, 1937

Nuptials expresses the very individualistic 'cubist' manner of Léger at this period, when he felt closer to the researches of his friend Robert Delaunay than to the pure cubism of Picasso or Braque. Rounded forms jostle prisms and angles, and broad flat-washes make their first appearance. Certainly the geometric volumes, the multiplicity of viewpoints, the deformation of human figures and the black outlines all demonstrate Léger's interest in cubism. But he was primarily engaged in a constant search for contrasts. His fondness for cylindrical or tubular forms earned him the title of 'tubist' from the critics of the day. (C. L.)

18 ERNST LUDWIG KIRCHNER (1891–1938)
Woman before the mirror (the toilette) 1912
Oil on canvas, 100 × 75 (39½ × 29½)
Purchase of the Centre Georges Pompidou, 1980

Kirchner, who had started off as a student of architecture, defined his artistic aims early in his career as the ability 'to express the sensations of actual experience in large simple forms and pure colours'. These words sum up the whole of German expressionism, of which Kirchner was one of the most impetuous representatives. To express his sensations of actual experience, Kirchner painted and drew a great deal – a total of more than two thousand works. In this way he learned to condense his impressions into a few cross-hatched strokes, as in this picture constructed around obliques and verticals that intersect at acute angles: the manner is bold and only faintly modelled, the space is almost flat. But Kirchner is not content with seeing. His imagination is also active: this slightly unreal blue is the product of his imagination, as is the restless composition, and this woman who looks at herself in a mirror but seems to be contemplating someone else. Ambivalence, anguish and solitude run beneath the surface of all Kirchner's work. (C. Sc.)

19 MICHAIL LARIONOV (1881–1964)
Portrait of Tatlin 1911
Oil on canvas, 89 × 69 (35 × 27)
Gift of Suzanne and Michel Seuphor, 1977

Larionov was one of the key figures in the many artistic exchanges which took place between France and Russia prior to the Revolution. In 1906 he accompanied Diaghilev to Paris, helping him organize an extensive exhibition of contemporary Russian art at the Salon d'Automne. In 1908 it was his turn to bring the works of Picasso, Braque and Matisse to Moscow, where they promptly found enthusiastic collectors – Shchukin and Morosov. But Larionov was also attracted by Russia's artistic, popular and religious

traditions, and so, after a period of Cézanne-inspired impressionism, he reverted, between 1908 and 1910, to what has been called 'neo-primitivism', the Russian equivalent of German expressionism.

This portrait of Tatlin, who was Larionov's pupil, is fascinatingly ambiguous. On the one hand, there is the icon-like expression of hieratic severity, the small head with its gaze turned inwards, and the dominant yellow which suggests the gilt of mosaics. On the other hand, we find a free and very spontaneous manner, and the few words inscribed informally across the top of the picture doubtless represent an unconscious recollection of cubism. Finally, the simple planes that intersect at an oblique angle express the new theories about 'rayonism' which Larionov was beginning to work out and which were intended to provide the sensation of a fourth dimension. (C. Sc.)

20 ROGER DE LA FRESNAYE (1885–1925)
Seated man 1913–14
Oil on canvas, 130 × 162 (51 × 64)
Purchase of the Musées Nationaux, 1957

Seated man is the last painting La Fresnaye completed before his departure for the Front, when he left his *Quatorze juillet* (14 July) for ever uncompleted. He was close to the artists of the Section d'Or, but always remained independent of the products of cubism. The years 1913 and 1914 were artistically the most fruitful of his life.

La Fresnaye came from a family of scientists, and his work expressed a constant striving towards perfection and strict discipline, allied to a feeling for colour. In this painting, the imposing human figure flanks straight geometric shapes in pure colours, suggesting space. The bareness and simplicity of these forms, lit by a succession of luminous planes, express the artist's classicism. (C. L.)

21 JUAN GRIS (1887–1927)
The breakfast 1915
Oil and charcoal on canvas, 92 × 73 (36 × 29)
Purchase of the Musées Nationaux, 1947

Like Roger de La Fresnaye, Juan Gris died young, at the age of forty. Following his scientific studies in Madrid he arrived in Paris in 1906 and made the acquaintance of Picasso at the 'bateau lavoir'. He did not come to cubism until 1911, but then devoted his entire work to its elaboration. He applied with astonishing facility such cubist principles as geometrization of objects, multiplication of viewpoints, and insertion of typography. These aspects are all on display in *The breakfast*, together with an investigation of chromatism and figuration, seen in the way he simulates the texture of wood to suggest cubist *papiers collés*. Gris' strictness of temperament led him quite naturally to these admirably orchestrated still lifes. He incarnated the cubist spirit so perfectly that he became known as the 'grammarian of cubism'. (C. L.)

22 WASSILY KANDINSKY (1866–1944)
With the black bow 1912
Oil on canvas, 189 × 198 (74½ × 78)
Gift of Mme Nina Kandinsky, 1976

In 1912 Kandinsky published two essays of the greatest importance, *Concerning the Spiritual in Art* and *The Almanach of Der Blaue Reiter*. Both are intuitive rather than theoretical works, intuitions of a new world in which art would at last be liberated from its representational role and would express only its 'interior necessity', a world in which black African and medieval art, Matisse and Douanier Rousseau and even music itself would unite – as in the *Almanach* – in a shared spirituality.

His concept of energy and dynamic radiance achieves perfect expression in this composition, in which three great blazing masses revolve in

boundless space, barred by a heavy black bow as though to check all the anarchic movement. It is difficult to place a literal interpretation on this work, although it may refer back to certain *Improvisations* of 1910–11 in which horsemen charge to assault impregnable mountain peaks. Perhaps these words of Kandinsky's from *Concerning the Spiritual in Art* best convey the picture's profound meaning: 'Every work is born, technically, in just the same way that the cosmos was born, through catastrophes which, starting out with the chaotic screeching of instruments, end up by forming a symphony, the music of the spheres.' (*C. Sc.*)

23 FRANCIS PICABIA (1879–1953)
Udnie 1913
Oil on canvas, 300 × 300 (118 × 118)
Purchase of the State, 1949

From being a fashionable impressionist artist, Picabia executed his first abstract painting *Caoutchouc* (Rubber) in 1909, the first of many such conversions to new ideas. His stated purpose at that time was to create 'a painting situated in pure invention, which re-creates the world of forms in terms of its own desire and its own imagination.' Desire, imagination: two key words in defining Picabia's variegated artistic production. Although he was involved in the avant-garde movements of his era – exhibiting with the cubists at the Salon des Indépendants and associated with the Section d'Or group – he was never a wholehearted adherent of cubism, which was far too restrictive for his capricious temperament. The only artist with whom he felt a genuine affinity was Marcel Duchamp, who also rejected all systematic thought.

According to Picabia, the enigmatic subtitle of this picture, 'young American girl, dance', alludes to his journey to America in 1913 and the dance performed by a young girl on the transatlantic liner. He completed three paintings on the same theme, all of enormous dimensions, corresponding – it would seem – to the massive impression that New York made on him. The hard-edged planes collide and telescope and then come together in a central vortex, evoking to some extent the circular forms that Robert Delaunay was creating at the same period. But Picabia's colours are cold and dominated by greys, greens and whites, revealing an intellectualism which is the exact opposite of Kandinsky's painting.

Two years later Picabia switched to his 'mechanist' period. (*C. Sc.*)

24 ROBERT DELAUNAY (1885–1941)
The window 1912–13
Oil on canvas, 111 × 90 (44 × 35½)
Purchase of the Musées Nationaux, 1950

It was Delaunay's friend the poet Apollinaire who in 1912 coined the happy term 'orphism' to describe his painting. Although Delaunay was associated with the initial phase of cubism, breaking the surfaces of his townscapes, pictures of the Eiffel Tower and the church of Saint-Séverin into countless facets, one can already detect a movement, a lyricism and, above all, an emphasis on pure colour which distinguish them from what he himself termed the 'toiles d'araignée cubistes' (the English translation – 'cubist spiders' webs' – misses the double French pun). These qualities brought him nearer to artists of Der Blaue Reiter, with whom he in fact exhibited.

With his series of twenty *Windows*, Delaunay liberated himself totally from the depiction of reality. The Eiffel Tower was reduced to a distant motif, overwhelmed by the transparent play of planes brought about by the successive passage of colours and their luminous contrasts. By these methods Delaunay achieved his much-sought 'pure dramatic work'. The following year saw the appearance of his *Circular forms* and *Discs*, which would present nothing but the continuous flow of pure colours, containing vague allusions to the sun and the moon. (*C. Sc.*)

25 SONIA DELAUNAY (1885–1979)
Electric prisms 1914
Oil on canvas, 250 × 250 (98½ × 98½)
Purchase of the State, 1958

Two paintings by Robert and Sonia Delaunay are placed side by side here not simply because they were man and wife, but because their individual work did genuinely follow the same paths. Sonia, however, while wholly endorsing Robert's theoretical concepts, had a more intuitive approach. It seems that her extensive study of the art of embroidery had taught her early to free herself from representation and to invent rhythms which depended on colour alone. In this respect she was in a position to aid Robert's own process of disengagement from the object.

In her autobiography, Sonia Delaunay wrote: 'Colour became for us a form of expression as vital as words.' And she describes how they used to wander up and down the Boulevard Saint Michel, dazzled and fascinated by the electric lights that had just replaced the old gas jets. They loved everything that was new: jazz, motor cars, the poetry of Guillaume Apollinaire, and the writings of the poet-essayist Blaise Cendrars, whose *Prose du Transsibérien et de la petite Jehanne de France* Sonia illustrated. (It is interesting to note that Cendrars' name appears in *Electric prisms*.) 'Simultaneous contrast' was the phrase they invented to describe this whole panorama of modern life; and this picture, with its intense colours, huge format and whirling rhythms, is indeed bursting with joy and energy. (*C. Sc.*)

26 FRANZ KUPKA (1871–1957)
Vertical planes – I 1912–13
Oil on canvas, 150 × 94 (59 × 37)
Purchase of the Musée du Jeu de Paume, 1936

Kupka settled in Paris in 1896, to escape, he claimed, from 'decadent metaphysical questions'. In fact he soon abandoned the symbolism of his early years in Prague and Vienna, and immersed himself in complex researches into plane, colour and motion. By 1910 he was producing his first abstract paintings. But although he made common cause with all the most advanced ideas of his time; was hailed by Apollinaire as a creator of 'orphism' on equal terms with Delaunay; and participated in the activities of the Section d'Or along with Villon, Duchamp and Picabia, he never totally identified himself with any one movement.

Kupka had always been imbued with philosophical and religious interests, and was an enthusiastic student of astronomy and biology. He was not really interested in analysing the visible world. In his own words: 'I do not believe that it is necessary to paint trees ... I paint only the conception, the synthesis'. He found this synthesis essentially in the circle, the symbol of universal gravitation, and in the vertical. For Kupka, 'a rectilinear world seems to be the most energetic, the most abstract and the most elegant'. That is why this picture, of which he completed two further versions during the same year, is so moving: it constitutes the first approach to his whole future oeuvre. (*C. Sc.*)

27 HENRI LAURENS (1885–1954)
The bottle of Beaune wine 1916
Polychrome wood and sheet metal, 66 × 27 × 24 (26 × 10½ × 9½)
Purchase of the Centre Georges Pompidou, 1978

Initially influenced by Rodin, Laurens became the friend of Braque, Gris, Léger and Picasso, and was deeply influenced by the cubist spirit. *The bottle of Beaune wine* belongs to a series of polychromatic constructions in various media executed between 1911 and 1921 in which the sculptor demonstrates his attachment to cubism. The basic principles of that movement are represented in this work: the influence of still lifes, a vertical composition, and the use of simple forms such as the cylinder and the

triangle. At the same time Laurens completed a number of *papiers collés*. Concerning his multiple colour processes, he wrote: 'I have made many polychromatic sculptures ... The whole idea behind this process was to provide the sculpture with its own source of light'. Laurens paid meticulous attention to the question of combining different materials in ways that would create plastic rhythms and subtle harmonies between them. The results, seen here, demonstrate his exacting nature and his profound sensibility.

(*C. L.*)

28 GEORGES BRAQUE (1882–1963)
Man with guitar 1914
Oil on canvas, and sawdust, 130 × 73 (51 × 29)
Purchase of the Centre Georges Pompidou, 1981

This recent acquisition may be considered a complement to the *Woman with guitar*, executed a year earlier, also in the museum. *Man with guitar* is one of the last pictures that Braque painted before leaving for the Front, and the war interrupted his artistic production for several years. Here cubism has become synthetic, and light plays on the horizontal and vertical forms. The inclusion in the centre of the picture of a simulated strip of green braid, of sawdust and of painting imitating the colour and texture of wood, provides a link with the *papiers collés* which Braque had been producing since the end of 1912. Musical instruments, and especially the guitar, appear in many of his paintings.

(*C. L.*)

29 PABLO PICASSO (1881–1973)
Portrait of a young girl 1914
Oil on canvas, 130 × 97 (51 × 38)
Georges Salles Bequest, 1967

Painted during the summer of 1914 while he was staying in Avignon, Picasso's *Portrait of a young girl*, with its high colouring, reflects the period of financial success and happiness he was enjoying at the time. Executed in trompe l'oeil technique, the portrait continues the manner of the *papiers collés* that he had been producing for two years. He chooses a few cut-out papers, some of them imitating wallpaper, makes extensive use of pointillism, and gives full play to his sense of fun in the emphasis on the hat and its details, and on the small bouquet of flowers at the base of the low neckline. He even succeeds in introducing a cubist still life into a corner of the canvas: the basic elements of a bowl of fruit. This amalgam of disparate elements led some critics to speak of these works of 1914 as 'rococo cubism'. (*C. L.*)

30 ALBERTO MAGNELLI (1888–1971)
Workmen in the cart 1914
Oil on canvas, 100 × 75 (39½ × 29½)
Purchase of the Centre Georges Pompidou, 1976

Magnelli's meeting with the cubists during a stay in Paris in 1914, and especially his contacts with Apollinaire, Léger and Picasso, persuaded him to rethink the whole direction of his work. He transformed his vision by reducing perspective to a flat-wash that masked the different planes of the composition. And yet this Florentine painter, trained in the school of Piero della Francesca while the futurist revolution was in full swing, retained a wholly original mind. In *Workmen in the cart*, for instance, the surface is fragmented into several planes whose bright pure colours, outlined in black, suggest the idea of dynamic movement. The range of colours, which he uses with the freedom of a fresco painter, is particularly harmonious and produces a feeling of genuine gaiety: these 'workmen' hardly give the impression of being exploited toilers.

Although this picture belongs to a brief one-year period which Magnelli called 'semi-figurative', the artist perceived it as an abstract composition.

The richness of colour and the luminosity are positively dazzling. The painting announces Magnelli's new-found interest in abstraction, which was to remain his chosen form of expression. (*C. S.*)

31 RAYMOND DUCHAMP-VILLON (1876–1918)
The large horse 1914
Bronze (cast in 1976), 150 × 97 × 153 (59 × 38 × 60)
Purchase of the Centre Georges Pompidou, 1976

This sculptor brother of the artists Jacques Villon and Marcel Duchamp was chiefly concerned with the problems of space and movement. His ability to project his new vision of forms in a constant spirit of synthesis allowed him to create a truly original style of sculpture.

The idea of movement that obsessed Duchamp-Villon is perfectly illustrated in this *Large horse*, which was preceded by a long series of preliminary drawings made during the war while serving with a cavalry regiment. But his interest in horses went back to 1913, when he executed a number of bronzes all testifying to his conceptions of movement and of the machine in sculpted form. This monumental horse derives its inspiration from the new spirit that was abroad not only in art but in architecture (in 1912 Duchamp-Villon constructed a 'cubist house'), and has affinities with both cubist and futurist ideas.

In 1918 Duchamp-Villon expressed his desire to see this work enlarged. His brothers achieved this in 1930–31, and then again in 1966 with pieces measuring 1 by 1·5 metres. These were presented in the same year to the Galerie Louis Carré. This final enlargement is one of the four stages of the work in the museum's collection. (*C. S.*)

32 KASIMIR MALEVICH (1878–1935)
The black cross 1915
Oil on canvas, 80 × 80 (31½ × 31½)
Gift of the Scaler Foundation and the Fondation Beaubourg, 1979

Russia's 1917 revolution was a signal to the artists of that country for a radical transformation. Already in 1916 Malevich had published his manifesto entitled *From Cubism to Suprematism*, in which he claimed to have 'discovered the nullity of forms ... Oppositions and contradictions: in those are to be found our harmony'. This *Black cross*, utilizing suprematism's two basic shapes, the square and the circle, and obtaining its cross by dividing the square into two rectangles at a ninety degree angle to each other, shows Malevich to have been one of the first, together with Kandinsky and Mondrian, to concern himself with radical abstraction.

In his approach to abstraction, Malevich emphasized dramatically the relationship between form and the space surrounding it, thus creating a tension that seems to make the composition vibrate. His intention, with his suprematism, was to attain the essence of form and thus the perfection of painting. Pushed to its farthest limits, this conception led him to create works using only black and white in the simplest shapes, and finally to a white square on a white background. 'Suprematism', said Malevich, 'is unified sensation, infinite whiteness, a feeling of the absence of the object'. (*C. S.*)

33 HENRI MATISSE (1869–1954)
Violinist near the window 1917–18
Oil on canvas, 149 × 97 (58½ × 38)
Purchase, 1975

In the winter of 1917–18 Matisse discovered Nice. *Violinist near the window* was completed during this first visit. 'When I realized that each morning I would see this same light, I could hardly believe my luck. Most people come here for the light and the picturesque surroundings. I am a northerner. The things that made me stay on were the great coloured reflections of January,

the luminosity of the day.' And Matisse began to spend more time, each year, beside the Mediterranean.

When war broke out in 1914 Matisse was already forty-five. Paradoxically, the dramatic events served to inspire him to fresh artistic adventures. With no exhibitions and no collectors to satisfy, circumstances seemed favourable for the pursuit of a precise objective: the creation of a consummate masterpiece. The *Violinist near the window* certainly merits this description. Its luminosity, restrained tones, and poetic point of view combine, in perfect harmony, to unite the painter's universe with external reality. (*C. S.*)

34 ANDRÉ DERAIN (1880–1954)
Portrait of Itturino 1914
Oil on canvas, 92 × 65 (36 × 25½)
Gift of Mme Gallibert, 1969

Although Derain's work was first oriented towards fauvism, his interest in classicism very soon asserted itself. The style of this portrait provides the evidence: its grey background in the manner of David, intended to display and isolate the individual, can be found in his portraits until 1920. Later, Derain rounded his forms, but here the face seems to be carved from wood, and the elongated body recalls El Greco.

Itturino was a painter who exhibited with the dealer Ambroise Vollard in 1901, at the same time as Picasso. His ascetic appearance, like one of Francisco de Zurbarán's monks, made him a popular model, and from 1889 onwards he posed frequently for Derain and other painters.

This composition radiates a curious intensity, and both Balthus and Giacometti were among its admirers. The former commented: 'In this modern El Greco with its sharp details and monochromatic verticality, the hands and face achieve an astonishing symmetry'. Both artists made something of a cult of Derain, presenting him as a 'giant' at work against the tide of events; they inherited his liking for solitude, his contempt for conventions and his secretiveness. Perhaps these uncompromising qualities attracted André Breton, who at one time owned this portrait. (*C. S.*)

35 GIORGIO DE CHIRICO (b. 1888)
Premonitory portrait of Guillaume Apollinaire 1914
Oil on canvas, 81 × 65 (32 × 25½)
Purchase, 1975

Guillaume Apollinaire, the poet and art critic, was vastly impressed by the work of Chirico when he first saw it on display in 1912 at the Salon d'Automne. 'The most astonishing painter of our time,' he proclaimed. The young Italian had arrived in Paris the previous year, after studying at the Munich School of Fine Arts where he had discovered the romantic allegories of the Swiss painter Arnold Böcklin (1827–1901). During 1913 Chirico invited Apollinaire to visit his studio, and offered to paint his portrait.

This curious portrait is in fact treated in a fairly negligent manner, in the background, in profile, rather like a shadow. In the foreground the bust of a 'poet' with 'bandaged' eyes is far more important. 'What I hear is worthless, there is only what my eyes see, when open or even more when closed.' This declaration by Chirico, and the symbolism of the obtrusive plaster bust, reveal the artist's interest in the depths of things, in inner vision, the imaginary, the dream, rather than the 'real' things that make up day-to-day existence. This is also why Chirico includes in the same composition curious objects that are juxtaposed without any apparent logic. Painting becomes an enigma.

Another curious aspect of this picture is the thin white semicircular line marking the top front of Apollinaire's profile. Four years later the poet received a head-wound in battle, exactly in the spot indicated. He himself was convinced of the portrait's premonitory nature. (*C. S.*)

36 HENRI MATISSE (1869–1954)
Portrait of Auguste Pellerin 1916
Oil on canvas, 150 × 96 (59 × 38)
Ceded to the State in settlement of death duties, 1982

From 1913, Matisse undertook a series of large-scale portraits: Madame Matisse (1913), Yvonne Landsberg (1913), Michael and Sarah Stein (1916). This picture, one of the most recent additions to the national collections, belongs to this series but is one of the least known, having seldom been shown in public. It is the second version of the composition, since Pellerin, the celebrated collector of Cézanne's work, disliked the original and initially refused it. He later relented and bought both versions.

This portrait gives a completely stylized rendering of the model's face, which seems as firmly and violently simplified as some sixth-century mosaic. The severe frontal posture accentuates the hieratic character common to this whole series of portraits, but particularly intense here. (*C. S.*)

37 RAYMOND DUCHAMP-VILLON (1876–1918)
Portrait of Professor Gosset 1918
Patined plaster, 30 × 23 × 23 (12 × 9 × 9)
Gift of Mme Teeny Duchamp, 1977

This portrait is the last work of Raymond Duchamp-Villon, completed a few months before he died of an infection contracted at the Front. It demonstrates clearly the important place occupied by the second of the three Duchamp brothers in the field of modern sculpture. This head is remarkable for the boldness of the concept, which attempts both synthesis and expression. The work originated in the hospital where Duchamp-Villon was a patient, and represents the physician who was treating him. The model is reconstituted into a masked face, a disquieting and ominous image achieved by fitting simple dynamic volumes into each other. This strict architecture eliminates all unnecessary volumes, such as the neck, and gives the head an equivocal position. Is it inclined, vertical, horizontal? The sculptor declines to tell us.

Starting off from the mechanist researches of the 1914 *Horse*, Duchamp-Villon developed his sculpture into constructions that go beyond the ideal reductions of Brancusi's post-1910 heads and the expressive volumes of Matisse's *Jeannette*, and in their turn presage the huge heads which Picasso was to sculpt in 1932 at Boisgeloup.

The portrait, the most modernistic of all Duchamp-Villons's sculptures, is part of the important donation by Mme Teeny Duchamp, that enriched the museum's collection in 1977. (*C. S.*)

38 MARC CHAGALL (b. 1887)
To Russia, to the donkeys and others 1911
Oil on canvas, 156 × 122 (61½ × 48)
Gift of the artist, 1949

Chagall grew up in southern Russia, in the small town of Vitebsk, and remained there until he was twenty. His family was poor but, as he wrote in his autobiography: 'It was there at home, watching my father beneath the lamp, that I began dreaming about the skies and moons that existed far from our own street. I concentrated all the poetry of life into my father's silence and sadness. Ineffable source from which I nourished my dreams, my father, fellow creature of the motionless, secret, silent cow sleeping on the roof of the *isba*.' It was from such simple but profound images that Chagall constructed his whole pictorial universe.

Chagall arrived in Paris in 1910, 'with mud on his boots', but was not overwhelmed by the fashionable theories of the time, as can be seen in this painting, which borrows from cubism only a few elements of pure form. The rest is sheer poetic vision, an almost hypnotic vision in which the artist

succeeds in seeing the most radiant colours in the black night, in which a cow's tail seems to be a flame, and in which a farmer's wife flies away and loses her head as she gazes at the sky. (C. Sc.)

39 MARC CHAGALL (b. 1887)
Double portrait with wine glass 1917
Oil on canvas, 235 × 137 (92½ × 54)
Gift of the artist, 1947

Sitting on Bella's shoulders, Chagall gaily celebrates his wedding anniversary. 'One should be able to sink into colours as into a carpet', Chagall believes. And indeed it does seem that one could stretch out one's hand and stroke Bella's marvellous white robe, or walk into the great golden halo that hovers over this little town of Vitebsk. In his autobiography Chagall writes: 'Everything can change in this democratized world of ours, except the heart of man and his aspiration towards knowledge of the divine. Painting, like all poetry, participates in the divine.' Thus the artist transforms the simplest event into a supernatural happening in which everything may suddenly take flight, like this angel, who enlivens almost all Chagall's paintings with his lighthearted presence. (C. Sc.)

40 RAOUL HAUSMANN (1886–1971)
The spirit of our time. Mechanical head 1919
Assemblage of wood and assorted materials, 32 × 21 × 20 (12½ × 8¼ × 8)
Purchase of the Musées Nationaux, 1973

This 'mechanical head', the most important example of dada 'art' in the museum, has been hailed as 'a masterpiece of dada sculpture' although it is not in fact sculpted at all. Hausmann contented himself with choosing a hairdresser's dummy head, to which he affixed various objects symbolizing 'the spirit of our time': the purse, for instance, represents the importance accorded to money by society, while the ruler, the watch movement, the goblet and the tape-measure glued to the brow suggest the various elements that make up human life (space, time, imagination, and so on).

Analogous assemblages of commonplace materials had already been produced in 1912 by Italian futurist sculptors aiming 'to express the most intense impressions resulting from the dynamism of modern life' (Boccioni, in a manifesto on futurist sculpture). This use of a ready-made object recalls Chirico's paintings incorporating antique sculptures surmounted by mannequins' heads: these had greatly impressed the Berlin dadaists when the series was exhibited at the Sturm gallery in 1915.

This is no simple satire on 'petit bourgeois mentality', but Hausmann expresses with clarity his feelings of attraction and repulsion for mechanized society. The head is also, of course, a fine example of the provocative humour with which dada denounced the standardization of a dehumanizing industrial era. (C. S.)

41 SOPHIE TAEUBER-ARP (1889–1943)
Carved head (portrait of Jean Arp) 1918–19
Painted wood, 34 × 20 × 20 (13½ × 8 × 8)
Gift of Mme Arp, 1967

In 1918 Sophie Taeuber-Arp sculpted some marionettes for the traditional play *The King Stag* presented at the Zurich puppet theatre. This undertaking probably inspired her first works, which were polychrome pear-shaped heads resting on bases that resembled collars. These object-heads, despite their small scale and stylization, may be considered parodies of portraits; they serve equally well as hat stands. This utilitarian function cancels their aesthetic character. Here Sophie Taeuber-Arp reflects perfectly the dada spirit fermenting in Paris and Berlin as well as in Zurich, where the movement came officially into being in 1916 while war raged all around.

This movement of revolt against the war, against fanaticism in general and dessicated rationalism, a movement based on protest and rejection, was destined to inspire the creation of a number of works of unquestionable beauty and poetic content. This enchanting sculpted head is a fine example. (C. S.)

42 THEO VAN DOESBURG (1883–1931)
Composition 1920
Oil on canvas, 130 × 80 (51 × 31½)
Purchase of the Musées Nationaux, 1964

Strongly influenced by Kandinsky and Mondrian, van Doesburg was in 1916 one of the first strictly geometric abstract artists. *Composition* is a particularly significant example. Verticals and horizontals animate the surface with variously coloured, sharply defined rectangular planes.

His art is less severe than that of Mondrian, but equally representative of the 'neo-plasticist' painting which has exercised a decisive influence on architecture, painting, typography and advertising. Based on geometric forms and basic colours (blue, yellow, red or black, grey and white), neo-plasticist art does not concern itself with the representation of external objects; its aim is to express the cosmic forces signifying the 'essence' of the world. These artistic theories were propounded in a journal called *De Stijl*, founded by van Doesburg in 1917, which aimed to elaborate not a new system of painting but a language accessible equally to applied plastic arts and to architecture. Van Doesburg made an important contribution to the new ideas proposed by the Bauhaus when it was founded in Weimar in 1919. (C. S.)

43 ANTOINE PEVSNER (1886–1962)
Construction in space 1923–25
Bronze and cut glass, 64 × 84 × 70 (25 × 33 × 27½)
Gift of Mme Pevsner, 1962

Pevsner's sculpture, like that of van Doesburg, represents a particular current of thought that developed around abstract art. In 1920, Pevsner and his brother Naum Gabo had published their *Constructivist Manifesto* in Moscow, and this 'construction in space', made of bronze and Baccarat cut glass, represents the first fruits of Pevsner's researches into its principles. For both of them, art was an essentially spiritual activity: 'plumb-line in hand, eyes gauging as precisely as a ruler, mind as rigid as compasses, we construct our work in the same way that the universe constructs its own.'

Pevsner and Gabo intended to liberate volume from mass, and to create depth, 'the only plastic form of space', by means of planes. Empty space and transparency, rather than opaque substances, would call sculptural space into existence – a concept beautifully expressed in this construction. (C. S.)

44 FRANCIS PICABIA (1879–1953)
The cacodylic eye 1921
Oil and photographs on canvas, 146 × 114 (57½ × 45)
Purchase of the State, 1967

This huge picture with an absurd title that means 'bad smell', made up of signatures, whirling messages, a painted eye and with two small photographs glued on, is filled not only with the spirit of Picabia but with that of the whole era. Picabia was, with Tristan Tzara, one of the most active of dadaists, publishing reviews, organizing public demonstrations and composing pictures with the aid of toothpicks, matches and straws. His imagination was boundless. A celebrated dandy, he participated in all the 'crazy' parties of the era. It was at a New Year's Eve party of this kind that this picture was composed, with some help from Picabia's friends.

144

This dadaist 'eye' lightheartedly condemns the uniquely created work of art and its speculative value, and almost prefigures the 'happenings' of the 1970s. It is a splendid example of the defiant spirit that Picabia retained all his life – defiance of good taste, of serious-mindedness and, above all, of boredom, that 'worst of all maladies' as Picabia himself put it.　　　(C. Sc.)

45 GEORGE GROSZ (1893–1959)
Remember uncle August, the unhappy inventor 1919
Oil, crayon and collage on canvas, 49 × 39 (19½ × 15½)
Purchase of the Centre Georges Pompidou, 1977

The question mark on uncle August's brow could symbolize this whole tragic post-war era. The dada movement, especially the Berlin group in which Grosz was active, rebelled against all generally held values – political, social or aesthetic. 'Kick up a din! Explode! Break out!' commanded Grosz in 1918.

Photomontage was one of the Berlin group's favourite methods of attack: it was quick, it reflected a complex reality confronting simplistic ideologies, and it made fun of great art, of 'those illustrators of sentiment and weakness: Picasso and Cézanne'. Even the individual's autonomy is denied in these photomontages; he becomes an automaton, a dummy, as in so many pictures of the period, or a machine in the image of uncle August, that unhappy engineer of a world in ruins.　　　(C. Sc.)

46 OTTO DIX (1891–1969)
The journalist Sylvia von Harden 1926
Oil on wood, 121 × 89 (47½ × 35)
Purchase of the Musées Nationaux, 1961

In post-war Germany the old romantic 'expressionistic' exaltation of the individual seemed outdated. It was first of all necessary to make a clean sweep, and this the dadaists undertook. An attempt then had to be made to discover what remained of reality in this desolate world, and such was the aim of the movement called 'new objectivity', which provided a common front for a broad spectrum of artists until it was declared 'degenerate' by the Nazis.

Otto Dix followed precisely this evolutionary process. The 'new objectivist' artists noted the role of portraiture in the great German artistic tradition, and they made it one of their favourite themes. But these were more than psychological studies, they were the collective portrait of a society. And the faces share with inanimate objects the same indifference, the same cold precision, the same smooth surface texture.

In this portrait of Sylvia von Harden, Dix is delineating not only a celebrated journalist of the 1920s but also a certain type of woman of the era, a woman in the process of self-emancipation, wearing a monocle, sitting in a café, smoking ostentatiously, assuming a provocative attitude that is accentuated by the acid reds. Dix's paintings refrain from open criticism but invariably contain this element of very perceptible irony.
　　　(C. Sc.)

47 PABLO PICASSO (1881–1973)
Harlequin 1923
Oil on canvas, 130 × 97 (51 × 38)
Gourgaud Bequest, 1965

Picasso, like Léger and many other artists of the time, was always attracted to the atmosphere of the circus and the theatre, a love he communicated as early as 1905 with his series of *Acrobats*. In 1917 Jean Cocteau introduced him to Diaghilev in Rome, and later that year he met Stravinsky and Massine, and designed the scenery and costumes for the Ballets Russes's production of Satie's *Parade*. He did further theatre designs for Cocteau, and continued

his collaboration with the Ballets Russes with designs for ballets by Falla, Stravinsky and Milhaud. In July 1918 he married the Russian ballerina Olga Khoklova.

This neo-classical *Harlequin* belongs to a series that Picasso completed in 1923, and shows his friend the Catalan painter Jacinto Salvado posing in a costume belonging to Cocteau. Despite all his innovations over the years, Picasso still remained attached to traditional precepts. What does this Commedia dell'Arte personage symbolize as he sits there, motionless, sad eyes gazing into space? Perhaps a certain human resignation.　　　(C. L.)

48 FERNAND LÉGER (1881–1955)
Mechanical element 1924
Oil on canvas, 146 × 97 (57½ × 38)
Gourgaud Bequest, 1965

Léger intends to demonstrate here that, as he wrote at the time, 'the beautiful machine is the beautiful modern subject'. In his enthusiasm for the new industrial era, he never ceased to extol the plastic beauty of the machine. In a series of 'mechanical elements', of which this is the definitive version, Léger wanted to prove that every industrial object possessed an absolute value irrespective of its specific role. His friends Le Corbusier and Willi Baumeister also held strongly to this view during these years. In Léger's words: 'The mechanical element is not simply a personal prejudice or attitude, but a means of giving an impression of force and power'. Simplification of forms and broad flat-washes of very brilliant colours give this purely abstract work great intensity and monumentality.

A period of totally abstract work led Léger in 1925 to execute paintings that were practically architect's sketches. He later returned to a more figurative style with the 1927 series of 'objects in space'.　　　(C. L.)

49 LÁSZLÓ MOHOLY-NAGY (1895–1946)
Composition A XX 1924
Oil on canvas, 135 × 115 (53 × 45)
Gift of the Société des Amis du Musée National d'Art Moderne, 1962

This Hungarian-born painter was also a sculptor, a notable photographer and an essayist. In 1917 he was one of the co-founders of the 'MA' (Today) group in Szeged (Hungary), and edited a review of the same name. He moved to Vienna in 1919, and then to Germany in 1921. Between 1923 and 1928 he was the head of the metal workshop and foundation course at the Bauhaus in Weimar and then Dessau: there he found himself teaching alongside Klee, Kandinsky, Feininger and others. During these years he published (in Munich) several essays summarizing his theoretical researches. In 1935 he moved to London, where he was associated with the constructivist group 'The Circle' (Naum Gabo, Barbara Hepworth, Henry Moore). Then, in 1937, he moved again, to Chicago, to become director of the short-lived New Bauhaus School there. The following year he was the founding director of the Chicago-based School of Design (1938–46).

Composition A XX, painted by Moholy-Nagy while he was teaching at Weimar, illustrates his preoccupation with a new plastic dimension, the phenomenon of transparency. Here his researches into light are combined with geometrical elements, the whole composition showing evidence of Russian constructivism.　　　(C. L.)

50 PAUL KLEE (1879–1940)
Villas at Florence 1926
Oil on cardboard, 49 × 36 (19 × 14)
Purchase of the Musées Nationaux, 1970

Blended, fading tones; lines disposed in semicircles or crosses, like an endless embroidery or a carpet such as the ones the artist admired in

Tunisia; a few diffident signs of reality – a tree, a window, a dome: this is all that Klee shows us of Florence. Long before the theories of surrealism or *art brut*, Klee had been receptive to the drawings of children and the insane, to ideograms and calligraphy: they seemed to him to approach that 'central point of creation' which he was seeking. So Klee's line becomes a 'psychic improvization', as flowing and spontaneous as handwriting. Perspective is totally absent, as always in his work, but in its place is a yielding, purely mental space in which everything communicates – high and low, macrocosm and microcosm – as in dream or memory. *(C. Sc.)*

51 WASSILY KANDINSKY (1866–1940)
Accent in pink 1926
Oil on canvas, 100 × 80 (39½ × 31½)
Gift of Mme Nina Kandinsky, 1976

Kandinsky had been teaching at the Bauhaus in Weimar, and then in Dessau, for four years when he painted this picture in 1926. After the lyrical explosion of the preceding years he felt the need to reflect on abstract art as such, and from this he distilled a method which he described in the treatise published that same year: *Punkt und Linie zu Fläche* (Point and Line to Plane). Until his departure for France in 1933 all his work is characterized by a monumentality that he himself qualified as 'cold'. But these paintings, basing their construction solely on the primary geometric forms of circle, square and triangle traced out with ruler and compasses, still never lose the vivacity and sense of movement which we associate with this artist, and always retain an infinite variety in their composition and colours.

In this particular work Kandinsky plays on the opposition between circle and square, the stable and the unstable, light and shade, black and pink, large and small, the vague and the precise; tensions that collectively give the final impression of cosmic serenity, a mysterious equilibrium 'speaking mysteriously of the mysterious'. *(C. Sc.)*

52 PABLO PICASSO (1881–1973)
Still life with antique head 1925
Oil on canvas, 97 × 130 (38 × 51)
Gift of Paul Rosenberg to the State, 1946

After the rich experience of cubism, Picasso reverted, between 1920 and 1925, to a form of classicism. *Still life with antique head* represents a blend of belated cubism and the classical spirit. The antique bust, engraved with a thin white line, is stylistically reminiscent of ancient Greek vases. A noticeable feature of the composition is the interplay between curved and straight lines, and the brown spreading into broad areas of white which themselves overflow the edges of the design. The fruit dish, shown in vertical section, harks back to the cubist manner.

The advent of surrealism in 1924 helped impel Picasso momentarily in a different direction. In 1926 he took part in the surrealists' first collective exhibition in Paris, and Breton claimed that his large canvas *The three dancers* showed 'convulsive beauty' (a key surrealist phrase of approval). *(C. L.)*

53 FERNAND LÉGER (1881–1955)
Reading 1924
Oil on canvas, 114 × 146 (45 × 57½)
Gourgaud Bequest, 1965

Reading remains perhaps the most balanced and accomplished of all Léger's paintings. Before composing this 'definitive state', he executed a number of drawings and paintings of each of the women, first separately and then together. *Reading* contains not a single superfluous detail or brushstroke, and the decor has simply vanished. The severity and precision of the attitudes, the simplification of the background, attain an absolute classical authority. With the colours, too, the play between pinks and ochres achieves a sort of purist perfection.

A heavy feeling of rigid inertia emanates from these two object-women, with their hieratic features and intense gaze focussed on the distance rather than on their book, all in cinematic close-up. That same year, 1924, Léger produced his marvellous film *Le ballet mécanique*. *(C. L.)*

54 JACQUES LIPCHITZ (1891–1973)
Figure 1926–30
Painted plaster, 220 × 95 × 75 (86½ × 37½ × 29½)
Gift of the Fondation Jacques et Yulla Lipchitz, 1976

About 1925, Lipchitz began to produce a series of sculptures collectively known as 'transparents', much admired by Picasso and Gonzales. The diverse ways in which he presented the interiorization of space within volume testified to a great creative imagination. These experiments proved valuable during the five-year period of gestation of this *Figure* whose totemic appearance derives from Lipchitz's enthusiasm for primitive art. In creating it, he also developed the researches that had preceded his sculptures of 1926, such as *Ploumanach* (from which he borrowed a few formal characteristics), as well as the parallel researches that had produced his 'garden monuments' (of which the first maquette had been created for Coco Chanel).

Figure in fact originated as a private commission for the entrance hall of a villa. But the prospective owner doubtless found it too abstract, and perhaps too mysterious as well, and the work was finally refused and returned to the sculptor. Today its importance seems self-evident: it sums up magnificently Lipchitz's sources of inspiration, cubism in particular. New York's Museum of Modern Art realized this long ago, and in 1963 bought another version of the sculpture. *(C. S.)*

55 ALEXANDER CALDER (1898–1976)
Josephine Baker 1926
Wire, 101 × 95 × 25 (40 × 39½ × 10)
Gift of the artist, 1966

The American Alexander Calder came from a family of painters and sculptors. He studied engineering for a time, before discovering his talents as a graphic artist. Then, for his own amusement, he started creating jewellery and toys from wire. After settling in Paris in 1926, in a studio near Montparnasse, Calder began to fashion toy animals out of wood and wire. Soon he began working with wire alone, and the first results of this new technique were *Josephine Baker model one*, and a negro boxer wearing a top hat. He subsequently created several additional models of the famous American Negro entertainer. At the end of the same year Calder began work on the countless human figures and animals of his miniature *Circus* (now in New York's Whitney Museum). His enormous sense of humour and his pleasure in game playing, later led to the increasingly monumental 'mobiles' for which he became famous. *(C. L.)*

56 JULES PASCIN (1885–1930)
Portrait of Flechtheim as bullfighter 1927
Oil on canvas, 104 × 80 (41 × 31½)
Alfred Flechtheim Bequest, 1938

Pascin was something of a nomad. Born in Bulgaria of Spanish and Italian parents, he led a restless existence in Vienna, Berlin, London, New York,

North Africa and, above all, Paris. He acquired American nationality while living in the United States during the First World War. Like Toulouse-Lautrec, or his contemporary Rouault, he chose for preference the private universe of prostitutes and other inhabitants of Paris's semi-underworld, and became well known in the bars, bistros and nightclubs of Montparnasse. Debilitated and weakened by alcohol and other excesses, Pascin put an end to his own life in 1930.

Pascin's art is both mordant and sarcastic. The soft translucent atmosphere of his paintings and graphics exudes a sense of melancholy and a sort of black humour which well express his unstable temperament. This picture records a visit to Paris by his friend the celebrated German art dealer Flechtheim, who regularly exhibited the younger French and German artists in his Düsseldorf and Berlin galleries. To celebrate the occasion they both put on toreador costumes. (C. L.)

57 CHAIM SOUTINE (1893–1943)
The pageboy c. 1928
Oil on canvas, 98 × 80 (38½ × 31½)
Matsukata sequestration, attribution to the Musée National d'Art Moderne, 1952

Soutine was of Lithuanian origin, coming from a large and poor Jewish family. In 1913 he emigrated to Paris, and soon made the acquaintance of Chagall and Modigliani. Between 1920 and 1922 he lived in Ceret in the South of France, where he painted a number of landscapes and still lifes which so impressed the celebrated American collector Dr Alfred D. Barnes that in 1923 he bought one hundred canvases.

Soutine chose his models from among the underprivileged, through whom he could instinctively express the anguish of his own existence. He had his first one-man show in Paris in 1927. During that same period he painted a series of studies of pageboys, cooks and choirboys, which showed, among other things, his fascination with their costumes. The nervous line, and the deformed and sometimes even dislocated profiles, reveal the misery of the characters portrayed. In their costumes he achieves dazzling symphonies of colours, relying especially on red and white. Soutine's painting is, above all, that of an anxious restless spirit. (C. L.)

58 JOAN MIRÓ (b. 1893)
Siesta 1925
Oil on canvas, 113 × 146 (44½ × 57½)
Purchase of the Centre Georges Pompidou, 1977

From 1919 onwards Miró lived alternately in Spain and France. In France he began associating with Picasso, Masson, Ernst, and then the newly organized surrealists. He collaborated happily with them until 1937, but had no need for their theories about 'automatic psychic functioning' in order to be dominated by an inner dream that he has always pursued, even in the realistic paintings of his earliest creative years. He would not only 'smash the cubist guitar', as he had announced: he would smash all the other preconceived ideas on art as well. And nowhere in his work is this artistic iconoclasm better expressed than in the pictures he painted between 1925 and 1927. Usually monochromatic, verging on emptiness, they are built up from a single point or stroke or line. Associations form freely, revolving around a few basic images to which Miró himself has provided the key. A woman and a house, a long snaking white kite, the black blob of the sun, a sinuous black line joining sky to sea, a mountain peak in the distance, and figures dancing the Sardana, disguised as a circle of dots at midday. Nothing could be more spontaneous than these images, springing as they do from Miró's nostalgia for his native Catalonia, whose light, colours and transparent air have indelibly marked his memory. (C. Sc.)

59 YVES TANGUY (1900–55)
At four o'clock of a summer, hope 1929
Oil on canvas, 129 × 97 (51 × 38)
Purchase of the Centre Georges Pompidou, 1978

Tanguy was a Breton, and although he attended school in Paris he always holidayed in Finistère. He later returned there regularly until his departure for the United States in 1939. From 1918 to 1921 he worked as a merchant seaman. Seeing a Chirico in a gallery window in 1923 made him decide to become a painter. The following year he read the newly published *Surrealist Manifesto*, and through some poet friends made the acquaintance of André Breton.

Tanguy was absolutely discreet about his work, never indulging in theories. But if surrealism was (as Breton had himself defined it) 'the exercise of pure psychic automatism', then Tanguy was certainly the most surrealist of them all. As a painter he was self-taught, but in less than two years he had discovered his pictorial universe, his 'prison' as he once called it. Landscapes that are half aquatic half aerial lead one astray within their infinite horizons. Weightless forms or beings wander, fly, float. A single point of bright light, like the marvellous yellow in this particular painting, glows to give a touch of warmth to the cold pale distant light. One could glide gently into this drifting absent universe, like one drifts into sleep, if it were not for the almost imperceptible atmosphere of anguish. (C. Sc.)

60 JEAN ARP (1886–1966)
Dancer 1925
Oil on cut-out glued wood, 149 × 112 (58½ × 44)
Purchase of the Centre Georges Pompidou, 1976

Jean Arp first trained in his native Strasbourg, and later studied art in Weimar and Paris. In 1912 he went to Munich, where his friend Wassily Kandinsky introduced him to the painters of Der Blaue Reiter. He returned to Paris in 1914 and became acquainted with Robert Delaunay, Modigliani and Picasso. But he seemed to have no great inclination to become a painter, and it was not until he moved to Zurich in 1915 that he began to produce his first painted reliefs. He also became one of the co-founders (together with Tristan Tzara, Richard Huelsenbeck and others) of the dada movement in Zurich in 1916.

After the war Arp lived in Germany until 1924, when he and his wife Sophie Taeuber moved to Paris. There, Arp's friends Max Ernst and Joan Miró introduced him to the surrealists. *Dancer* dates from the following year. It shows the impact on Arp of surrealism, and displays the fantasy and humour to be expected of the former dada prankster. But over and above such influences there is the sheer audacity and total plastic freedom with which the forms and colours of this painted relief have been treated.

Among the fine group of sculptures by Arp in the museum's collection, *Dancer* is the only example of his surrealist period. (C. S.)

61 MAX ERNST (1891–1976)
Loplop introduces a young girl 1930
Oil, plaster on wood plank, with assorted material, 195 × 89 (77 × 35)
Ceded to the State in settlement of death duties, 1982

With a father who painted religious subjects, Max Ernst could hardly help becoming a subversive artist. He completed studies in philosophy, literature and art history. Then in 1914 he met Arp, and soon became one of the most dedicated exponents of dadaism in Germany. In 1919 his discovery of Chirico proved a powerful stimulus and led to his first collages, made up of cut-outs from old illustrated magazines. When these collages were exhibited in Paris in 1922, they created a sensation in the world of avant-garde art and

literature. Among the admirers were a number of poets and painters with whom he helped to found the surrealist movement two years later.

The collages provide the keystone of Ernst's work, showing how the artist, making use of an apparently simple technique, succeeds in juggling with the most banal reality, and stimulating deeply secret fantasies. Over the years Max Ernst invented various new techniques, including frottage, grattage and decalcomania, which all helped him to retain this ironic distance between the work and himself, and allowed the work to gush forth, so to speak, of its own accord.

In this assemblage, *Loplop introduces a young girl*, Ernst has covered an old wooden door with plaster, from which emerges the outline of a monstrous bird, a mocking worldly presence representing Max Ernst himself. Like his other theme – the forest – that of the bird recurs at regular intervals throughout his work, and Loplop will continue to introduce, in turn, Paul Eluard, the fine season, two flowers. *(C. Sc.)*

62 SALVADOR DALI (b. 1904)
Partial hallucination, six images of Lenin on a piano 1931
Oil on canvas, 114 × 146 (45 × 57½)
Purchase of the State, 1938

Part genius and part madman, exhibitionist and fraud, with a personality inseparable from his art, Salvador Dali has succeeded in his own self-centred aim: 'I am perfectly happy to be considered a bad painter so long as everybody proclaims that I am an extraordinary individual'. A mediocre painter, as he himself has said, if compared with Rembrandt, yet perhaps the best of all contemporary painters. Dali fascinates, provokes, scandalizes, defies. The subject of this painting is a case in point.

The year 1931 marked the beginning of Dali's 'great era', when he was associated with the surrealist group. The revolutionary climate of this movement and the traditional manner of its painting suited Dali very well. But instead of allowing free reign to his imagination he transcribed the spontaneous dream images into his conscious mind, incorporating deliberate and often wilfully absurd interpretations.

Here Dali displays the Russian revolutionary leader equivocally to say the least. Lenin, shown at the piano, resembles a zombie more than a human being. The repetition of the cherry motif, and their violent red colour, contrasts strongly with the funereal atmosphere of the piano-coffin and the music-stand swarming with ants. The artist obliges Lenin to endorse some far from amusing dream images. Is it a way of insinuating that both social revolution and the surrealist revolt lack dynamism and are even perhaps death-oriented?

The provocative and derisive manner in which Dali continued steadfastly to treat his pictorial subjects was by no means appreciated by the surrealists, with whom he soon broke. He has since adopted a wholly opposite political stance. *(C. S.)*

63 RENÉ MAGRITTE (1898–1967)
Double secret 1927
Oil on canvas, 114 × 162 (45 × 64)
Purchase of the Centre Georges Pompidou, 1980

The surrealistic dream images of René Magritte are very different from those of Dali, frequently presenting perfectly humdrum objects juxtaposed in a startlingly unexpected manner, diverted from their normal function or shifted from their natural domain. Loaves of bread take wing, trains steam into fireplaces, horses gallop along the roofs of taxis, and so on. The picture representing a pipe carries the inscription 'This is not a pipe'. No doubt Magritte is seeking to suggest the poetic power of even the plainest and most humble objects. In this sense Magritte's work is the concern of the poet

and the philosopher as much as the art historian: all the more so because, during the period between 1926 and 1929 especially, Magritte went out of his way to give a 'badly painted' look to his pictures.

The subject of *Double secret* is uncanny: the portrait has mysteriously split in two, one portion gaping open to reveal the interior of the head and upper torso filled with small bells. Bells frequently recur in his work, an obsession inspired apparently by the memory of the horses which used to trot through Brussels, with a tinkling bell at their neck. The theme of the double image, of 'man and his shadow', is one of the most seminal in Magritte's repertory, and one to which he returned regularly. *(C. S.)*

64 JULIO GONZALEZ (1876–1942)
The angel 1933
Iron, 163 × 46 × 32 (64 × 18 × 12½)
Purchase of the Musées Nationaux, 1952

Julio Gonzalez belonged to a Catalan family of goldsmiths and was trained in metalworking by his father and grandfather. He at first created jewellery, and only then began on painting and graphic art. In 1900 the family moved to Paris where Gonzalez, through his old friend Pablo Picasso, met the leaders of the Parisian avant-garde. Stricken by the sudden death of his brother Joan in 1908, he gave up painting altogether. After a period of withdrawal from all artistic activities, he began experimenting with metal, especially masks. But it was not until 1927 that with the encouragement of Brancusi and Gargallo he found his true vocation as a sculptor, producing his first constructions in welded iron. In the early 1930s he allowed his imagination to develop abstractly: the metal is deployed lightly and boldly, and the tapering forms have affinities with Giacometti's surrealist sculptures. But Gonzalez was never truly an abstract sculptor and later became more naturalistic in manner.

The original title given by the artist to this sculpture was *The insect*. It was Picasso who rechristened it *The angel*. *(C. L.)*

65 ALBERTO GIACOMETTI (1901–66)
Sharp point in the eye 1931
Wood and iron, 12 × 58 × 29 (4¾ × 33 × 11½)
Purchase of the Centre Georges Pompidou, 1981

Giacometti went to live in Paris in 1922. He attended Antoine Bourdelle's sculpture classes for five years, an experience he found not particularly profitable. After some cubist experiments which left him dissatisfied, he made contact with the surrealist group in 1929. He broke with them in 1935, and for the first time worked from nature. The sculpture of his surrealist period consisted of strange, imaginary structures that were often haunted by erotic fantasies. *Sharp point in the eye*, originally called *Disintegrating relationship*, certainly seems to contain allusions to sexual cruelty. Using very simple means, perhaps inspired by African sculpture (which he greatly admired), and playing on little more than space itself, Giacometti succeeds in creating almost unbearable feelings of tension and anguish. *(C. Sc.)*

66 BALTHUS (Balthazar Klossowski de Rola) (b. 1908)
Cathy at her dressing table 1933
Oil on canvas, 194 × 150 (52½ × 59)
Purchase of the Centre Georges Pompidou, 1977

At the height of the popularity of surrealist and abstract art, Balthus chose to learn painting by copying Poussin and Piero della Francesca. Like Giacometti at the same period, he proceeded from reality, but only in order

to transform it into what Cézanne called a 'harmony parallel to nature', governed by a strict architecture of forms, space and light. Balthus limited himself to the simplest subjects, the ones he knew and loved – portraits, nudes, landscapes – but always conferred on them a kind of mysterious grandeur which is unique to his work.

Cathy at her dressing table is one of his first paintings, and one of the very few that does not spring from this special sort of reality: its theme is derived from Emily Brontë's *Wuthering Heights*, which he had previously illustrated with drawings. Already his work reveals an obsession with the paradisal innocence of childhood and adolescence, a theme which underlies his entire oeuvre. The construction and execution of the painting are classic. But the slightly stylized attitudes of the figures, and the contrasts between black and white (the old woman with her starkly outlined profile, the naked girl with her vacant gaze) suggest a suppressed violence and an ambiguity that are quite alien to classicism. (*C. Sc.*)

67 HANS BELLMER (1902–73)
The doll 1934–37
Painted wood, with assorted materials, 61 × 170 × 51 (24 × 67 × 20)
Gift of the artist, 1972

Bellmer has never been able to forget the world of his childhood: a severe father, a gentle, rather childlike mother, and a big house filled with little girls and toys – 'those multipliers of images'. His whole work constitutes a pursuit of these early phantoms of his imagination. In 1934 he decided to 'construct an artificial girl with anatomical possibilities capable of "rephysiologizing" the vestiges of passion to a point of inventing new desires'. The doll is articulated around a system of balls, so that the head, trunk and limbs can be adjusted to form limitless relationships. Bellmer manipulated his doll into twelve different positions, photographed these, and published the photographs in 1934 in a small book *Die Puppe* (The doll). The surrealists, with whom Bellmer was in touch while living in Paris during 1934–35, hailed these erotic permutations.

In 1938 Bellmer left Berlin to settle in Paris, where he led a retiring existence, unceasingly creating drawings and engravings and photographic studies that continued to discover new possibilities for 'the anatomy of desire'. The delicate precision of his graphic work partly reflects his early training as an industrial draftsman (Berlin Technical School of Art, 1923–24). (*C. Sc.*)

68 HENRI MATISSE (1869–1954)
Decorative figure against ornamental background 1925–26
Oil on canvas, 130 × 98 (51½ × 38½)
Purchase of the State, 1938

Matisse often integrated sculptures into the painted space of his pictures. Henriette, his usual model, posed for this sculpture in Nice during 1924–25. The plaster, placed against a background of floral wallpaper, the carpet and the Venetian mirror constitute between them the calculated setting of the picture. Matisse is concerned here with the relationship between a figure 'in relief' and a flat background.

The stiffness of the human figure contrasts with the profusion of the most decorative environment imaginable. The geometrization of the figure (the untraditional rectangle of body and neck, the oval of the face, the curves of breasts and belly) produces an almost idol-like image. Indeed, the design of this thoroughly non-academic nude shows just how far Matisse had gone in abandoning his previous harmonious manner. In Matisse's oeuvre, this painting marks the end of the delectable cycle of Nice interiors and the return to a certain simplification which recalls the work executed between 1914 and 1917. (*C. S.*)

69 PABLO PICASSO (1881–1973)
Confidences 1934
Oil, collage and gouache on canvas, 194 × 170 (76½ × 67)
Gift of Mme Marie Cuttoli, 1963

Confidences is a tapestry cartoon commissioned by Marie Cuttoli, that was woven the same year by Aubusson. Mme Cuttoli played an essential role during the 1930s in the renewal of the art of tapestry-work, commissioning designs from many distinguished artists such as Braque, Léger, Rouault, Matisse, Miró and, of course, Picasso himself.

Picasso was marking a pause in his painting, having recently devoted all his energies to sculpture and engraving (the amazing sequence of 'Minotauromachies'). The technique of *Confidences* is composite: oil, collage and gouache. But these two women kneeling face to face already proclaim the direction of the work that he was to produce in 1935, the year of his exhibition of collages at the Galerie Pierre organized by Tristan Tzara. (*C. L.*)

70 HENRI MATISSE (1869–1954)
The dream 1935
Oil on canvas, 81 × 65 (32 × 25½)
Purchase of the Centre Georges Pompidou, 1979

In this painting Matisse is pursuing his 'art of enjoyment'. Just as *Le luxe* (Plate 10) conveyed an impression of idleness, so here *The dream* takes up the theme of repose. A woman informally posed asleep on a table is represented in a harmony of colours that contain echoes of happiness ('rosy prospects', 'blue skies'). The arabesque design enhances the sense of nonchalance.

Using a single model, Matisse proceeds through progressive stages of simplification. His own comment is crucial: 'My models, human figures, are never merely minor actors within an interior. They are the principal theme of all my work . . . When I start working with a new model, it is the spontaneity of her attitude when relaxing that allows me to guess at the pose which will be appropriate to her and which will hold me in its thrall.' Matisse pursued this aim from 1930, the date of his 'escapes' to Tahiti and the United States which culminated in the gigantic mural *The dance* executed for Dr Alfred C. Barnes at Merion. (*C. S.*)

71 KASIMIR MALEVICH (1878–1935)
Man running 1933–34
Oil on canvas, 79 × 65 (31 × 25½)
Anonymous gift, 1978

Malevich here represents a running man, his hair and beard flying in the wind. There is no attempt to express volume, and the colours used are simple and applied in flat-wash. *Man running* is an example of the new style practised by Malevich after a long artistic hiatus. The suprematist period had long since ended with his abandonment of painting in favour of architectural researches. The appearance of this human figure marks Malevich's return to traditional values in art, and no doubt also symbolized his deep disappointment with the course of events in Russia since the 1917 revolution.

In any case, this work provides evidence of the rich variety of Malevich's art. First, the idealistic experiments in absolute abstraction embodied by his theory of suprematism. Next, the transition to a realization of the concrete, which obliged him to come to grips with the realities of architecture. Finally, the total self-renewal in which he offers us figurative images of a freshness that only a still-youthful spirit could evoke. (*C. S.*)

72 HANS HARTUNG (b. 1904)
T 1935 – 1 1935
Oil on canvas, 142 × 186 (56 × 73)
Purchase of the Centre Georges Pompidou, 1976

Hans Hartung began painting in the abstract style in 1922 while still studying art at the academies of Dresden and Leipzig. His discovery at this time of the blot ('tache', hence 'tachisme') as a new plastic element provided the basis, later, for his 'informal' compositions which made such an original contribution to the evolution of contemporary dynamic painting. The researches he pursued during these years (the period when the Bauhaus was flourishing in Weimar) achieved expression in a series of watercolours and drawings, culminating in this large and splendid composition. Here the freedom and rhythm of the signs, the freshness and sense of lightness, demonstrate Hartung's independence at a moment when geometric abstraction was in the ascendancy. Nevertheless, this pioneer of lyrical abstraction long remained unappreciated in the various circles of abstract artists in Paris, where Hartung had settled in 1935 after leaving Germany for good. (The anti-Nazi feelings were to cause further difficulties during the war for this dissident German in Nazi-occupied France.) However, he retained the loyal support of a few admirers, and continued to express himself in the luminous 'handwriting' he had developed partly during 1932–33, in the clear bright light of Minorca.

With this composition, and the series of paintings executed between 1934 and 1938 entitled *Ink blots*, Hartung reveals himself truly as 'the poet of space and the musician of line'. *(C. S.)*

73 ALBERTO MAGNELLI (1888–1971)
Oceanic round 1937
Oil on canvas, 114 × 146 (45 × 57½)
Purchase of the State, 1950

Fleeing from the academism of fascist art, Magnelli settled in Paris in 1933. In his Kandinsky-like *Explosions* he had already worked out strictly geometric abstract forms. It is this same repertoire that he presents in this later painting, but using a more sober palette of umber browns and whites, colours which derive directly from cubism and present a complete contrast to the bright pure colours of his early work such as the 1914 *Workmen in the cart* (Plate 30). *Oceanic round* appears as a well-ordered construction, with its flat-toned forms that overlap each other and are sheltered mostly within segments of a large circle. The whole atmosphere is that of a dynamic universe, a world of objects 'as sharp as steel'.

Magnelli had his first one-man show in New York in 1937 (Nierendorf Gallery). But it was not until 1947, when he began to show at the Galerie René Drouin in Paris that he became at all well known. The 1950 Venice Biennale confirmed the importance of this artist of intransigent independence who remained faithful throughout his life to his concept of abstract painting. *(C. S.)*

74 JOAN MIRÓ (b. 1893)
Object of sunset 1937
Painted wood, metal, string, 68 × 44 × 26 (27 × 17½ × 10¼)
Purchase of the Centre Georges Pompidou, 1975

From the mid-1920s Miró had been actively associated with the surrealists. After contributing to the 1926 surrealist exhibition in Paris, he began producing his dream-like linear compositions. Some two years later, he changed even more radically from his earlier styles to what has since been called 'anti-painting': making use, with marvellous inventiveness, of all manner of objects and materials, pebbles, lengths of string, scraps of iron, anything that seized his fancy. The results are convincing evidence that art has more to do with play and pleasure than with theories. He explores the

third dimension too: in this *Object of sunset* Miró has taken a section of tree trunk (a carob, typical of his native Catalonia), has painted a blue eye on the protruding stump on one side, and on the other side a sort of black protozoon (often, in his work, a symbol of the female sex), the whole thing capped by a bedspring and other frivolous objects. According to the artist, the construction presents a visual parody of a married couple.

This assemblage was originally bought by André Breton. It is a fine example of those 'objects with a symbolic function' that the surrealist leader loved to collect. *(C. Sc.)*

75 ANDRÉ MASSON (b. 1896)
The labyrinth 1938
Oil on canvas, 120 × 61 (47 × 24)
Gift of M. and Mme Goulandris, 1982

Although Masson experimented with many styles and techniques, including automatic drawing in 1923, he always remained true to what he himself termed his need for 'expressive paroxysm', the better to reveal what lies 'at the roots of the human being: hunger, love, violence'. Masson's cultured mind has always concerned itself as much with philosophy as with art, so mythology has been of great importance to him. The labyrinth, in particular, is a theme he returns to throughout his work, with the figures of Theseus, the Minotaur, Pasiphae.

This monster seems to have emerged from subterranean depths, rearing up in all his hallucinatory presence, greater than sky and sea, sums up all Masson's preoccupations and questionings. Animal, vegetable and mineral intermingle in whirling spirals to compose this hybrid being, an image of those endless metamorphoses and that 'demon of doubt' which obsess him. A premonition of the approaching war? *(C. Sc.)*

76 JULIO GONZALEZ (1876–1942)
Mask of Montserrat shouting c. 1935–36
Iron, 23 × 15 × 12 (9 × 6 × 5)
Gift of Mlle Roberta Gonzalez, 1964

Montserrat is the rocky massif dominating Barcelona. It is also the name of the Virgin patron of Catalonia whose effigy is kept in a Benedictine monastery. From 1936 until his death, *La Montserrat* provided Gonzalez with his favourite theme. Symbol of the republican struggle in the Spanish civil war, the huge realistic statue was displayed in the Spanish pavilion of the 1937 international exhibition beside Picasso's *Guernica*. This shouting *Mask* translates eloquently the cry of agony and all the passion of the Catalan peasants engaged in the fight against fascism. The work forms part of the remarkable donation made to the museum in 1964 by the artist's daughter Roberta, comprising objects, paintings, sculptures and drawings which together retrace Gonzalez's whole artistic career. *(C. L.)*

77 HENRI LAURENS (1885–1954)
The great musician 1938
Bronze, 195 × 110 × 85 (77 × 43 × 33½)
Purchase of the State, 1952

'Sculpture is essentially the taking possession of a space, the construction of an object by means of hollows and volumes, fullnesses and deficiencies, their alternations, their contrasts, their constant reciprocal tension, in short, their equilibrium.' This definition by Henri Laurens applies well to his monumental work *The great musician*, in which precisely such a play of solids and voids predominates, and the tension of the elongated forms accentuates the effect of movement.

The human figure, more especially the female figure, constitutes Laurens' preferred subject from 1930 onwards. His style may be compared with that

of his friend Maillol, his contemporary Duchamp-Villon and, later, that of Henry Moore. The nobility of bronze is ideally suited to these large-scale compositions of the 1930s. In 1939, however, he abandoned it in favour of marble.

Thanks to the donation in 1967 by the sculptor's heirs, the museum today possesses a magnificent range of Laurens' work. (C. L.)

78 JEAN HÉLION (b. 1904)
Against the stream 1947
Oil on canvas, 113 × 146 (44½ × 57½)
Purchase of the Centre Georges Pompidou, 1975

In his artistic progression, Jean Hélion cuts a slightly eccentric figure. While most artists, at the end of the Second World War, were discovering abstraction, Hélion was abandoning the geometric forms of the 1930s in order to tackle figurative painting and, in particular, the human figure.

After meeting van Doesburg in 1930, who led him to abstract painting, and his subsequent participation in the Art Concret group and then the Abstraction-Création group, Hélion was by 1939 evolving gradually towards realism with his series of schematic men's heads. The 1947 *Against the stream* represents a sort of manifesto for Hélion: he depicts himself standing between one of his abstract paintings displayed on an easel in a window, and a naked woman lying head downwards – symbols of life and of his return to figuration. From then on, Hélion would, like his friend Léger, derive his themes from everyday life. (C. L.)

79 FERNAND LÉGER (1881–1955)
Acrobats in grey 1942–44
Oil on canvas, 183 × 147 (72 × 58)
Purchase of the Centre Georges Pompidou, 1981

After several journeys to the United States during the 1930s, Léger made his home there between 1940 and 1945. It was there that he painted this picture, contemporary with, and very close in style to, the famous series of *Divers*. Léger had always enjoyed circuses and fairs, themes to which he returned several times in his painting. *Acrobats in grey* reveals an extraordinary intensity, power and monumentality, deriving from the close-up effect and the restrained range of colours. The limbs are so entangled that it is sometimes quite difficult to make out which arm or leg belongs to whom. This confusion is deliberate, of course, as is the effect of compression achieved by the sinuous but precise outline enclosing the acrobats. (C. L.)

80 PIERRE BONNARD (1867–1947)
Studio with mimosa 1939–45
Oil on canvas, 127 × 127 (50 × 50)
Purchase of the State, 1978

Begun in 1939, this painting shows the little studio at Le Cannet, with its view through the window on to the heights of Cannes, where Bonnard settled at the beginning of the war. Despite the tragic nature of the time when it was painted, the vision in this painting is luminous, flooded with shades of yellow and orange. Bonnard completed *Studio with mimosa* some years later. The painting represents the outcome of his investigations into the play of equilibrium between infinite nuances of cold and warm tones on the one hand and, on the other, the very elaborate structure of verticals counterbalanced by obliques which indicate depth. The few familiar 'objects' represented, such as the female figure (his companion Marthe, who died in 1942) give the picture a touch of intimacy and gentleness. Bonnard's aim is to 'show what one sees on suddenly bursting into a room'. The mimosa, represented by the vibrating yellow strokes which seem to invade the whole surface of the picture, fulfils his desire to 'render light, forms and human figures with nothing but colour'.

To the end of his days, Bonnard sought to express this sense of intimacy, this love of detail, this richness of tone. None of the many beautiful works by Bonnard in the museum's collection convey these qualities more vividly than this most recent acquisition. (C. S.)

81 CONSTANTIN BRANCUSI's studio

This is no sun-drenched studio such as Bonnard's painting opposite, but the real studio in which Brancusi once lived and worked, transported intact to the piazza of the Pompidou Centre. In 1956, one year before he died, Brancusi bequeathed to the French state the total contents of his studio in the Impasse Ronsin (15th arrondissement), where he had gone to live in 1904, and where he remained for fifty-three years, creating the major part of his work.

In addition to the furniture and fittings carved by Brancusi (door, stools, plinths), the studio presents an almost complete panorama of his work since its beginnings, thanks to the many plaster models that replaced the original marble, stone or bronze sculptures as soon as they had been disposed of by the sculptor. We may thus follow Brancusi's progress step by step, from the simplified volumes of the *Sleeping muse* (Plate 13), *Mlle Pogany*, *Bird in space*, *Fish*, *Seal*, *Large cocks*, to the later, more monumental works which punctuate the studio's space: the *Temple of love* and the *Temple of deliverance* (project for a temple in India), the themes of the *Kiss* and the *Endless column*.

This painstaking reconstruction provides fascinating evidence of Brancusi's determination not to isolate his work from his chosen environment: his studio, a world created solely by himself, in which everything is made or marked by his hand, from the great fireplace to the most modest and functional object. (C. S.)

82 WIFREDO LAM (1902–82)
Light in the forest (or The big jungle) 1942
Gouache on glued paper on canvas, 192 × 123 (75½ × 48½)
Purchase of the State, 1947

In 1924 Lam left his native Cuba for Spain, where he remained until his departure for Paris in 1938. He became a close friend of Picasso, who introduced him to the surrealists and even arranged his first exhibition in Paris (Galerie Pierre Loeb). The war scattered people in all directions, and Lam returned to Cuba after an absence of nearly twenty years. Thereafter, whether he was living in France, Italy or elsewhere, he never forgot his homeland, where man is at one with nature, where legs mingle with sugar-cane stalks, breasts with fruits, and where masked demons hide behind the palm trees, as in this gouache, a preliminary study for the huge painting *The jungle* which was received with mixed feelings when it was first shown in New York in 1943. However, this violence is never anarchic; it is always contained within a strict formal discipline in which lines predominate over colour and organize themselves into huge strict rhythms. For even primitive nature has its laws, and Lam is initiated into all their mysterious powers. (C. Sc.)

83 VICTOR BRAUNER (1903–66)
Composition on the theme of 'The Palladist' 1943
Oil on canvas, 130 × 162 (51 × 64)
Purchase of the Musées Nationaux, 1974

In 1924, in Romania, Victor Brauner had already invented the term 'pictopoetry' to describe the kind of painting for which he was aiming. On arriving in Paris in 1932 he joined forces with the surrealists, sharing their fascination with symbolism and the occult. He announced that all his work would be an 'appeal-homage to ancestral sources'. One such source was eroticism. In this painting, with its enigmatic title, Brauner seems to

investigate, yet again, this mystery of the woman in whom he sees the 'great initiator'. But the woman, whether appearing facing forward or in profile, remains silent, and the question continues to pose itself, terrifyingly, on this deserted stage, in front of this dark forest. The tightly gripped handle-weapon; the wriggling snakes are powerless. One might equally well read into this painting the theme of the double which would continue to haunt Brauner all his life: the wide open legs and the faintly sketched image of the fish inside the man's head are both apparitions of this double. (C. Sc.)

84 JEAN DUBUFFET (b. 1901)
Happy land 1944
Oil on canvas, 130 × 89 (51 × 35)
Purchase of the Centre Georges Pompidou, 1980

Dubuffet's first exhibition of forty paintings at the Galerie René Drouin in 1944 excited some viewers and profoundly shocked others. Although as a young man he had done a certain amount of painting and drawing, it was only at the age of forty-one that he really decided to become a painter – and straightaway created a new way of seeing, thinking, feeling. He rejected all established cultural values in favour of what he called *l'art brut* ('raw art'), which for him included the art of the insane, whose inner logic fascinated him. Similarly, he avoided the great traditional themes of painting, preferring the banal spectacle of everyday life, the Paris métro, for example, or, as in this picture *Happy land*, simple country folk in their fields, cows, a cyclist, the roof of a house. Perspective may be repudiated, scale non-existent and drawing rudimentary, but this is quite deliberate: it is a question of trying to recapture that world of childhood in which things had not yet become mental images but remained primarily sensations, impressions and emotions.
(C. Sc.)

85 NICOLAS DE STAËL (1914–55)
The hard life 1946
Oil on canvas, 142 × 161 (56 × 63½)
Purchase of the Centre Georges Pompidou, 1980

The title of this painting reflects the artist's own difficulties during the year of its creation, his poverty and the illness and death of his first wife. Even so, 1946 marks the true beginning of his artistic career. De Staël was a friend and admirer of Braque, and had come to abstract painting partly through the influence of his friends Domela and Magnelli, whom he first met during the war. The compositions which de Staël produced in 1946 feature heavily worked surfaces of varied texture. They are dominated by a sense of tension and violence, evoked by the confusion of broken, mutually hostile strokes in an undefined space, and by the use of sombre colours. Of the works of this period, Gindertael remarked: 'The flashes, the cracks, the fractures, the streaming or meandering fluid all trace the nervous handwriting of a great symphonic poem whose component pattern is discord and disharmony and whose theme is the fickleness and harshness of life.'

The colours in de Staël's paintings did gradually become brighter, and from 1950 his work began to evolve towards figuration. Yet the anguish remained and finally drove him to suicide. (C. L.)

86 JEAN DUBUFFET (b. 1901)
Metafisyx 1950
Oil on canvas, 116 × 89 (45½ × 35)
Purchase of the Centre Georges Pompidou, 1976

Although Dubuffet's work consciously explores unknown territory, his artistic aims have always been perfectly coherent, as is shown by his many erudite and witty writings on the subject. He has, in particular, written frequently about pictorial technique, because 'man's thought moves, and takes shape, it becomes sand, oil . . . it becomes spatula, scraper'. This anti-aestheticism, almost an existentialism of matter, reaches its paroxysm in the series of

Women's bodies (of which *Metafisyx* forms a part), all the more violently because the nude is pre-eminently the classic subject in painting. The bodies are presented frontally, limbs spread wide, struggling through an opaque matter, their features bloated, lacerated, roughly handled, sex organs emphasized in comparison with tiny grimacing heads. But this aggressiveness is by no means devoid of the humour which, as always with this artist, attacks above all man's humanistic and anthropocentric ideas about himself. (C. Sc.)

87 JEAN FAUTRIER (1898–1964)
The tender woman 1946
Oil, pastel and ink on canvas-backed paper, 97 × 146 (38 × 57½)
Purchase of the Centre Georges Pompidou, 1981

Fautrier started his career with a thoroughly traditional training at London's Royal Academy where he was admitted at the age of fourteen. His first exhibition in Paris in 1927 (Paris, Galerie Bernheim), with his black nudes, flayed rabbits and monstrous fruits, revealed a profoundly original talent that was on the periphery of the artistic fashions of the time. Although this was a great success, Fautrier two years later abandoned sculpture as well as figuration and oil painting itself which, he declared, 'disgusted' him. From then on he produced nothing but small, totally abstract compositions in pastel and ink on paper.

It was during the war that Fautrier found his definitive manner and technique, with the celebrated series of *Hostages* which André Malraux called 'pathetic ideograms', and which made him one of the precursors of so-called 'informal' painting. The new technique involved laying down a preliminary sketch covered with layer upon layer of oily impasto kneaded with the fingers, then a light sprinkling of soft-toned pastels, and finally a few strokes of an ink-charged brush to awaken this undefined mass and give it a semblance of form. (C. Sc.)

88 WOLS (Alfred Otto Wolfgang Schulze) (1913–51)
The butterfly wing 1947
Oil on canvas, 55 × 46 (21½ × 18)
Gift of René de Montaigu, 1979

Something of a vagabond all his life, Wols lived peacefully with his wife Grety, his dog, his bottle of wine or brandy, his banjo, and the scraps of paper on which he transcribed his miniature dreams with a little ink and watercolour. He preferred the country to the town, and lived successively in Ibiza, Cassis and the little village of Dieulefit in the Drôme. He had all the time in the world to scrutinize 'the stones, the fish, the rocks, the salt pans, the sea, and the butterflies – who are content with being beautiful for a single day'.

In 1945, however, Wols was introduced to the dealer Renée Drouin, who helped him to settle in Paris and provided him with canvases and paints. During the course of the two following years Wols painted forty pictures which Drouin exhibited in 1947, in which the paint explodes in blots, streaks and splashes. After these paintings, declared the painter Mathieu, 'we shall have to go back again, right to the beginning'. They are born of a movement, a gesture and a matter which constitute a challenge to all accepted rules.
(C. Sc.)

89 GERMAINE RICHIER (1904–59)
The she-hurricane 1948–49
Bronze, 179 × 67 × 50 (70½ × 26½ × 19½)
Purchase of the State, 1957

Although she attended the sculpture classes of Léon Bourdelle, Germaine Richier very soon developed a totally independent manner. At first she sculpted animals. She always felt close to nature, and was most ingenious in

transforming it, creating in particular an energy, a power and an impetus which were to lead her to astonishing developments. Her personages are alternately strangely skinny and bloated, in an almost baroque manner. As the poet-essayist René Solier (who was her husband) has remarked, Germaine Richier's thought-process is hybrid, creating other hybrids: bird-men, forest-men, night-men, occasionally veritable cosmic monsters. This female hurricane proclaims a dominating presence that is almost super-human. Possessed by a secret vision, she appears transfixed or hypnotized, conveying a strong impression of fear and anxiety. (C. L.)

90 MARIA ELENA VIEIRA DA SILVA (b. 1908)
The library 1949
Oil on canvas, 114 × 147 (45 × 58)
Purchase of the State, 1951

Arriving in Paris in 1928 from her native Portugal, Vieira da Silva attended the sculpture classes of Léon Bourdelle and Charles Despiau, but a year later gave up sculpture for painting and engraving. Together with her husband, the Hungarian painter Arpad Szenes, she returned frequently to Portugal in search of solitude. They spent the war years in Brazil, returning to France in 1947. Since that year she has exhibited her work regularly in Paris (Galerie Jeanne Bucher).

Her paintings are meditations on space, suffused with poetry and reverie. Devoted to music and literature, she has always been fond of the theme of the library, in which books detach themselves from shelves like Byzantine or Roman mosaics, invading space. Vieira da Silva weaves her labyrinth meticulously, but without being too sure at first where the threads are leading. 'In this work', wrote the poet René Char, 'we are no longer submissive and passive, we are at grips with our own mystery'. There are no 'series' or 'periods' in Vieira da Silva's work. Her free spirit soars beyond such categories. (C. L.)

91 ALBERTO GIACOMETTI (1901–66)
Seated woman 1956
Bronze, 77 × 14 × 19 (30 × 5½ × 7½)
Gift of Aimé Maeght, 1977

From the moment in 1935 when he resumed his investigation of nature, Giacometti remained obsessed by the problem of how we perceive a figure in space. What the eye sees depends on the distance, and whatever the space between eye and object, we still see imperfectly. This doubt, this impossibility of seeing man as a single whole, troubles Giacometti in all his sculpture. Perhaps by lightening the body's substance, by paring it down to its skeletal structure, by stretching it out thin, or shrinking it to the size of a pinhead, the sculptor may succeed in extracting the hidden soul and breath.

It is this struggle with reality, this simultaneous strength and fragility of life, that finds expression here, in this seated woman, so tiny in the surrounding space, and yet as solid and majestic as an ancient idol from the Cyclades.
(C. Sc.)

92 ALBERTO GIACOMETTI (1901–66)
Portrait of Jean Genet 1955
Oil on canvas, 73 × 60 (29 × 23½)
Purchase of the Centre Georges Pompidou, 1980

Giacometti worked on portraits all his life – of his mother, his brother Diego, his wife Annette. He made his subjects pose endlessly in his Montparnasse studio, where he lived for forty years. Throughout his life he followed the maxim of Ingres: 'Drawing is the probity of art'. His drawings are those of a sculptor – he constantly remodels, never trusts mere appearances, con-

stantly reworks, tears up and begins again. Genet describes the making of this portrait in a moving passage of *The Studio of Alberto Giacometti*. The picture shows him imprisoned in the frame, on a grey background whose neutrality is barely lit by occasional brush-strokes. He is posed as a crouching scribe, echoing a theme of Egyptian sculpture much admired by the artist. The focal point of the picture is the head – pivot of the picture – and especially the look in the eyes, 'which distinguishes the living from the dead', as Giacometti reported. (C. Sc.)

93 FRANCIS BACON (b. 1909)
Van Gogh in landscape 1957
Oil on canvas, 152 × 119 (60 × 47)
Purchase of the Centre Georges Pompidou, 1981

Bacon has never been interested in abstract art. In his view it offers a merely aesthetic effect, whereas for him – as he remarked in one of his discussions with David Sylvester – 'art is a lifetime obsession'. His paintings concentrate on a few great themes – the crucifixion, the nude, the portrait, the self-portrait – with the human figure always a central element. But how to paint these great subjects, already treated so often, without being illustrative? How to 'touch the nervous system'? This is the problem which confronts Bacon's painting, as it confronts all representational painting today. And Bacon's answer is similar to Giacometti's: by investing confidence solely in what he sees and what he feels. Bacon's method is to establish new relationships between his figures and surrounding space, to invent perspectives and foreshortenings, to force the movement of his bodies so as to give them the greatest possible tension. Finally, and most importantly, Bacon gives free play to the chance elements in painting, to the very texture of the painting, as no other artist has done since Van Gogh. This may well be why Bacon has always taken such an interest in Van Gogh, frequently rereading the famous letters, and completing no less than eight portraits of the Dutch painter walking, with his wild gaze, along the Tarascon road.

This painting forms part of a series of researches which Bacon was undertaking, during these years, into the relationship between man and landscape, a series which he eventually abandoned. (C. Sc.)

94 AUGUSTE HERBIN (1882–1960)
Friday – I 1951
Oil on canvas, 96 × 129 (38 × 51)
Purchase of the Centre Georges Pompidou, 1976

One of the French pioneers of geometric abstraction, Herbin remained faithful to his concept of the intimate relationship between the vitality of form and colour. According to this artist-theoretician's edict: 'The whole action of painting derives from the relationship between colours, the relationship between forms, and the relationships between colours and forms.' Herbin was a founder, along with van Doesburg, Hélion, Delaunay and others in 1931, of the Abstraction-Création group. Thereafter, he never wavered in his advocacy of non-objective art, and according a fundamental role to colour. In 1949 he published an essay that summarized all his researches and theories, *L'art non-figuratif non-objectif*. This painting applies these theories: precise arrangement of geometric forms such as the circle, the triangle and the square to achieve a perfect balance. (C. L.)

95 JEAN DEWASNE (b. 1921)
Tomb of Anton Webern 1952
Industrial paint on sheet iron, 151 × 23 × 92 (59¼ × 9 × 36)
Purchase of the State, 1974

After the war, Jean Dewasne, like most Parisian artists, supported abstraction. In 1945 he became a founder-member (along with Arp, Pevsner,

Sonia Delaunay and others) of the Salon des Réalités Nouvelles, devoted entirely to abstract art. In 1950 he founded the Atelier de l'art abstrait for which he gave several lecture courses.

Dewasne has been particularly attracted by the art of mural painting, and his own work is often on a very large scale and horizontal. His compositions are clear and simple, featuring pure, intense, brilliant colours, and creating a play of contrasting forms. For the *Tomb of Anton Webern* (the Austrian composer who died in 1945) on the other hand, Dewasne chose to construct one of his 'Antisculptures', in which he takes parts of automobile bodies or other industrial products and erects them as freestanding objects, painting them in patterns that sweep over, around and through the functional hollows, protuberances and curves of the surface, providing a kind of camouflage effect.
(C. L.)

96 JESUS-RAFAEL SOTO (b. 1923)
Rotation 1952
Oil on plywood, 100 × 100 × 7 (39½ × 39½ × 3)
Purchase of the Centre Georges Pompidou, 1980

Soon after his arrival in Paris in 1950, Soto was introduced to the abstract artists of the Salon des Réalités Nouvelles. He was an admirer of the work of Mondrian and Malevich, and started to consider adding a dynamic quality to geometric or neo-plastic compositions. *Rotation* is a product of Soto's very first optical researches. His aim: 'By systematically multiplying the same plastic symbol, I depersonalize it to the point of anonymity. I avoid any possibility of subjective intervention'. Here, lines, squares and dots are arranged in a series of circular patterns which appear to change according to the position of the viewer. This element of chance emphasizes the artist's desire to preserve a certain anonymity in his work.

These preliminary experiments led him to the development of his *Vibrations*, in which visual kinetic effects are obtained by the superimposition of a grille (of wires, nylon cords and so on) over a painted panel that is sometimes three-dimensional. The viewer's optical response alters each time he changes his position: art is no longer immobile. In 1954 Soto, together with a number of other practitioners of 'kinetic art', defined the principles of what they called 'cinétisme', and the Galerie Denise René became the forum for their experiments in controlled or illusory movement.
(C. L.)

97 JEAN TINGUELY (b. 1925)
Meta-mechanical-automobile sculpture 1954
Metal plates and coloured wires, 134 × 79 × 56 (53 × 31 × 22)
Purchase of the Centre Georges Pompidou, 1981

While still a child in Basel, Tinguely used to construct wheels with levers attached, which struck jam jars as they moved round. His precocious ingenuity soon led him to study movement through the action of hydraulic wheels.

Tinguely's first mobile constructions were made of moulded wire. He exhibited these in 1954 at the Galerie Arnaud which, like the Galerie Denise René at the same time, welcomed young experimental artists. These so-called 'automatic' sculptures were rebaptized 'meta-mechanical sculptures' by his friend the art critic (and later director of the Pompidou Centre) Pontus Hulten: they are 'reliefs' in which simple geometric forms move slowly in front of a glossy surface.

This particular *meta-mechanical-automobile sculpture* was constructed at the end of 1954, and contains the element of colour which Tinguely was now introducing into his reliefs. It was shown the following year in the exhibition at the Galerie Denise René which launched 'kinetic art'. Alongside Duchamp and Calder, their predecessors, Tinguely, Soto and other young artists (such as Pol Bury and Agam) showed 'assisted' mobiles and visual-optic reliefs of various kinds.
(C. L.)

98 SAM FRANCIS (b. 1923)
Other white 1952
Oil on canvas, 205 × 190 (81 × 75)
Purchase, 1974

Other white is one of the most delicate compositions ever produced by the American painter Sam Francis, and its acquisition by the museum is all the more appropriate in that the artist was inspired to paint it by his discovery of the very special light that reigns over Provence. Francis has lived and worked in France for many years. His work shows the influence not only of the American abstract expressionists but also of Monet and his water-lily ponds. His technique has also been influenced by his interest in Japanese calligraphy, which has taught him to apply his brushstrokes in a particular manner. His painting, above all, is sensitive and lyrical, as *Other white* shows, with its subtle colour values – the blue bleaching into white, the white gradually tingeing into blue, and with its delicacy of touch.
(C. S.)

99 JACKSON POLLOCK (1912–56)
The deep 1953
Oil and lacquer on canvas, 220 × 150 (86½ × 59)
Gift of the Menil Foundation, 1975

Jackson Pollock's 'action painting' developed from a variety of sources. Most important was his meeting with the surrealists in around 1943 (several of whom, including Ernst, Tanguy and André Breton, were refugees in America during the war). Subsequently he applied to his painting the surrealist technique of automatism. Pollock abandoned his paintbrushes, stood over a canvas stretched on the floor and dripped paint (often industrial paint) on to the surface, using a can with a hole drilled in the bottom, or squirting the paint directly from the tube. Moving over the canvas without premeditation or hesitation he produced these characteristic networks and swirls of colour that convey such extraordinary energy. The act of painting becomes as important as the result: the canvas may be viewed as the site on which the artist gives material form to a 'happening'. In Pollock's own words, 'painting is a way of life'.

The deep is one of the final works of his last truly productive year, 1953. It indicates a return to figuration: the dark central fissure in the white layer partly covering the dripped design produces a certain sense of depth that expands the picture's field. This kind of 'inner space' provides a new dimension in the evolving pattern of these great improvised compositions.

Jackson Pollock was certainly the most celebrated of the American abstract expressionist painters, and it is probably true to say that the sheer brilliance and originality of his work was the chief factor in the establishment of New York rather than Paris as the West's artistic centre after the Second World War. From 1950 onwards, he was both successful and famous in the United States, though his ultimate stature has always been the subject of controversy. He died in a car crash at the age of forty-four.
(C. S.)

100 GEORGES MATHIEU (b. 1922)
Capetians everywhere 1954
Oil on canvas, 295 × 600 (116 × 236)
Gift of the Galerie Larcade to the State, 1956

Abstract expressionism (or 'action painting') in the United States and lyrical abstraction in France were the two currents of abstract art to set themselves against the geometric formalism which was so in vogue during the 1940s. Mathieu was one of the theoreticians of lyrical abstraction and the leading publicist of what he called 'art informel', characterized by the display of the 'sign' or 'blot' (*tache*) or any other plastic element resulting from the working of the material or from the gesture. The enormous *Capetians everywhere*

asserts a freedom of gesture in which the whole body is involved. Mathieu, whom André Malraux has called 'the West's first calligrapher', frequently traces his 'writings' by squeezing the pure colour directly from the tube on to a prepared flat monochromatic background, then using the hand or a brush to smear the surface.

Mathieu has listed three preconditions for the act of painting: first, primary importance accorded to speed of execution; second, absence of premeditation of forms and gestures; third, necessity of split-second concentration. Following these precepts, Mathieu has executed enormous paintings in public, such as the twenty-metre-square canvas at the Théâtre Sarah Bernhardt in 1956 which provoked much heated discussion and publicity.

(C. S.)

101 PIERRE SOULAGES (b. 1919)
Painting 1956
Oil on canvas, 195 × 130 (77 × 51)
Purchase of the State, 1956

Soulages is a native of Rodez in the Tarn region of southern France, and he has always retained the deep imprint of two aspects of art in this region: the engraved menhirs (standing stones) and the Romanesque churches, from which he has drawn a sense of gravity, grandeur and power. The work of this artist follows the same general principles of lyrical abstraction as that of Georges Mathieu. Like him, Soulages executes large non-figurative paintings in which the essential feature is the tracing of the sign in space, and he seeks to express the rhythm of movement through a handwriting made up of broad brush strokes that give both strength and strictness to the composition. But this particular *Painting* proposes no tracings or calligraphic signs; the writing has become 'monumental', placing the accent on the vertical and the horizontal.

In his quest for harmony between architecture, matter and volume, Soulages, from 1947 onwards, traced 'flat' signs consisting of broad vertical and horizontal bands in a vertical format. His sombre pallette is based on browns, blacks, blues and greys, but this sobriety of colour is countered by the quality of the paint and its richness, due to the utilization of colourings such as walnut stain, printer's ink and tar. The swaths of thick or fluid paint, crushed on to the canvas with a knife (the brush is no longer used), are juxtaposed in a way that suggests space and rhythm. In these interlaced signs Soulages makes use of transparencies and creates luminous gaps which reflect his attachment to Romanesque architecture. This manner also fulfils the artist's own dictum that 'oil painting is the play between opacities and transparencies'.

(C. S.)

102 CHARLES LAPICQUE (b. 1898)
Portrait of the duc de Nemours 1950
Oil on canvas, 195 × 97 (77 × 38)
Purchase of the State, 1950

Encouraged by the dealer Jeanne Bucher, Charles Lapicque gave up his engineering career in 1928 to devote himself entirely to painting. The frequent visits that Lapicque made to Brittany inspired him to execute a whole series of marine studies, while in 1950 his love of history led him to paint a series of armed figures, among them Henri IV, Attila and the duc de Nemours. Lapicque has always been deeply interested in the scientific researches carried out into the way colours are perceived, and has submitted learned papers on the subject to the Institut d'Optique in Paris. He is, above all, a colourist, with a preference for reds, yellows and oranges. He uses his colours with such freedom that they are usually independent of the contour, and unrelated to the local tone or modelling. His art remains highly individual in its concern to express a reality exalted by colour. (C. L.)

103 ASGER JORN (1914–73)
Lord of the mountain trolls 1959
Oil on canvas, 129 × 80 (51 × 31½)
Purchase of the Centre Georges Pompidou, 1981

The consistent impulse of this restless Danish painter (who divided his time between Paris, Switzerland and Italy) was to preserve his freedom of action. He was not seduced by dogmatic theories of any kind, and was attracted, above all, to art at its experimental stage. When the Belgian painter Christian Dotremont launched a dissident surrealist group, 'le surréalisme révolutionnaire', in 1947, Jorn participated in its brief activities. The following year, Jorn became a co-founder (along with Dotremont, Karel Appel, Corneille and others) of the Paris-based COBRA group. This owed much to Jorn's enterprise during the four years of its existence: its many publications and exhibitions paved the way for a new and highly expressive formal art.

Lord of the trolls belongs to a series of 'modifications' which were first shown in 1959 (Paris, Galerie Rive Gauche). In his introduction, Jorn declared: 'With this exhibition I am erecting a monument in honour of bad painting . . . It is painting as an object of sacrifice'. Choosing landscapes already composed by other artists, Jorn proposed to transform them through the application of a spontaneous inspiration. Here he conjures the image, rising above the mountain, of an enormous figure, a sort of genie who towers above a valley lit by fire.

(C. L.)

104 LUCIO FONTANA (1899–1968)
Space concept 1960
Oil on canvas, 150 × 150 (59 × 59)
Purchase of the State, 1979

During the 1950s, Lucio Fontana's interest in the 'picture' was limited to its function as an element in the environment. In 1947 he had founded the 'spatialist' movement and, in collaboration with a group of architects, proposed a scheme for 'luminous images in motion' that resulted in his 'neon environments' of 1951–53. For Fontana, the picture is a sort of spatial symbol, testifying to the artist's constant reflection upon space: 'the discovery of the cosmos provides a new dimension, which is infinity, so I puncture this canvas which was at the base of all the arts and create an infinite dimension'.

Like the 'tearings' and 'lacerations' in other examples of Fontana's work, the holes of *Space concept* are evidence of a new space created out of the picture's traditional surface. Fontana inscribes a line in a densely painted surface, gouges the tracing, makes the punctures, and the incised line joins the perforations together, delineating an oval, which is the symbol of the cosmic circle. In this way, Fontana achieves a certain balance between a plastic purity of form, a feeling for matter, and the quest for a new space.

(C. S.)

105 YVES KLEIN (1928–62)
Here lies space 1960
Panel covered with gold leaf and assorted materials, 100 × 125 (39½ × 49)
Gift of R. Klein-Moquay, 1974

Yves Klein's quest of the absolute seems very different from that of Fontana. Klein has been labelled 'the monochromist' as a result, in particular, of his absolutely blue compositions – faultless colour fields showing no trace of human intervention. These pictures created something of an uproar when they were first shown, and also gained immediate notoriety for the artist. Klein's pursuit of the infinite started with his discovery of a special blue powder that produced a mysterious and etherial colour, a sort of cosmic reality.

Here lies space, a 'planetary relief', is a kind of symbolic tombstone which testifies to Klein's interest in 'human sentimentality and morbidness'. In 1961 he declared: 'It is only very recently that I have become a sort of gravedigger of art'. In his conquest of the immaterial, of empty space, of the cosmos itself, Klein has been inspired to create paintings with a 'living paintbrush', which is to say, a nude model smeared with blue paint and then pressed against the blank paper; and also to convert into creative tools such natural elements as rain, wind and lightning.

During his spectacular brief career, Klein organized a number of 'events' and 'happenings' which were greeted with partisan feelings of enthusiasm or indignation. His desire to open up the work of art to the world at large, however much his seriousness may have been tinged with farce, provided the first evidence of a new 'conceptual' attitude in art, and the introduction into art of such considerations as behaviour and environment.

In 1960, shortly before his death, Klein became a member of the Nouveaux Réalistes group, promoted by the critic Pierre Restany with a manifesto directed against abstract painting. The group includes Christo, Arman, Tinguely and César. (*C. S.*)

106 BARNETT NEWMAN (1905–70)
Shining forth (to George) 1961
Oil on canvas, 290 × 442 (144 × 168)
Gift of the Scaler Foundation, 1978

Barnett Newman belongs to the generation of American abstract painters more or less influenced by the surrealists, who from 1943 onwards declared themselves abstract expressionists. Newman's work of that period, like that of Jackson Pollock, Arshile Gorky and Mark Rothko, was tinged with both expressionism and surrealism. But in Newman's case the 'subjective' element in painting soon disappeared in favour of a stricter and more simplified approach. *Shining forth*, dedicated to his dead brother George, is a good example of this modified style: the white field is interrupted by three vertical bands which fragment and punctuate the monochromatic pictorial space.

This paring away and simplification by no means indicate a lack of intellectual content. Newman's paintings invariably make implicit reference to a religious mysticism profoundly inspired by the Kabbalah. Dissatisfied with an art based on personal feeling, he proposes 'an art which seeks to penetrate the mystery of the world, which reaches out to the sublime . . . a religious art'. A whole generation of young American painters advocating 'minimal' art are greatly indebted to Newman's work. (*C. S.*)

107 ANTONI TÀPIES (b. 1923)
Large brown triangle 1963
Mixed technique with sand on canvas, 195 × 170 (53 × 67)
Purchase of the State, 1968

Sand has been used as a material by a number of painters in the recent past, including André Masson and Jackson Pollock. Tar, bitumen and asphalt helped to give life to Jean Dubuffet's *hautes pâtes*. But it was only in 1955 that the use of extraneous matter in painting became systematized. The work of the Catalan painter Tàpies provides an example of the consistent use of mixed media.

While Dubuffet and Fautrier were making their individual researches into matter, Tàpies was busy inventing a 'universe of crushed stone'. He executed works with a technique of impastos interrupted by informal signs, achieved by a sort of *grattage* (scraping) inscribed into the thick coatings. These pictures, in which Tàpies integrates all kinds of coarse material such as waste scraps and lengths of string, demonstrate his attachment to his native land, to the sedimentations of old walls, the dust on the ground. The

use of Chinese ink, and the addition of pigments sprinkled over the fresh matter, give the colour an intensity which accentuates the relief. This relatively regular texture is unified by an almost totally monochromatic field untouched by any tonal alteration or illusionistic suggestion, while the plane is divided by a single incised line: the total effect is one of a humanized matter, symbolizing the body and its sufferings. In these compositions, Tàpies aims straight at the primary emotions, and it is this directness which confers a particular importance on his work. (*C. S.*)

108 BERNARD RÉQUICHOT (1929–61)
The forest shrine 1957–58
Agglomerate of oil paint and various elements, 66 × 45 × 28 (26 × 18 × 11)
Purchase of the State, 1968

Bernard Réquichot was a marginal artist whose sense of isolation finally drove him to suicide. His work resembles his life, and shows the same tormented violence. Réquichot wanted to possess everything, he would take even the merest tuft of turf or rock noticed on one of his long walks. He wanted to 'sign' everything, to enclose everything in those boxes and shrines so packed with material that they took years for him to construct. But confronted with this impossibility of saying *everything*, Réquichot's rage for possession was transformed into a rage for destruction. The resulting reliefs are composed of material that has been torn into fragments, rolled up, twisted; the oil paint itself is made a party to this havoc, the intense-coloured impasto invades everything, like an evil vegetable growth, and creates an inextricable space. It would seem that Réquichot, by this total calling into question of composition, of form, of painting material itself, desired to rediscover what one might call the organic sources of creation. (*C. Sc.*)

109 DADO (Miodrag Djuric) (b. 1933)
The slaughter of the innocents 1958–59
Oil on canvas, 194 × 259 (76½ × 102)
Gift of the Scaler Foundation, 1978

Dado, a native of Yugoslavia, arrived in Paris in 1956. Two years later he was working as a technician in a lithographic studio when he was discovered by Jean Dubuffet, who arranged his first exhibition (Paris, Galerie Daniel Cordier). This *Slaughter of the innocents* might stand as the embodiment of all Dado's work, for his paintings resemble a sort of murderous children's game, each one resembles life, and like life the paintings proliferate and destroy themselves. The matter itself cracks, a prey to slow but inexorable decay. These infants have all the illusory appearance of life, each is separately delineated, painted and repainted, and yet their identity vanishes in this confused palpitating mass. Under this implacable lunar light, typical of Dado's pictures (perhaps a distant memory of Montenegro), only the naked flesh retains an identity. There is little difference between the dotard and the infant, between man and animal. These infants can weep and scream, but no one will hear them. Their contortions are merely paltry gestures, and they must inevitably be sucked back into the common grave which this picture finally resembles. (*C. Sc.*)

110 SERGE POLIAKOFF (1900–69)
Composition in red and blue 1965
Oil on canvas, 130 × 162 (51 × 64)
Ceded to the State in settlement of death duties, 1972

Unlike the exponents of geometric abstraction, Poliakoff never stuck to a set of rules in organizing his compositions. Indeed, at first sight his paintings may even seem to lack balance. Poliakoff preferred to follow his intuition

rather than his intellectual processes, and hence invented forms that would appear to reflect the spontaneous, random quality of life. His forms travel in heavy or buoyant masses, carrying their weight of colour and matter. Poliakoff ground his own colours and applied them layer upon layer without ever mixing them beforehand, so as to endow the matter with the vibration which for him was an essential element of painting. Malevich's *Square on white background*, which Poliakoff had been able to admire in the 1952 Paris retrospective, had already provided verification of this central concept: 'Even if there is no colour, a picture in which the matter vibrates remains alive'. Thus, in this *Composition in red and blue* nothing can halt the expansion of that enormous mass of red, except, perhaps, the coldness and lightness of the blue. There we have the whole magic of the painting. (*C. Sc.*)

111 SIMON HANTAÏ (b. 1922)
Without title 1969
Oil on canvas, 275 × 238 (108 × 94)
Gift of the artist, 1974

Of Hungarian origin, Simon Hantaï came to live in Paris in 1954. During the 1960s his work exercised a considerable influence on a whole generation of young French painters. Closely associated with the surrealists during his first years in Paris, Hantaï experimented with the various effects to be achieved by different technical procedures such as *impression* (pressing one surface to another), *couture* (allowing the paint to run freely), *frottage* (rubbing), *pliage* (folding), *collage*. In 1959 he abandoned the expressionist aspect of his painting and began to concentrate on one of the technical processes that he had been investigating, *pliage*. With this method, the canvas is first prepared with a black glaze, followed by a white glaze, then folded and crumpled, and finally colour is applied in flat-wash, resulting in a surface fragmented into painted and unpainted folds.

In this particular untitled painting of 1969, the finished process suggests the forms of white flowers or multiple birds' wings against a blue background. When the canvas is unfolded, the white seems to lift above the colour. The colour's contour is not outlined beforehand, and achieves a new freedom which is reminiscent of the motion and space imparted by Matisse to his *papiers découpés* (collages of cut-out papers). (*C. S.*)

112 ÖYVIND FAHLSTRÖM (1928–76)
The cold war 1963–65
Tempera on steel and plastic, variable diptych, 153 × 244 (60 × 96½)
Purchase of the Centre Georges Pompidou, 1980

Öyvind Fahlström was a Scandinavian of mixed Swedish-Norwegian parentage who spent his youth in Sweden. In 1961 he settled in New York, though in fact he never stopped travelling between Stockholm, Paris, New York and Rome. Fahlström was blessed with a spirit of rare curiosity, and was continually fascinated by everything new. In the mid-1950s he associated with Matta and other artists close to the surrealist movement, and absorbed some of their influences. During the 1960s he joined some of New York's pop artists in organizing a number of 'happenings' and 'sound events'. He also worked in the theatre and wrote plays and poems.

Fahlström's remarkably inventive spirit guided him towards a genuinely personal art. *The cold war* is one of a series of seven panels or phases executed by Fahlström in 1963 which belong to a category of composite pictures called 'variables' or game-paintings. As Fahlström explained, the forms go in pairs and possess 'pendants' following the rules set down for these game-paintings. The elements displayed on each panel of this composition correspond to each other in particular ways. These 'variables' presuppose the presence of an observer, who actively participates in the artistic process by arranging the paired elements in a composite pattern. (*C. L.*)

113 JEAN-PIERRE RAYNAUD (b. 1939)
Psycho-object, 3 pots 3 1961
Assemblage on painted hardboard panel, 185 × 124 × 23 (73 × 49 × 9)
Purchase of the Centre Georges Pompidou, 1981

Jean-Pierre Raynaud was a student of horticulture before he turned to art. His first compositions were assemblages with affinities to the ideas of the Nouveaux Réalistes (such as Yves Klein and Tinguely). In 1963 Raynaud began work on the series of 'psycho-objects' which he exhibited two years later in Paris (Galerie Larcade). The poet-critic Alain Jouffroy has described these works as a 'mental laboratory', and they do, it seems, present a confrontation between a world of outside reality and a world of the mind. The object, in these assemblages, is no longer something obvious and self-contained: Raynaud is calling for a new vision, or rather, a new perception emanating from individual thought processes. (*C. L.*)

114 ARMAN (Fernandez Arman) (b. 1928)
Chopin's Waterloo 1962
Pieces of piano, glued to wooden panel, 186 × 300 × 48 (73 × 118½ × 19)
Purchase of the Centre Georges Pompidou, 1979

Arman was a student at the Ecole des Arts Décoratifs in Paris when in 1946 he first met Yves Klein. The ensuing friendship exposed Arman to new ideas which radically changed his whole artistic outlook. His first assault on traditional values came in 1958, with his series of *Cachets* and *Allures* in which an object is first inked, then dragged across the canvas. Arman's taste for scandal found more open expression in 1960 when he exhibited a series of dustbins in a Paris gallery, an act of bravado that won him instant inclusion in the newly organized group of Nouveaux Réalistes. The *Poubelles* (Dustbins) were the first demonstrations of Arman's unflagging enthusiasm for the accumulative process. He was equally devoted to its corollary, the destructive process, which he celebrated with his *Colères* (Rages). *Chopin's Waterloo* is the end result of an 'exhibition' in Switzerland during which Arman smashed a piano to bits with a sledgehammer, then glued the pieces to a panel exactly as they had lain on the ground. This element of chance has always played a strong part in Arman's work, which continues to obey the infernal logic of our materialistic civilization: production, consumption, destruction. (*C. Sc.*)

115 CÉSAR (César Baldaccini) (b. 1921)
Car compression; Ricard 1962
Elements of car body, compressed, 150 × 70 × 62 (59 × 27½ × 24½)
Gift of the artist, 1968

César's studies at the Ecole des Beaux Arts in Paris were conventional, but his inquisitive nature inevitably led him beyond the formalities of sculpture. In 1953 he discovered for himself the unusually expressive possibilities of scrap iron and began to use this economical material to weld together enormous animal and human forms that were not lacking in humour. In 1960 César saw a giant crushing press at work swallowing whole vehicles and reducing them to compact slabs. It was a revelation. What could a sculptor do, faced with a reality of such compelling and immediate beauty? César solved this problem, in the words of the critic Pierre Restany, by 'appropriating' these new shapes of reality. Hence the *compressions dirigées*.

For César, as for Giacometti (whom he knew and admired), sculpture is less a matter of form than of presence, and the 'compressions' were a powerful expression of this conviction. His inventiveness has not diminished and, following the 'compressions', he has invented fresh creative processes which make use of contemporary materials such as plastic, plexiglass and polystyrene. (*C. Sc.*)

116 ETIENNE-MARTIN (Martin Etienne) (b. 1913)
The coat 1962
Assemblage of various materials, 160 × 200 × 30 (63 × 79 × 12)
Purchase of the Musées Nationaux, 1973

For the sculptor Etienne-Martin, the prodigious series of *Demeures* (Homes), of which *The coat* constitutes the fifth segment, provides the means of reviving and perpetuating his childhood home. These works of assemblage and construction could almost classify Etienne-Martin as an architect actually living in the environment he has created. In his own words: 'I have remembered my childhood, and drawn my house. A house. This house is myself. Myself with all my contradictions. And the rooms are the paths of my thought, the paths of my life through all its phases.'

The coat is one of Etienne-Martin's most curious creations: an enormous chasuble built up of fabrics and interlaced cords, a sort of shrine encrusted with amulets. He has constructed his house with loving care, providing the various elements with different settings within which the body can 'feel at home' and the mind can indulge in random reflections. Since time immemorial, man has built his house in his own image. Etienne-Martin, poet of form and matter, envisages architecture as 'a place of mystery for a dreamed life', whereas the architect is concerned chiefly with the functional arrangement of space. Nevertheless, *The coat* provides clear evidence of the lifelong dialogue that Etienne-Martin has conducted with the architects who are his friends and collaborators. *(C. S.)*

117 ROBERT RAUSCHENBERG (b. 1925)
Oracle 1965
Assemblage of various materials
Gift of M. and Mme Pierre Schlumberger, 1976

With *Oracle*, Robert Rauschenberg presents the modern city in the shape of five basic domestic elements: a shower bath, a sort of stairway, a huge tube on wheels, a window frame, a car door. Here is a city in miniature; more specifically, New York crumbling apart, paralysed by some strike or electricity breakdown, New York buried under its own debris. The allegory which Rauschenberg has developed in *Oracle* is, logically, enhanced by that basic accompaniment of city life: noise. Each of the five elements in the 'environment' is equipped with a battery, a radio receiver and a loud-speaker, and these units broadcast the output of New York's radio stations, switching at brief intervals from one channel to another. This strident symphony can also be modified and controlled by the viewer. When shown in Paris. *Oracle* broadcast a hotchpotch of simultaneous programmes from stations all over Europe: the resulting cacophony transmitted the very voice of urban civilization.

Rauschenberg's research into 'sound collages' was an extension of his 'combine paintings', which were also collages, where fragments of wood, fabrics and silk-screen prints are integrated into the picture. Whatever technical innovations Rauschenberg introduces, the raw material of his art is invariably drawn from the vulgar mass-images churned out by the consumer industry in the form of advertisements, posters and so on. Rearranged, these signs give the viewer a chilly, remote view of his own environment, and perhaps even prompt him to reflect critically on life in industrial society. Rauschenberg may be considered one of the American artists who provide a link between the abstract expressionism of Jackson Pollock and the gestural exponents of pop art such as Andy Warhol. *(C. S.)*

118 JOSEPH BEUYS (b. 1921)
Homogeneous infiltration for grand piano 1966
Piano covered with felt, 100 × 152 × 240 (39½ × 60 × 94½)
Purchase of the Centre Georges Pompidou, 1975

Joseph Beuys may be an artist, but he also claims to be a theoretician, a professor, a political thinker, a writer. He was also, during the Second World

War, a bomber pilot; hence the sense of horror which pervades much of his work. In the early 1960s Beuys was associated with the international Fluxus movement, which specialized in festivals that featured 'happenings', a form of art in which Beuys has always excelled. His constructions/assemblages of this period were often made of the debris resulting from these violent manifestations. During the latter half of that decade Beuys's researches developed into a sort of alchemical process based on a few substances which appeared to obsess him, namely fat, felt and steel. For Beuys these forms of matter represented, respectively, energy, heat insulation and dynamics. Felt, for example is an amorphous, inorganic matter which conserves energy in the form of insulating layers, but which Beuys's wartime experiences must have taught him was also essential survival material.

When shown in Paris at the exhibition entitled 'Prospect 68', this *Piano* provided the setting for a 'happening' in which the honking of a goose substituted for the sound of the piano silenced by its felt camouflage. The colour of the covering, and the red cross marking it, refer yet again to the war, to sickness, and to the silence of the musical German people.

Art allows Beuys to project himself into the very heart of the problems that beset us all, and to testify, tragically, to the events of recent history. *(C. S.)*

119 ANDY WARHOL (b. 1927)
Electric chair 1966
Acrylic and lacquer applied in silk-screen print on canvas, 137 × 185 (54 × 73)
Gift of the Menil Foundation, 1976

Andy Warhol takes his subjects from news magazines and the violent episodes of everyday life, and the story he has to tell is usually a tragic one. His aim is to devalue the aesthetic function of the work of art. In a mechanized society, the artist himself becomes a machine, and the pop artist is distinguished by his use of the most despised material. Warhol's predilection is for repetitions and series. Choosing themes from American life, he enlarges the photographs and converts them into silk-screen prints, sometimes repeating them in uncompromising rows which emphasize the brutality of the document. This expressive power is often accentuated by acid, aggressive background tints. In *Electric chair*, however, the blue and red colouring that seems to veil the image imparts a sense of gravity and tragedy. Images of violent death, or allusions to death, are frequent in his work. There is nothing literary or decorative about this *Electric chair*. Death is represented here with a total lack of sentimentality. The artist makes himself the spokesman for a crime perpetrated by society, any of us, a crime – or just a news item – reported with stark objectivity. *(C. S.)*

120 BALTHUS (Balthazar Klossowski de Rola) (b. 1908)
The painter and his model 1980–81
Oil on canvas, 227 × 233 (89½ × 92)
Purchase of the Centre Georges Pompidou, 1982

On several occasions throughout his career, Balthus has felt the need to summarize, in one directly accessible painting, all that he feels about art, its tradition, its universal and secret emotion, about the mental play of form and matter in their relationship with reality. Such paintings are the *Mountain* (1926), the two versions of *The street* (1933 and 1952–54) and *The room* (1952–54). Balthus repeats this fundamental interrogation each time in an always accomplished scheme of triangulation. The most recent of these master works once again marshals the traditional components of his universe. In making the gesture of drawing the curtain to let in the light, the painter in this composition seems to turn away from the model, the folds of her costume, the still life, the painting implements, the secret reflections of art history, the studio itself: yet at the same time he puts them all into play. In the centre of the scene, the young girl's ambiguous, ethereal face justifies and questions this strange and fascinating allegory. *(G. V.)*

Index

Acknowledgments

Our thanks to all the artists and their heirs who have given permission for their works to be reproduced here.
 Plates 4, 6–7, 10–11, 17, 20, 23, 29, 33, 35–36, 42, 44–45, 47–48, 50, 52–53, 56–57, 59, 61–62, 68–70, 79–80, 82–83, 88, 112–113, 117, 119, and front cover Copyright © by S.P.A.D.E.M. Paris 1983
 Plates 2–3, 5, 8–9, 13–16, 19, 21–22, 24–28, 30–31, 34, 37–39, 41, 51, 55, 58, 60, 63–65, 67, 72–78, 80–81, 84–87, 89–92, 94, 96, 101–102, 107, 110, 115–116, and back cover Copyright © by A.D.A.G.P. Paris 1983
 Plate 18 Copyright © by Dr Wolfgang and Ingeborg Henze, Campione d'Italia